Image World

Art and Media Culture

MARVIN HEIFERMAN AND LISA PHILLIPS

WITH JOHN G. HANHARDT

WHITNEY MUSEUM OF AMERICAN ART

Dates of Exhibition
November 8, 1989–February 18, 1990

Public Projects:
November 22–December 31, 1989

Library of Congress Cataloging-in-Publication Data
Image World: essays/by John G. Hanhardt, Marvin Heiferman,
 Lisa Phillips.
 p. cm.
 Includes bibliographical references.
 ISBN 0-87427-067-7
 1. Conceptual art — United States — Exhibitions. 2.
Avant-garde (Aesthetics) — United States — History — 20th
century — Exhibitions. 3. Art and photography — United
States — Exhibitions. 4. Video art — United States —
Exhibitions. I. Hanhardt, John G. II. Heiferman,
Marvin. III. Phillips, Lisa. IV. Whitney Museum of
American Art.
N6512.5.C64I4 1989
709'.73'0747471 — dc20 89-39739
 CIP

Installation design: Art Clark

Captions for illustrations in front matter:
Times Square, New York, 1969. (cover)
Telstar 3 communications satellite, 1984. (p. 1)
Producer Darryl Zanuck and star Bella Darvi,
silhouetted against the first CinemaScope film
shown in Paris, 1954. (pp. 2–3)
Magnetic Resonance Image of a human brain. (p. 4–5)

Contents

9 Sponsor's Foreword

11 Director's Foreword

13 Introduction

15 Everywhere, All the Time, for Everybody
MARVIN HEIFERMAN

57 Art and Media Culture
LISA PHILLIPS

95 Film and Video in the Age of Television
JOHN G. HANHARDT

174 Image World Chronology

185 Selected Bibliography

193 Metamedia: Films and Videotapes in the Exhibition

205 Works in the Exhibition

215 Acknowledgments

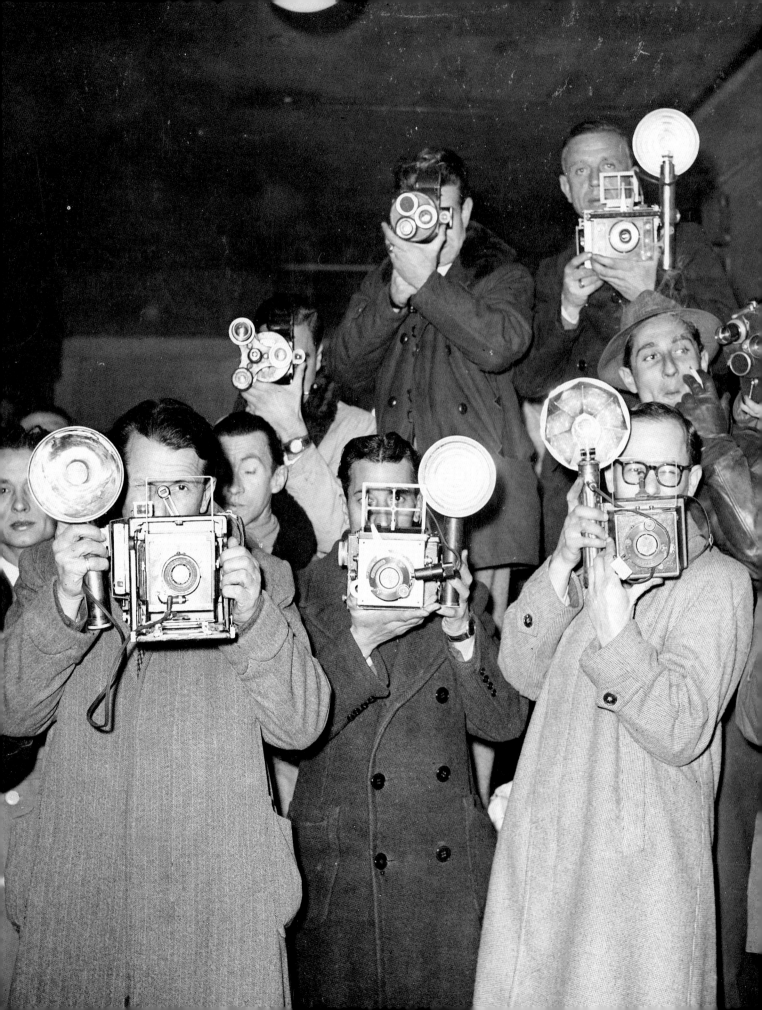

Sponsor's Foreword

Polaroid is very pleased to be associated with "Image World." Throughout our history, a basic enjoyment of images and a natural curiosity about them — in everyday life, in the sciences, in industry, in education, and in art — has helped to define our corporate culture. The recording of those images, the printing of those images, has defined our business.

Now, 150 years after the birth of photography, images are more pervasive than ever; their impact on life today is profound. The notion of photography is expanding beyond direct exposure of film, beyond the print on the page, even beyond photochemistry. That artists have chosen to explore the impact of the photographic image on art and society not only reflects our times, but also offers a glimpse of the nature of visual communications in the future.

I. MacAllister Booth
President and Chief Executive Officer
Polaroid Corporation

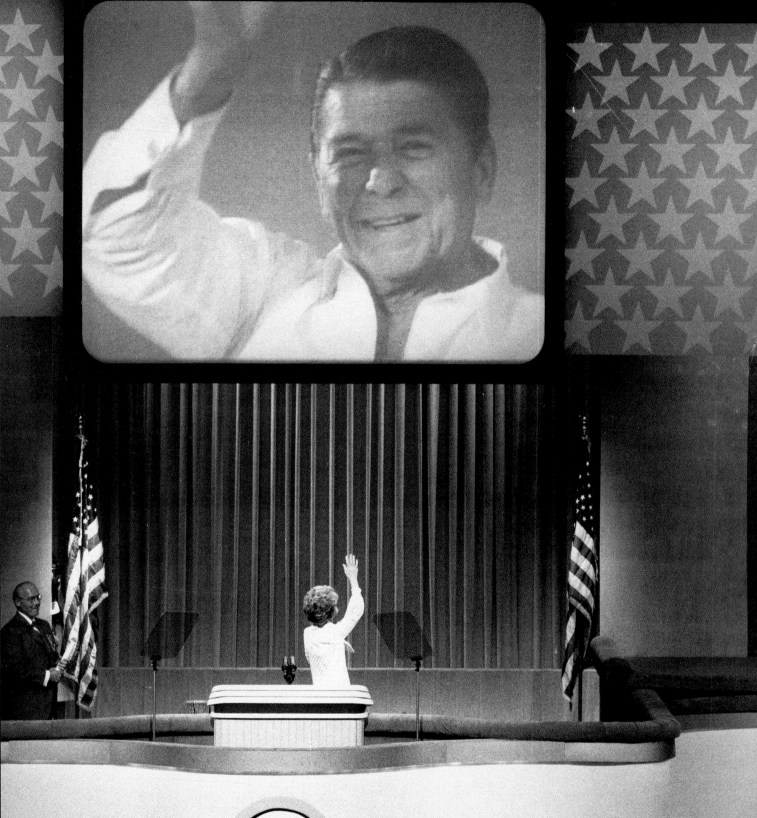

Director's Foreword

The staff of the Whitney Museum of American Art and I are continuously aware of the need to analyze certain aspects of our culture and explore current developments in American art through survey or thematic exhibitions. These exhibitions are challenging because they bring new insight to the experience of contemporary art.

"Image World" presents an overview of the complex interactions between art and the mass media in postwar America. The idea for this exhibition grew out of discussions between Lisa Phillips, curator of the Museum, and independent photography curator Marvin Heiferman. They then asked John Hanhardt, curator of Film and Video, to join them on the project because the moving image has played an integral role in the development of this chapter of American art history. The exhibition is thus a collaboration between curators with sympathetic views and individual areas of expertise.

"Image World" makes a clear case for the increased integration of the visual language systems and technical means of the media with those of art. In the process of this exchange, the photographic image has had a significant influence on all the arts, making it difficult to isolate photography as a separate entity. The exhibition will be provocative and will offer the first opportunity to assess some of the most important work of the past decade in a historical context.

We are extremely grateful to Polaroid Corporation for enabling us to present a pioneering statement about the art of our times.

Tom Armstrong

Introduction

For the past thirty years, a significant number of artists have made use of media imagery as a source, subject, and strategy in their work. The scale and force of this phenomenon underscore the pervasive presence of mass media and image-making technologies in our culture and society. In postwar America, media images have dominated our visual language and landscape, infiltrating our conscious thoughts and unconscious desires.

"Image World" proposes that the overpowering presence of the media has produced an Image World that is arguably the most important stimulus to the development of new art forms and practices. Artists have been forced to negotiate a relationship with media culture, exploring its ideological power and seductive materialism to redefine art. This exhibition chronicles recent developments in the visual and media arts as a means to consider broader cultural issues. From Pop Art to Conceptual Art to the more recent strategies of appropriation and multimedia installation projects, artists have observed, celebrated, and critiqued the media's complex myths and mechanisms.

"Image World" is not a definitive survey but rather a first attempt to consider this phenomenon as an important chapter in American art and cultural history. The Museum's exhibition spaces become a laboratory of images and ideas where film, video, painting, sculpture, and photography interweave to refashion our categories of art making. In this regard, the project is speculative, intended to raise such issues as the changing nature of representation, the dissolution of boundaries between media and the visual arts, and the circulation of images between art and popular culture.

The youth Narcissus mistook his own reflection in the water for another person. This extension of himself by mirror numbed his perceptions until he became the servomechanism of his own extended image. . . . It is, perhaps, indicative of the bias of our intensely techno-logical and, therefore, narcotic culture that we have long interpreted the Narcissus story to mean that he fell in love with himself, that he imagined the reflection to be Narcissus! —Marshall McLuhan[1]

Everywhere, All the Time, for Everybody

Red Eyes

Nothing feels real. Canned air enters the compartment through nozzles as the passengers, citizens of Image World, strap themselves into their seats. It is difficult to get comfortable. In-flight magazines, filled with pictures of the places they chose not to visit, press against the travelers' knees. Camera bags, stuffed with snapshots taken by automated cameras and processed in less than an hour, eat up the legroom.

It's a night flight, and as most Americans sleep the heavy jumbo jet taxies down the runway. In the first-class cabin, in business class, and in coach, the television monitors blink on, and the image on the screen is the same — an actor, costumed as a flight attendant, demonstrates the safety drill. In the aisles, real flight attendants mimic the same gestures.

American Airlines promotional postcard, c. 1950.

15

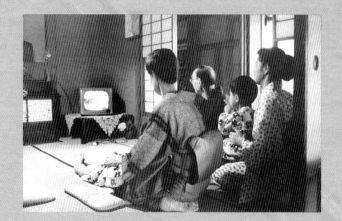

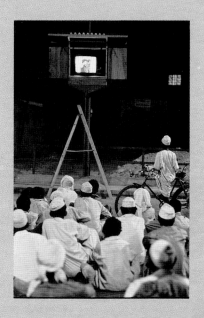

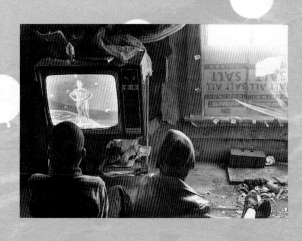

And as the plane picks up speed, as everything starts to shudder, the image on the screens changes. A video camera mounted behind the pilot's shoulder allows passengers to see the plane rise, just as gravity forces them back into their foam seats. On the monitors, the runway lights get smaller and smaller and smaller, and then the screen goes blank. It's take off on the red-eye.

Once the plane levels off, the real flight attendants return. "Care for a magazine?" They hand out brand name news weeklies full of colorful disaster shots. There are special interest journals crammed with special interest images of entrepreneurs and golfers. Hundreds of pages are flipped, hundreds of pictures are scanned. Then the cabin lights dim, and the monitors flick on, and it's time for yesterday's news, last week's sports, and a chopped up, shrunken movie. Many passengers don't watch; instead they stare out the windows into a darkness crisscrossed by invisible satellite transmissions. Flying against time, at 30,000 feet, at 600 miles per hour, from Hollywood to Madison Avenue, rest is fitful.

The sun comes up. The screens go blank. The plane comes down. Another day in Image World begins. Today, more than 10,500 Americans will be born and at least 5,800 will die. This morning, 260,000 billboards will line the roads to work. This afternoon, 11,520 newspapers and 11,556 periodicals will be available for sale. And when the sun sets again, 21,689 theaters and 1,548 drive-ins will project movies; 27,000 video outlets will rent tapes; 162 million televisions sets will each play for 7 hours; and 41 million photographs will have been taken. Tomorrow, there will be more.[2]

Perhaps this explains why people remember their dreams as if they were movies. Perhaps this reveals why any face observed in a mirror is scrutinized as if it were an advertisement. Perhaps this is why survivors of disasters describe their ordeals as if they had been watching themselves on television.

17

Welcome to Image World. Images are icons, fetishes, propaganda, informational constructs, and abstractions. Images are the theaters of spectacle, the arbiters of beauty, the mirrors of identity, the guides to consumer activity, the carriers of news, the documents of falsity, the templates of memory, the conduits of publicity, the vessels of celebrity, the official channels of public address, the borders of imagination, and, sometimes, the messengers of hope.

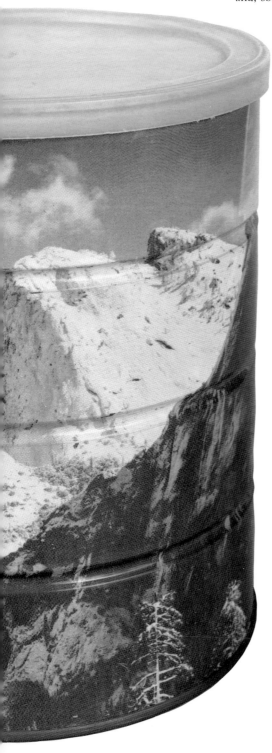

People walk the streets whistling commercial jingles they've come to despise and punctuate their speech with ad slogans. Every day, according to the Association of American Advertising Agencies, the average person is exposed to 1,600 ads. Although only eighty of these are noticed and only twelve provoke reaction, the atmosphere is thick with messages. Every hour, every day, news, weather, traffic, business, consumer, cultural, and religious programming is broadcast on more than 1,200 network, cable, and public-access television channels. Television shows (*60 Minutes*) are constructed like magazines, and newspapers (*USA Today*) emulate the structure of television. Successful magazine articles provide the plots for movies that manufacture related merchandise and then spin-off television series which, in turn, are novelized.

There are video dating services and sales campaigns that use images to promote life-styles in order to sell products. Pornography is made at home, while in the courtrooms of forty-five states cameras record the theater of justice. In the hallways of America's schools, in the elevators of office buildings, in banks, and at the front doors of many American homes, closed-circuit security systems monitor crime. In police stations, mug shots are computerized and there are now software programs that artificially "age" photographs of missing children so that their probable appearance can be described. Even disease has been mediated. What *People* magazine called Carsonogeneous Monocular Myctalopia, the temporary blindness caused by watching television with one eye on the TV and the other buried in a pillow, is named after Johnny Carson.

Ansel Adams, *Winter Morning, Yosemite Valley*, a special edition coffee can, 1969. International Museum of Photography at George Eastman House, Rochester, New York; Courtesy, Hills Bros. Coffee, Inc.

Surveillance monitor in an abortion clinic, New York, 1989.

Kellogg's Corn Flakes, 1985.

TV commercial for *The Love Line*, 1989.

Kennedy, NBC miniseries, 1983.

A cardiologist examines an image of a patient's heart on a monitor, 1961.

Multiplex cinema, Long Island, New York, 1989.

The life that begins with a sonogram will probably end in the glow of a rented TV in a hospital room. And the photographic image, as it always has, remains the best way to remember those who have died. At Gatling's Funeral Home in Chicago, there is a 24-hour drive-through service:

The motorist signs the register, conveniently tucked underneath the speakerphone, and drives a couple of feet to the viewing area where a head shot of the loved one in a coffin instantly appears on a 25-inch screen. . . . The picture lasts three seconds, but visitors can push a button to request to see the loved one over and over again, and some stare at the screen for over half an hour. When the car moves on, the next in line takes its place.[3]

American life was not always like this. If it seems now that photographic images have turned all notions of identity and reality upside down, remember that the construction of Image World began 150 years ago. And in that process, as visual representation was altered, so was the direction of American art.

To see life; to see the world, to eyewitness great events; to watch the faces of the poor and the gestures of the proud; to see strange things . . . to see man's work . . . to see things thousands of miles away, things hidden behind walls and within rooms, things dangerous to come to . . . to see and to take pleasure in seeing; to see and be amazed; to see and be instructed. —Henry R. Luce, in the first issue of *LIFE* magazine[4]

The public is completely uninterested in knowing whether the contest is rigged or not, and rightly so; it abandons itself to the primary virtue of the spectacle, which is to abolish all motives and all consequences: what matters is not what it thinks but what it sees. —Roland Barthes[5]

Young is better than old . . . pretty is better than ugly . . . TV is better than music . . . music is better than movies . . . movies are better than sports . . . anything is better than politics. —Richard Stoley, founding managing editor of *People* magazine, on choosing subjects for cover pictures[6]

Under the Influence

Photography was a European invention; after years of experimentation in England and France, the first public announcement of the photographic process was made in Paris on January 7, 1839, on behalf of Louis Daguerre. The traditional history of photography, the tracking of the medium as if it were only an aesthetic pursuit, begins with these early discoveries.

The history of art photography *is* an extraordinary picture story. Individual images, extracted from the larger histories of technology, economics, politics, and popular culture, are stripped of their context and meaning and then placed in a time line of formal invention. And photographs consciously created as art fit right into that aesthetic context, all on their own. Photographic images are intentionally made into, or are made as, beautiful, prized objects.

But in that process a problem is created. The history of art photography is divorced from a larger history of photographic realities. Photography is important because it creates communicative images, not objects. Over the past 150 years, photographic images have changed form and meaning and shape. And now, as sophisticated computer systems fabricate convincing photographic images without either cameras or negatives, and as amateurs store their snapshots on floppy disks for playback on television screens, it is obvious that the definition of photography must be rethought. There must be other histories of photography that are truer to the medium, and to life.

Daily interactions with images prove this. Vast quantities of photographic reproductions that have appeared in newspapers and magazines, on billboards, on packaging, in motion pictures, on television, and on videotape form a wrap-around picture environment, an Image World. And this world has its own language, its own goals, its own truths, its own criteria, its own complicated history. It is a history in which the photographic image has metamorphosed, like some creature in a science-fiction film. And to recognize that process, to construct a more generous photographic chronology, it makes sense to begin in America, and to start that history a little later.

In a symbolic sense, it can be said that Image World began on May 10, 1869, at Promontory in the Utah Territory, the instant that the "Golden Spike" joining the Central Pacific and Union Pacific railroads was hammered into the ground. The first telegraph line, opened in 1844, was already transmitting disembodied information, "news from nowhere,"[7] from one town to the next. But after this transcontinental transportation system was formed, mass-produced goods could travel from coast to coast. And that same network would soon carry newspapers, magazines, and films, "pictures from nowhere," along the same route.

But, in fact, the new medium of photography had begun to assert its importance in American life years before this event. The first Daguerrean studio opened in 1840,[8] and within a decade, similar businesses were in operation across the nation. By 1853, in New York, there were thirty-seven studios on Lower Broadway alone. In 1855, the

Commonwealth of Massachusetts calculated that 403,626 daguerreotypes had been made in the state during the previous twelve months. In 1860, the United States Census counted 3,154 working photographers, making portraits, still lifes, landscapes, and records of the nation's most important events.[9]

It was often noted by European visitors to the United States at the time that Americans were, by nature, a practical, enterprising people. This might help to explain the national fascination with photography. For the first time in the history of representation, the ephemeral nature of reality was captured, not by a "likeness," but in an "image" that looked *absolutely* real. The transitory nature of life could be recorded in photographic documents. The memory of appearances would be built upon the low-cost foundation of photographic fact. By mid-century, a daguerreotype could be purchased for as little as 25 cents.

The medium must also have seemed magical. Why else would people have so willingly allowed themselves to be strapped into chairs and held motionless by head clamps as they sat before the earliest cameras? Why else were photographers ushered into the homes of the rich and the poor to photograph the dead before their bodies were lowered into the ground? Through the full documentation of American life and death, the photographic image became the measure and proof of existence.

In the newly industrialized nation, photography proved itself amazingly efficient. Images not only described faces and places, but they gave the most abstract of philosophical concepts — truth, the sublime, and the American spirit — concrete photographic form. At London's Crystal Palace Exposition in 1851, displays of portraits of American leaders, views of Niagara Falls, and a single image of the moon printed on

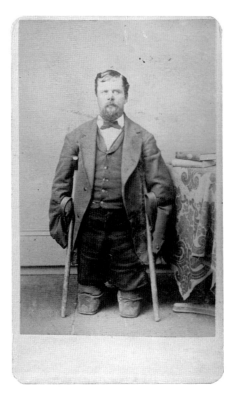

BENJAMIN FRANKLIN.

THE UNFORTUNATE SOLDIER, who lost all his limbs by freezing, while crossing the plains from Fort Wadsworth, Dakotah Territory to Fort Ridgely, Minn. While he was making the journey in company with four others, they were caught in one of those dreadful storms which frequently occur on the plains, and all his comrades perished. He was out eight days and seven nights without food or fire, when found by two Indians was nearly starved to death. He is the only Soldier in the United States without hands and feet, and is trying to sell his Photographs for the benefit of his family.

Price, 25 Cents.

Benjamin Franklin: The Unfortunate Soldier, carte-de-viste, c. 1870. The Burns Archive.

a silver plate won America three of the five medals given for photographic excellence, prompting Horace Greeley to boast, "Daguerreotypes . . . we beat the world."[10] And in the States, the ethereal nature of American beauty would be quantified by P.T. Barnum, who initiated a photographic competition to identify the first Miss America. Americans very quickly demonstrated a talent for exploring, exporting, and exploiting the photographic image.

By the mid-nineteenth century, with the manufacture of multiple photographic prints, images became commodities. Cartes-de-visite (small photographs mounted on boards, like baseball cards) of maimed Civil War heroes, of celebrities, of political leaders, and of human oddities like Tom Thumb were marketed, collected, and traded. In American homes, the viewing of stereopticon slides was a common family entertainment; one could stare at natural wonders that would never be visited and witness events, with an unearned intimacy, in three-dimensional simulations.

The parameters of personal knowledge were broadened by photography. A gap between experience and fantasy was bridged. The physical realities of geography dissolved. A new photographic "manifest destiny" was at work. In the process of becoming the world's largest producer of goods, the United States became the world's largest producer of, and audience for, photographic images. In fact, the invasive quality of media images had begun to infiltrate the lives of Americans before they were even aware of it. Throughout the Civil War, the wood engravings that illustrated battle accounts in the popular press were frequently based on photographs made by the country's first photojournalists.

By the early 1880s, the photographic image itself became the news. With the

invention of the halftone process (allowing images to be reproduced, as clusters of inked dots, simultaneously with text), the informational function of photography expanded. Even the idea of what a photograph *was* changed. Personal photographic icons were still cherished, but now most of the images produced were meant to be bought, "read," and discarded.

Soon, pictures would have no physical substance at all; they would fly through the air. The first practical motion picture projector was demonstrated by the Lumière brothers in Paris in 1895, and by 1897 itinerant showmen were traveling from one American town to the next, screening films for a fee at public gatherings. When the first movie theaters were opened in unlit, unventilated storefronts, audiences sat in the dark and cheered as images moved backward as well as forward. Radical visual jolts — huge close-ups, confusing shifts of perspective, abrupt transitions from one optical "space" to the next — crafted a startling new image "reality" from the sequencing of photographic fictions.

Having experienced the effects of a growing photographic freedom, the former subjects and consumers of images were able to become photographers themselves. In 1888, George Eastman's marketing of box cameras preloaded with film not only demystified photography, it made it simple. "You press the button, we do the rest," promised Eastman Kodak's advertising campaign, the largest of its time, with an 1889 budget reported to be $750,000.[11] For $25, the amateur audience could raise its own photographic voice in a photographic environment that, for the time being, appeared to be democratic.

Photography, so capable of encapsulating the past and picturing the present, now began to make promises for the future. Though the first American advertising agency had opened in Philadelphia in 1841, the first photographic illustration in an advertisement did not appear until 1896. A smiling baby, a spoon clenched in its pudgy fist, sat before a bowl of H-O Cereal.[12] To a public long accustomed to photography as fact and only recently exposed to moving images as fiction, advertising photography bridged the distance between the two. Americans could become what they saw. "See it, buy it, be it" was the perfect photographic concept to usher in the twentieth century.

During its first sixty years, the history of photography was one of technological development. During the next fifty, however, what transformed the American photographic environment was the multiplication of the sheer number of images. In 1908, there were nearly 10,000 nickelodeon theaters in the United States. By 1910, 26 million Americans paid to see movies each week. When World War I disrupted European film production, the new Hollywood studios, backed by Wall Street investors, began to distribute films to a worldwide market. In 1915, 36 million feet of film were exported, and by 1916, the figure was 159 million. That same year, 21,000 movie theaters were in operation in America. By the early 1920s, 40 million tickets were being sold each week. With the addition of sound to film in 1927, the illusion of a photographic world seemed so complete and real that within fifteen months after the conversion of theaters to accommodate sound films, motion picture profits increased 600 percent.[13]

23

During the Depression, the numbers changed. Movie ticket prices were cut as the unemployment rate rose. And while extravagant motion pictures of the period provided the needed escape from reality, advertising posited an image of a better reality to come. And it did so by using a higher percentage of photographic illustrations. One reason for the growing prominence of photography in advertising was simply economic — photographers were cheaper to hire than illustrators.[14] But there was another explanation as well.

An early George Gallup poll of 40,000 newspaper readers, made during this period, revealed that pages with pictures commanded greater reader attention.[15] And in a 1931 magazine readership poll, Gallup learned something else: advertisements worked best when they hinted at sex, vanity, and "quality" rather than efficiency or economy. The ability of the photographic image to ignite desire would help to restore the country to health. And soon the perfect vehicle was found.

From *LIFE* magazine's first weekly issue in 1936 (with a circulation of 466,000) to its last in 1972 (with 8 million copies sold),[17] advertisers had a perfect marketing tool to reach across the continent. Subscribers received something of equal importance in return — the perfect mirror of their image-saturated lives. Photographic narratives, seamlessly interwoven with ads, pieced together the American way of life as if it were a patchwork quilt.

Every seven days, photographic essays by the country's leading photojournalists would report on politics, news, sports, celebrity, fashion, culture, and art. Between these stories were full-page ads for automobiles, refrigerators, cigarettes, cheese, detergents, clothing, liquor, and personal hygiene products. What resulted was a democratic leveling of images that could give as much prominence to a gelatin-based fruit salad as to the President of the United States. It was a formula that should have worked forever — a classically proportioned blend of information, entertainment, and commerce. But it was rendered quaint by a technology that would provide an even greater number of images to the greatest number of people, faster.

On April 30, 1939, the Radio Corporation of America introduced television at the New York World's Fair. Less than a century after its invention, the physicality of the photographic image — the print, the still frame of motion picture film, the reproduction on a page — would be transcended. Though there were only one hundred televisions in home use at the time,[18] RCA promised that electronic images would fly into the living rooms of America in the very near future.

The transubstantiation of photography, in which images ceased being objects and became an environmental element, had to be postponed until the end of World War II. During the war, media images shouldered tremendous responsibility. Soldiers learned basic training procedures from films, battle strategies were based on reconnaissance images, and in the European and Pacific war theaters, an estimated 600,000 troops were entertained by feature films shipped from the States every night.[19]

Times Square, New York, 1920.

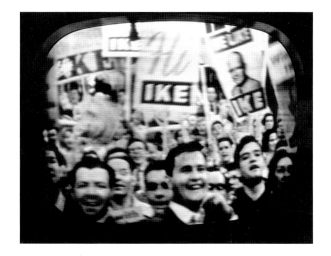

Eisenhower supporters at the 1952
Republican National Convention.

out on screens in the nation's living rooms. Adlai Stevenson, refusing to be packaged like "a breakfast cereal," chose to read his speeches from notes and, as a result, appeared distant and "intellectual." Dwight Eisenhower was able to look the electorate straight in the eye because he was reading scripts off a teleprompter — scripts that had been fashioned by advertising executives.

In the final two weeks of the campaign, the Republican National Committee spent an unprecedented $1.5 million to produce the first political TV spot campaign. Opinion polls were consulted to determine the public's most pressing concerns, which turned out to be political corruption, the high cost of living, and the war in Korea. In a television studio, Eisenhower (wearing a new suit, with his glasses removed, and in fresh makeup) voiced the "correct" answers to faked man-on-the-street questions. Forty 20-second spots were filmed in a day, to be aired across the country just before the election. The tactic worked, helping "Ike" to overturn twenty years of Democratic rule and, in the process, to forge a new, heavily manipulated format for the "image" of democracy.[26]

This calculated merger of photographic fiction (the language of film and advertising) with photographic fact (the language of photojournalism) changed politics, and also helped redefine the structure of news. In 1953, when news broadcasts expanded to a 15-minute length, there *had* to be news, and the news had to have visual impact. Press conferences, rehearsed speeches, awards ceremonies, these proved more photogenic than news analysis and achieved a broadcast prominence by simply providing the *image* of news.

Neil Postman, in *Amusing Ourselves to Death*, an analysis of how television has altered the nature of American discourse, thinking, and behavior, might as well have been describing the entire postwar media landscape:

"Now . . . this" is commonly used . . . on radio and television newscasts to indicate that what one has just heard or seen has no relevance to what one is about to hear or see. . . . Television did not invent the "Now . . . this" world view. . . . it is the offspring of the intercourse between telegraphy and photography. But it is through television that it has been nurtured and brought to a perverse maturity . . . we are by now so thoroughly adjusted to the . . . world of fragments . . . that all assumptions of coherence have vanished. And so, perforce, has contradiction. In the context of no context, so to speak, it simply disappears.[27]

 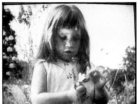 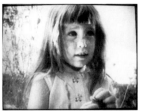 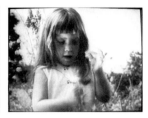

Child: One. Two. Three. Four. Five. Seven. Six. Sev . . . Eight. Nine. Nine . . . Man: Ten. Nine. Eight. Seven.

"Girl with Daisy" commercial by Tony Schwartz for Doyle Dane Bernbach, 1964.

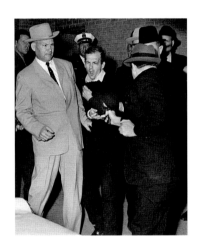

Jack Ruby shoots Lee Harvey Oswald, Dallas, 1963.

The acceptance of the photographic image as an abbreviated spectacle and of the media's use of images as disjunctive performances underlined the growing complexity and importance of photography. In advertisements of the 1950s, the lines of ad copy dwindled and the size of images grew. Even in the backyards of America, the dominance of the media and the victory of image form over substance prevailed. With the marketing of home movie cameras, portrait subjects no longer remained still. Family members were ordered to walk this way and that, directed to wave and smile, to look interesting and real, even to exaggeratedly mouth words for posterity.

The introduction of television caused movie attendance to decline throughout the decade. From 1949 through 1952, theaters actually showed television programs to bolster business.[28] But then a reverse tactic was developed. Hollywood began to revitalize the movies by making the film image bigger (Cinemascope was introduced in 1953), more colorful (by 1954, 50 pecent of movies were in color),[29] and more intense than television (*Bwana Devil*, the first 3-D movie, opened in 1952). Still, Americans stayed home.

The studios, hedging their bets, started producing television programming, and old films that had been languishing in archives were recycled — sold and leased for television broadcast. In the advertising world, too, images jumped from one display medium to the next. The picture that appeared on a package turned up in ads, on billboards, and in television commercials. With only slight adjustment, ad campaigns, movies, and television series were exported. America's new mythological figures — like the Marlboro Man or Lucille Ball — became "image ambassadors," spreading American style and products to a growing global audience.

Influence traveled in the reverse direction as well. Exotic images and foreign events entered the American consciousness with increasing speed. In 1953, Queen Elizabeth II's coronation was filmed off of a BBC broadcast in England, and the footage was processed at the airport and flown to America, where it was rebroadcast hours later.[30] By 1962, with the Telstar I satellite circling the earth, broadcast reports of Vice-President Lyndon Johnson's visit to Europe were screened almost instantly. Marshall McLuhan, in his radical tract *Understanding Media* (1964), foresaw the ramifications of an electronic media pipeline: not only would new communications systems affect the transmission of information, but they would — more importantly — alter the way the world was experienced and understood.

This had, in fact, already happened. In 1962, when John Kennedy briefed the nation about the Cuban Missile Crisis in a televised speech, it became clear that the cold war could turn hot faster than a commercial. A year later, the television audience's discomfort only increased when an amateur's film footage of Kennedy's

Six. Five. Four.

Three. Two. One. Zero.

Lyndon Johnson (voice-over): These are the stakes. To make a world in which all of God's children can live. Or to go into the dark. We must either love each other or we must die.

Voice-over: Vote for President Johnson on November third.

assassination was played over and over again, until it became believable, and Jack Ruby's murder of Lee Harvey Oswald was continually rebroadcast in the first use of instant replay. Then, all broadcast schedules were abandoned so that the nation could "participate" in Kennedy's funeral. For a four-day span, the media's normal state of disjunction matched the nation's confusion perfectly.

Good news and bad news, represented by good images and bad ones, mirrored the cultural schizophrenia of the time. In 1968, television viewers watched Martin Luther King's funeral and *The Beverly Hillbillies*, Bobby Kennedy's assassination and *The Dating Game*. At the Democratic National Convention in Chicago, student demonstrators chanted "the whole world's watching" as they were beaten by Chicago police. With the three major TV networks broadcasting in color, 83 million TVs were turned on to the vivid horror of the Vietnam War, and Lyndon Johnson's power base began to crumble.

It was television that helped undermine Richard Nixon's presidency as Nielsen ratings for the 1973 Watergate hearings topped those of *Let's Make a Deal*. It was the media that helped defeat Jimmy Carter because he was not "telegenic" enough. And, at the Republican Convention of 1980, where the ratio of media representatives to delegates was two to one,[31] an actor, Ronald Reagan, was nominated for the presidency. Eight years later, when sound systems tailored for the media made it impossible for those on the floor to hear George Bush's nomination, the delegates opted to retire to their hotel rooms to see and hear the event on TV. In the United States, images no longer are the representation of reality; they have become reality itself.

Execution of suspected Vietcong insurgent, South Vietnam, 1968.

President Lyndon B. Johnson, in the Oval Office, watches news coverage, 1967.

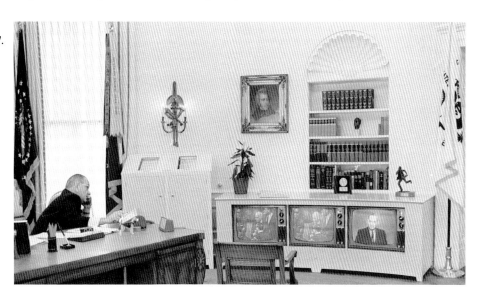

Robert Rauschenberg, *Erased de Kooning*, 1953. Erased drawing, 25½ × 21¾ inches. Collection of the artist.

The Second Coming

At the end of World War II, as birth rates soared, as suburbia grew, as highways were built, as the cold war began, as the American economy expanded, and as media images multiplied, doubt crept into American art. The American scene — the everyday sights observed and documented by painters and serious photographers — was preempted by a collaborative social realism that was pieced together by directors, models and actors, photographers and cameramen, art directors, costume designers, picture editors, film editors, sound editors, stylists, and photoretouchers.

Media culture, so adept at describing the surfaces and surface values of the world, could not help but influence the content and form of American art. The images that were most frequently seen and had the most influence on people were the products of the media, not the works of artists. To counter a specific photographic vision of the world that was defined by corporate priorities, postwar artists explored abstraction and used the materials of art as the extension of personal gesture. To ensure visibility in the media's shadow, art got bigger. If the goal of the media was to create a visual transcendency that would induce consumerism, art would still strive for an aesthetic transcendency that would touch the spirit.

Photographic reproductions of works of art brought the images of Abstract Expressionism (and of the entire history of art, for that matter) to a large audience. In 1953, William M. Ivins, Jr., wrote that the photograph "made it possible for the first time in history to get such a visual record of an object or a work of art that it could be used as a means to study . . . the qualities of the particular object or work of art itself."[33] But *LIFE* magazine's August 8, 1949, picture essay on Jackson Pollock suggested something quite different about the relationship between mass-media photographic images and art.

Bracketed by a picture story about a nun's sanctuary in Connecticut and advertisements for Fords and A&P cheese tidbits, Pollock's images and the "image" the media helped to create for him were absorbed into a larger, more powerful visual construct. The story, subtitled "Is he the greatest living painter in the United States?," would be replaced, in a week, by a new one about another celebrity. Art became just one more bit of subject matter in the visual encyclopedia of the new Image World. And as a second generation of Abstract Expressionists burrowed deeper into formal pursuits, another group of American artists, intrigued by the power and excited by the beauty of media images, began to re-position their art in relation to a visual discourse that they neither created nor controlled.

The incorporation of media imagery into works of art was not new. Picasso's early Cubist collages, Bauhaus posters, Russian Constructivist agitprop pieces, Surrealist collages, certain works of Marcel Duchamp, the politically engaged montages of John Heartfield and Hannah Höch, and Joseph Cornell's boxes — all had acknowledged and employed the media's photographic images.

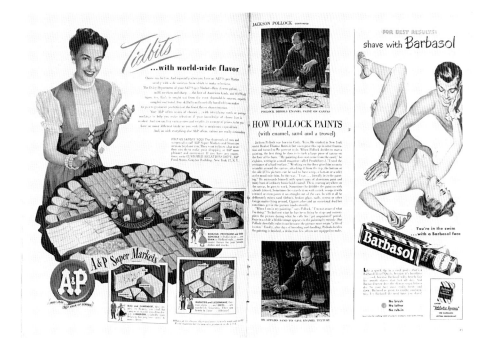

But it was a fascination with the power of the media and the absorption of media images and techniques into works of art that defined what would become a particularly American obsession. Just as photographic invention had begun in Europe, the origin of American art's media preoccupation can be traced to England, to the 1956 exhibition "This Is Tomorrow," organized by the Institute of Contemporary Art at the Whitechapel Art Gallery, London, and, in particular, to Richard Hamilton's collage *Just what is it that makes today's homes so different, so appealing?*

In the United States, however, the dense overlays of public and private images no longer seemed to be a collage. Sequences of fragmented images appeared normal, as did the conflation of fact and fiction. The media images that manipulated cause and effect did more than turn the visual environment surreal; they turned the basic surreality of photography into a reality all its own. Because images were omnipresent and overwhelming, they became believable, contrary to all the evidence of common sense. Whereas in the nineteenth century seeing was believing, viewers now shared images in an "ecstasy of communication" — the overload situation that Jean Baudrillard described as the "obscene" excitement of a visual environment in which there was too much to be seen.[34]

Media images became currency; they were minted, circulated, worn out, and replaced. In the world of art, where images were supposed to last, this constant excitement and image diversion presented challenges and raised some very basic questions. How could the categories and functions of media images best be understood? Whose needs were being served in the images of mass culture, whose goals achieved? What talents, technologies, and value systems were represented in media images? And, at the most basic level, if media culture had affected the perception and experience of the visual world, what did that mean for art?

Richard Hamilton, *Just what is it that makes today's homes so different, so appealing?*, 1956. Collage, 10¼ × 9¾ inches. Zundel Collection, Tübingen, West Germany.

Over the past thirty years, an increasing number of American artists have been investigating the idea that media images are not simple documents of experience but have come to precondition experience in general and the experience of art. In response, they have adapted the images, the language, and the tactics of the media. Yet Pop Art's enthusiastic or ironic celebration of the media's reach, the deconstruction of images in Conceptual Art, or the appropriation in the past decade of seductive media imagery make it quite clear that the messages of media culture as perceived by artists are neither straightforward nor simple.

Of course, many American artists have chosen to avoid any involvement in this ongoing dialogue with media imagery. Abstract art and the "purer" versions of representation continue within their own traditions. And the tradition of art photography continues as well, in an idealized realm that has purposefully disengaged itself from the photographic issues that the picture language of Image World raises.

But it *is* the media's images that define visual thinking and communication in America today, and as the power of the media is widening, the power base is consolidating. In the United States, it is common for a single corporate conglomerate to control movie studios, publishing houses, magazine empires, radio and TV stations, and advertising agencies. In 1981, forty-six corporations controlled most of the business in daily newspapers, magazines, television, books, and motion pictures; by 1986, that number had shrunk to twenty-nine. It is estimated that by the year 2000 ownership of the United States media industry may be in the hands of only six conglomerates, and global communication will be dominated by only twelve major corporations.[35] What began as a raucous democracy of images will be controlled and distributed by a few, very powerful businesses.

In the history of art, as in the media, what is said has been determined by *how* it is said. So when artists choose to react to our wrap-around visual culture, they are acutely aware of its beauty and its traps. The three generations of artists represented in the exhibition have confronted this situation with responses that swing from enthusiasm to criticism, from fascination to ambivalence, and from admiration to distrust.

This process of confrontation, as Marshall McLuhan observed twenty-five years ago, is important:

Art as a radar environment takes on the function of indispensable perceptual training rather than the role of a privileged diet for the elite. While the arts as radar feedback provide a dynamic and changing corporate image, their purpose may be not to enable us to change but rather to maintain an even course toward permanent goals, even amidst the most disrupting innovations.[36]

In the world of media images, art can still provide transcendence. When the objectivity of all images is open to question, art can outline a navigational path toward meaning. In a world where images are fleeting, art can provide some permanence. And in an Image World, where individuals have no choice but to become part of an audience, art can reclaim personal experience and provide perspective by speaking with its singular voice.

Notes

1. Marshall McLuhan, *Understanding Media: The Extensions of Man* (New York: McGraw Hill Book Company, 1964), p. 51.

2. Sources for statistics: daily birth and death rate of Americans, The National Service for Health Statistics, Hyattsville, Maryland, 1987; billboards, Institute of Outdoor Advertising, New York; newspaper and periodicals, *Gale Directory of Publications* (Detroit: Gale Research Company, 1989), p. VIII; theaters and drive-ins, National Screen Service, New York; video rentals, Bruce Apar, "What's New in Video Distribution," *The New York Times*, April 23, 1989, sect. 3, p. 19; television sets, "Television's 50th Anniversary," *People Weekly Extra* (Special Supplement, Summer 1989), p. 77; TV viewing time, *Trends in Viewing* (New York: Television Bureau of Advertising, February 1989), p. 6; photographs, "150 Years of Photography," *LIFE Anniversary Issue* (Fall 1988), p. 73.

3. Isabel Wilkerson, "New Funeral Option for Those in a Rush," *The New York Times*, February 23, 1989, p. A15.

4. Quoted in Leonard R. Kaufman, *Magazine Journalism and the American Lifestyle* (New York: St. Regis Paper Company, 1976), p. 138.

5. Roland Barthes, *Mythologies* (1957), transl. Annette Lavers (New York: Hill and Wang, 1972), p. 15.

6. Quoted in Ron Powers, "Sorry, Fawn, Your 15 Minutes Are Up," *GQ*, 58 (February 1988), p. 214.

7. Neil Postman, *Amusing Ourselves to Death: Public Discourse in the Age of Show Business* (New York: Penguin Books, 1986), p. 67.

8. Richard Rudisill, "Mirror Image: The Influence of the Daguerreotype on American Society" (1971), in *Photography in Print*, ed. Vicki Goldberg (New York: Simon and Schuster, 1981), p. 70.

9. For the statistics in this paragraph, see Beaumont Newhall, *The Daguerreotype in America* (New York: Duell, Slone and Pearce, 1961), pp. 55, 34.

10. Rudisill, "Mirror Image," p. 71.

11. Frank Presbrey, *History and Development of Advertising* (New York: Greenwood Press, 1969), p. 401.

12. Ibid., p. 386.

13. For the statistics in this paragraph, see *The New Encyclopaedia Britannica*, 15th ed. (Chicago: Encyclopaedia Britannica, Inc., 1989), s.v. "Motion Pictures."

14. Stephen Fox, *The Mirror Makers: A History of American Advertising and Its Creators* (New York: Vintage Books, 1985), p. 120.

15. Ibid., p. 138.

16. Ibid.

17. Gisele Freund, *Photography and Society* (Boston: David Godine, 1980), p. 141.

18. "Television's 50th Anniversary," p. 82.

19. John Izod, *Hollywood and the Box Office, 1895-1986* (New York: Columbia University Press, 1988), p. 114.

20. Ibid., p. 113.

21. Fox, *The Mirror Makers*, p. 172.

22. "Television's 50th Anniversary," p. 82.

23. Erik Barnouw, *Tube of Plenty: The Evolution of American Television* (New York: Oxford University Press, 1975), p. 114.

24. Ibid.

25. Ibid., p. 135, for statistics on the number of television sets.

26. Fox, *The Mirror Makers*, p. 309.

27. Postman, *Amusing Ourselves to Death*, pp. 99-100, 110.

28. Izod, *Hollywood and the Box Office*, p. 135.

29. "Motion Pictures" (as in n. 13).

30. Barnouw, *Tube of Plenty*, p. 170.

31. Joel Makower, *Boom! Talkin' About Our Generation* (Chicago: Contemporary Books, 1985), p. 127.

32. Oliver Wendell-Holmes, "The Stereoscope and the Stereograph," *The Atlantic Monthly*, 3 (June 1859), p. 745.

33. William M. Ivins, Jr., "New Reports and New Vision: The Nineteenth Century" (1953), reprinted in *Classic Essays on Photography*, ed. Alan Trachtenberg (New Haven: Leet's Island Books, 1980), p. 217.

34. Jean Baudrillard, "The Ecstasy of Communication," in *The Anti-Aesthetic*, ed. Hal Foster (Port Townsend, Washington: Bay Press, 1983), p. 131.

35. Ben H. Bagdikian, *The Media Monopoly* (Boston: Beacon Press, 1987), p. 4.

36. McLuhan, *Understanding Media*, p. XI.

"Photo Pistol" scares away criminals and also takes their pictures, 1957.

Eadweard Muybridge, Animal locomotion plate #344, collotype print, 1887. Laurence Miller Gallery, New York.

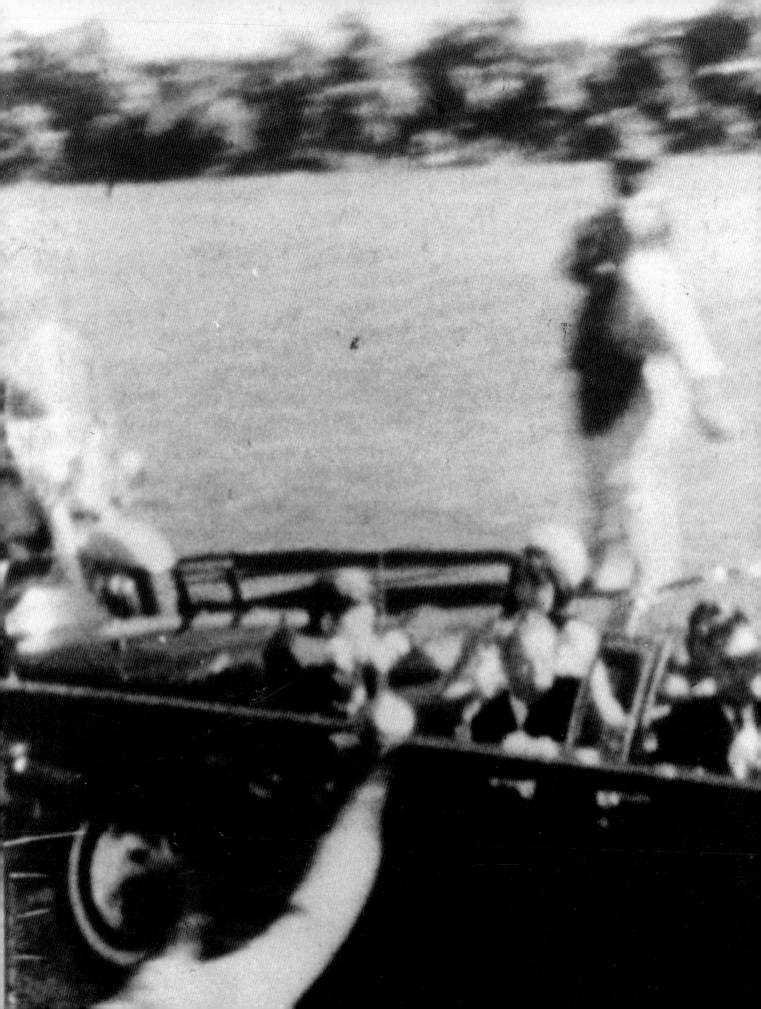

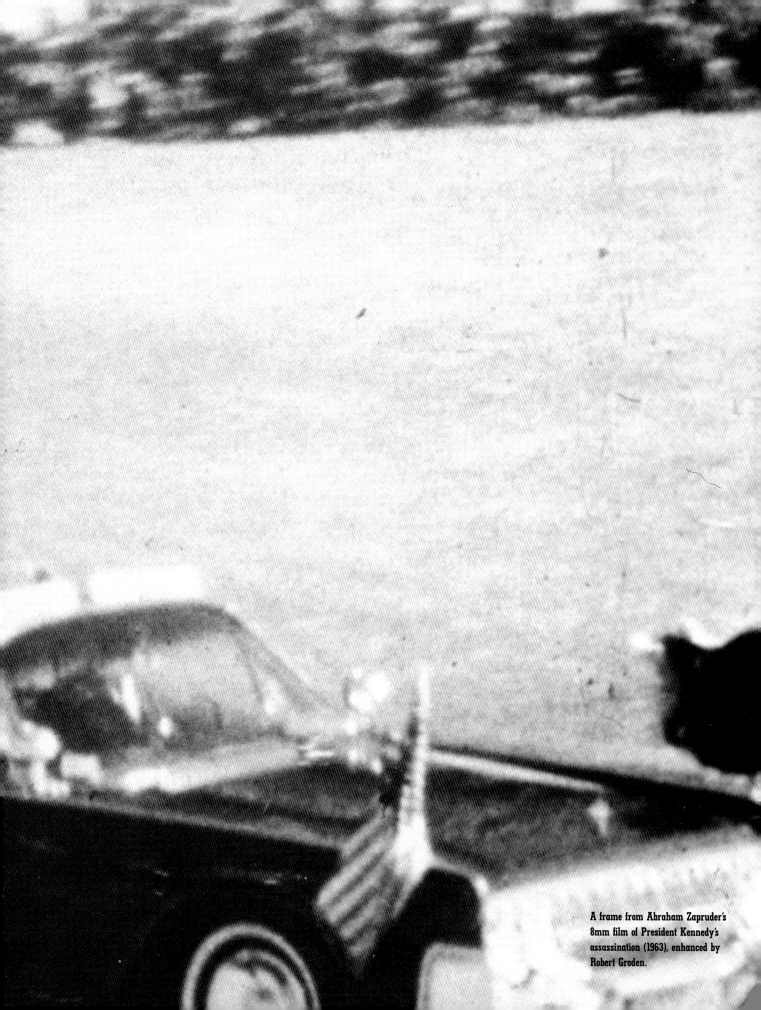

A frame from Abraham Zapruder's 8mm film of President Kennedy's assassination (1963), enhanced by Robert Groden.

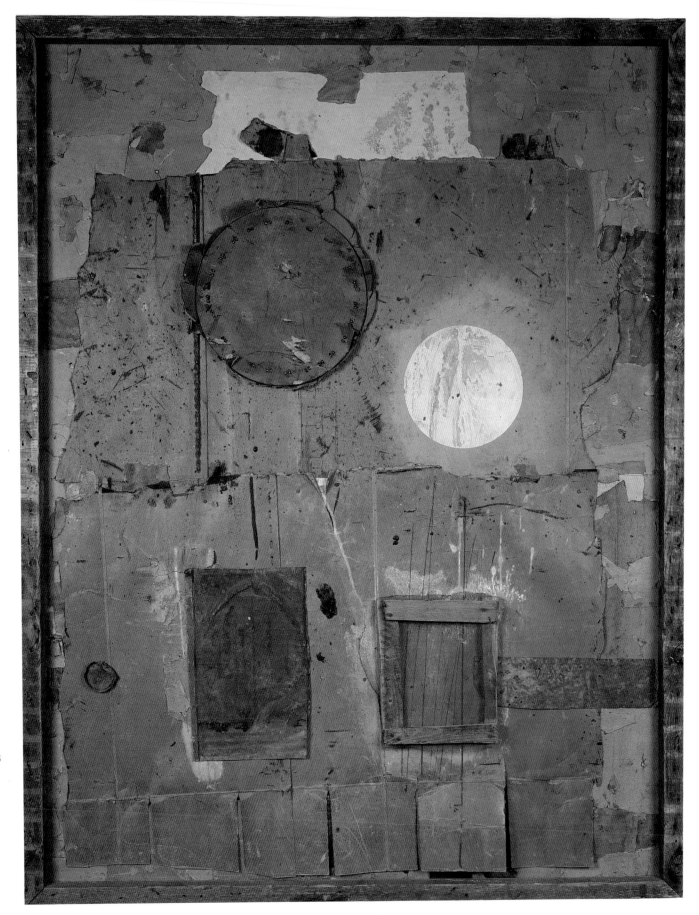

36

Bruce Conner, *Untitled*, 1954–62 (front and back)

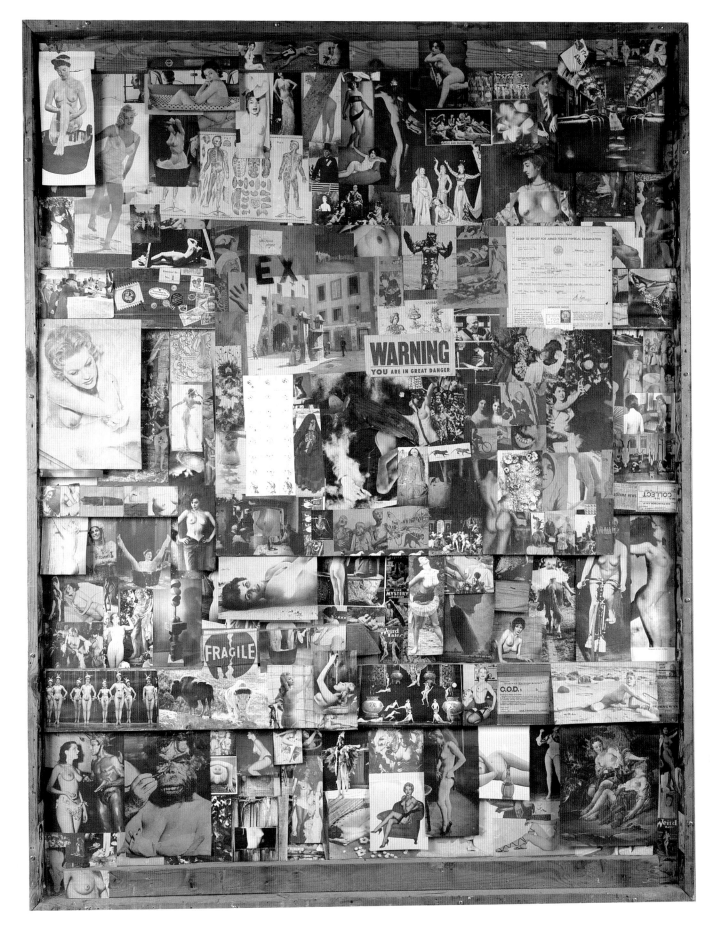

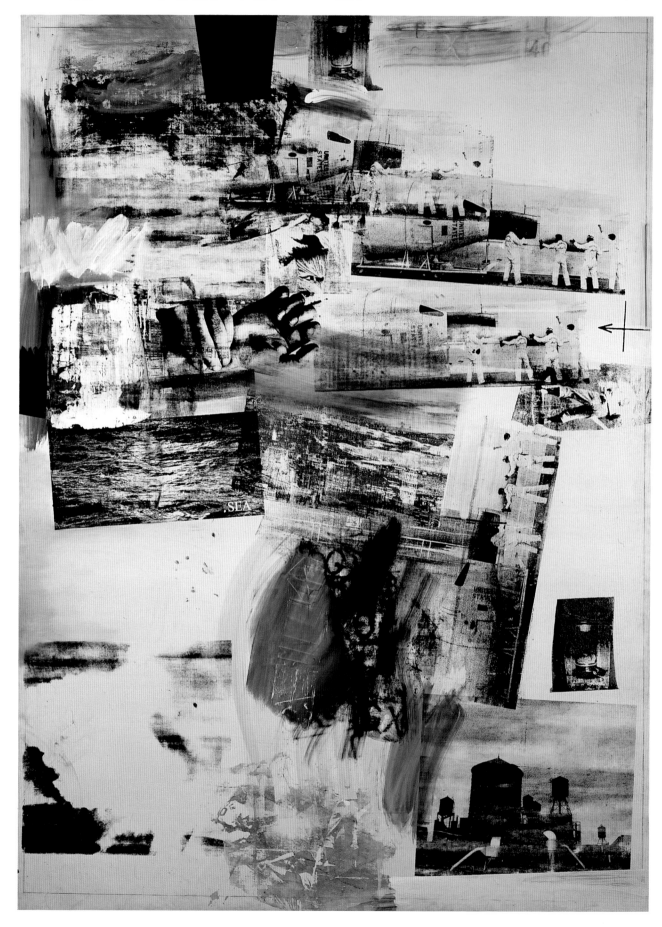

Robert Rauschenberg, *Overcast I,* 1962

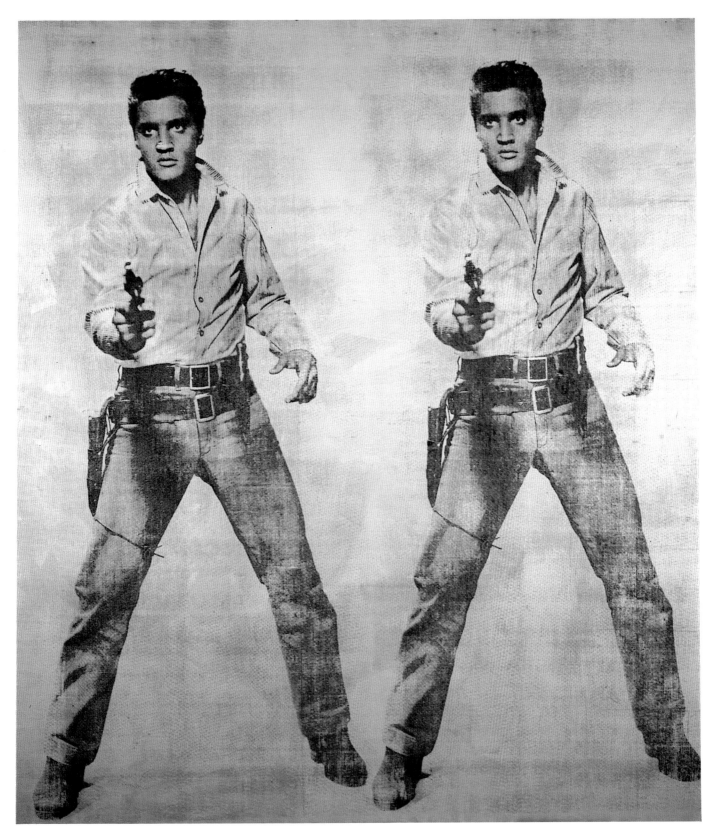

39

Andy Warhol, *Double Elvis,* 1963–64

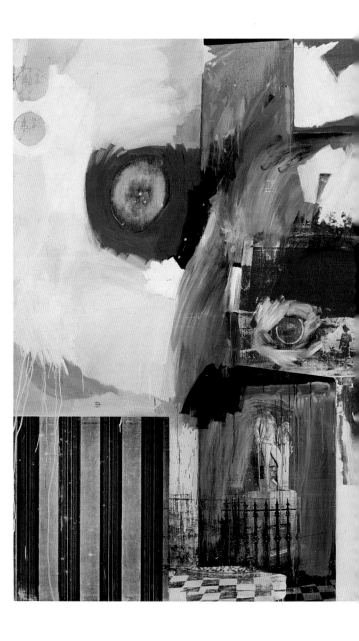

40

Robert Rauschenberg, *Die Hard*, 1963

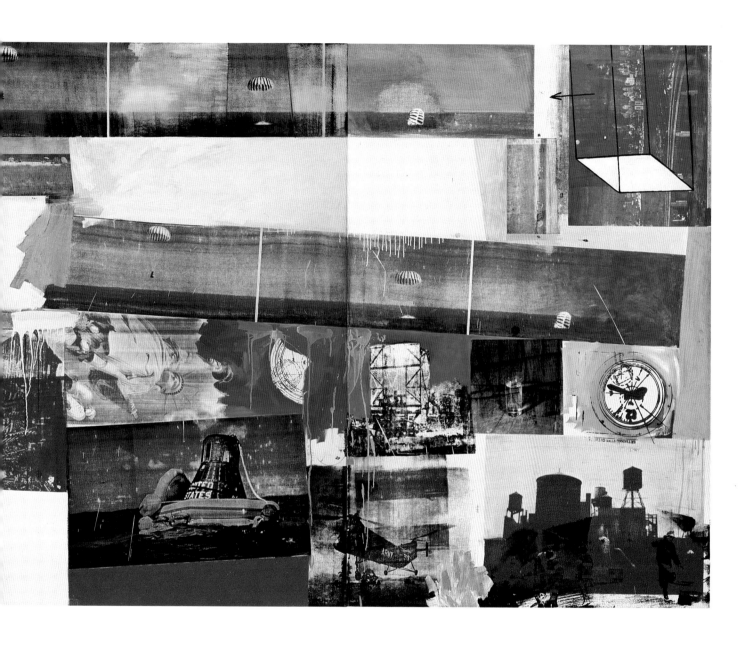

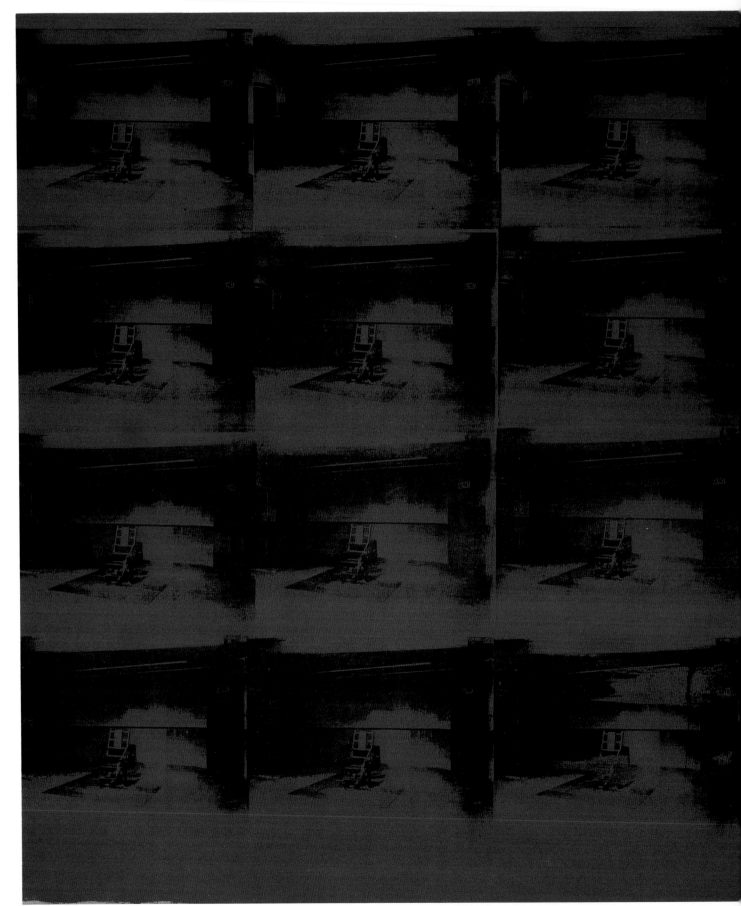

Andy Warhol, *Red Disaster*, 1963 and 1985

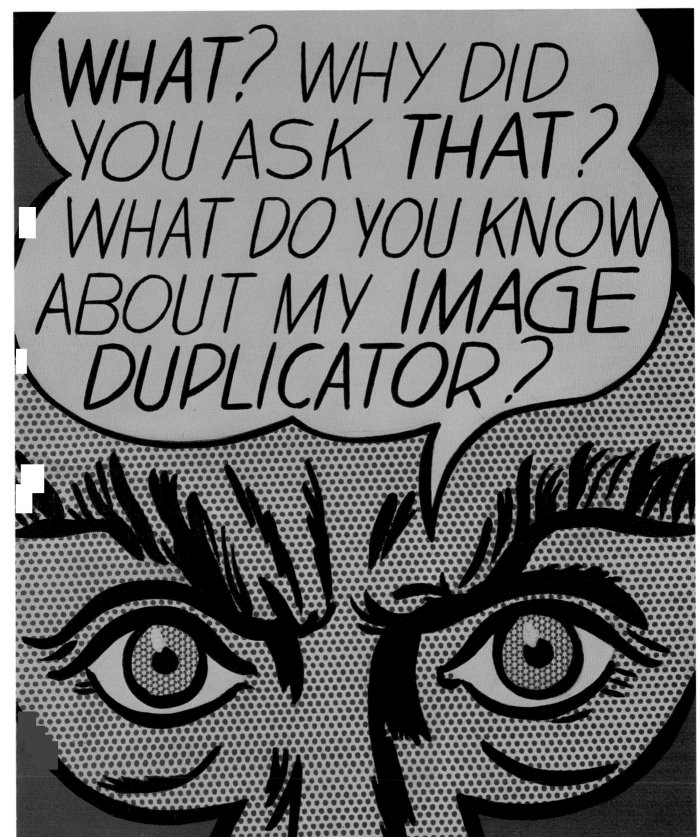

Roy Lichtenstein, *Image Duplicator*, 1963

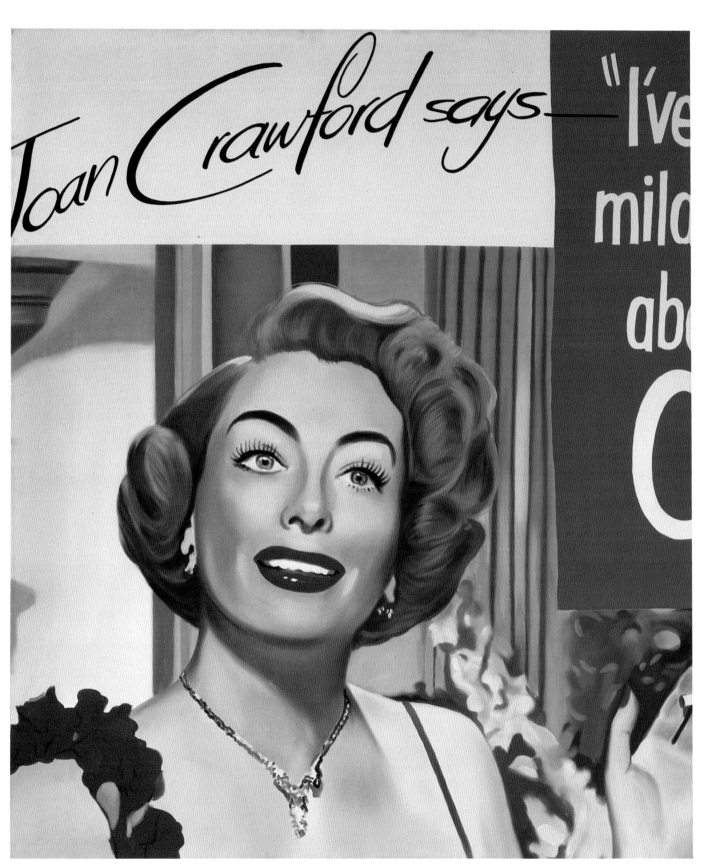

James Rosenquist, *Untitled (Joan Crawford Says)*, 1964

46

Edward Ruscha, *Hollywood*, 1968

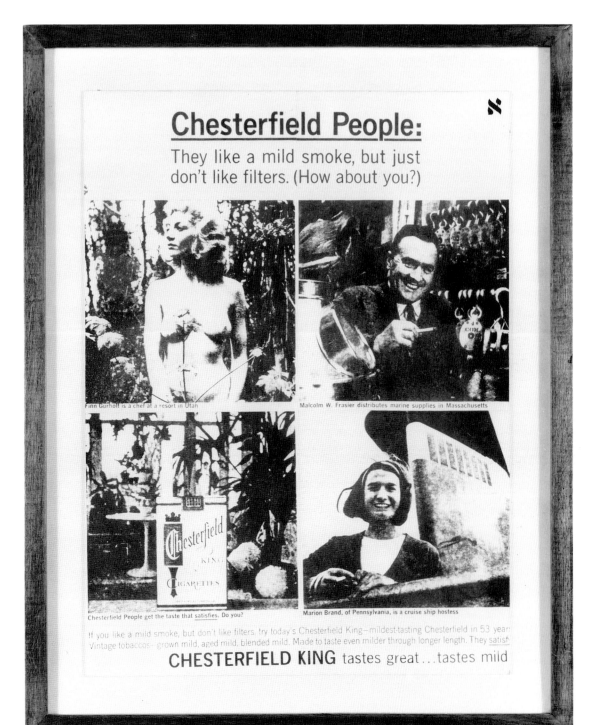

Wallace Berman, *Untitled (Chesterfield People)*, 1964

AN ARTIST IS NOT MERELY THE SLAVISH
ANNOUNCER OF A SERIES OF FACTS.
WHICH IN THIS CASE THE CAMERA HAS
HAD TO ACCEPT AND MECHANICALLY
RECORD.

John Baldessari, *An Artist Is Not Merely the Slavish Announcer*, 1966–68

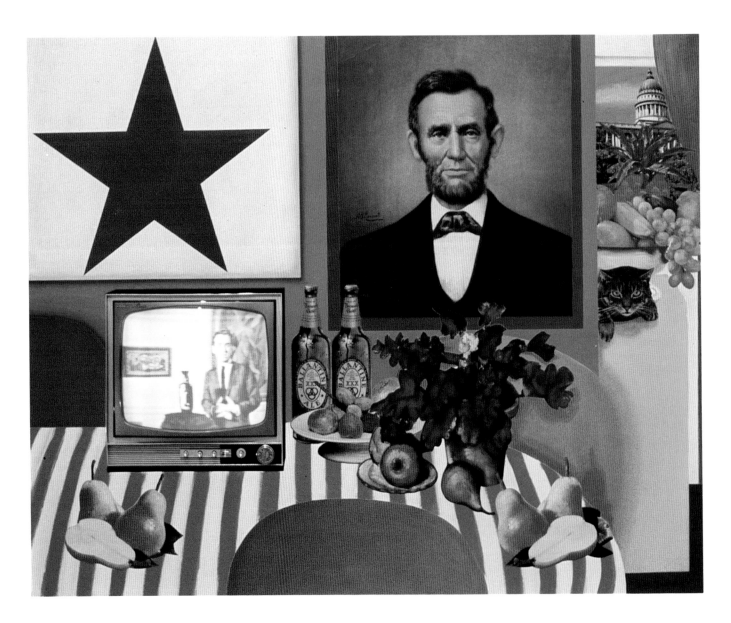

Tom Wesselmann, *Still Life #28,* 1963

John Clem Clarke, *Peyton Place Credits*, 1968

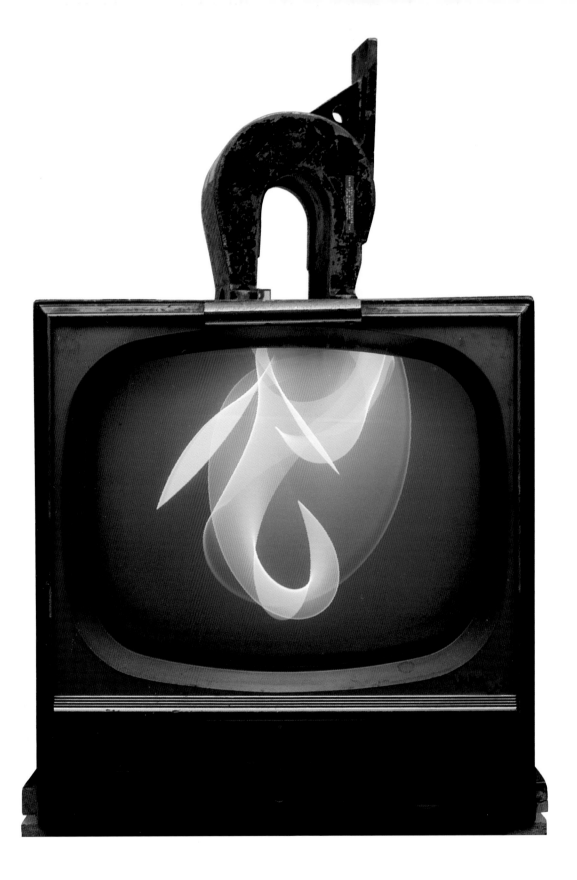

Robert Watts, *Yamflug/5 Post 5 Collage*, 1963
Stamp Machine, c. 1965 and 1982

Nam June Paik, *Magnet T.V.*, 1965

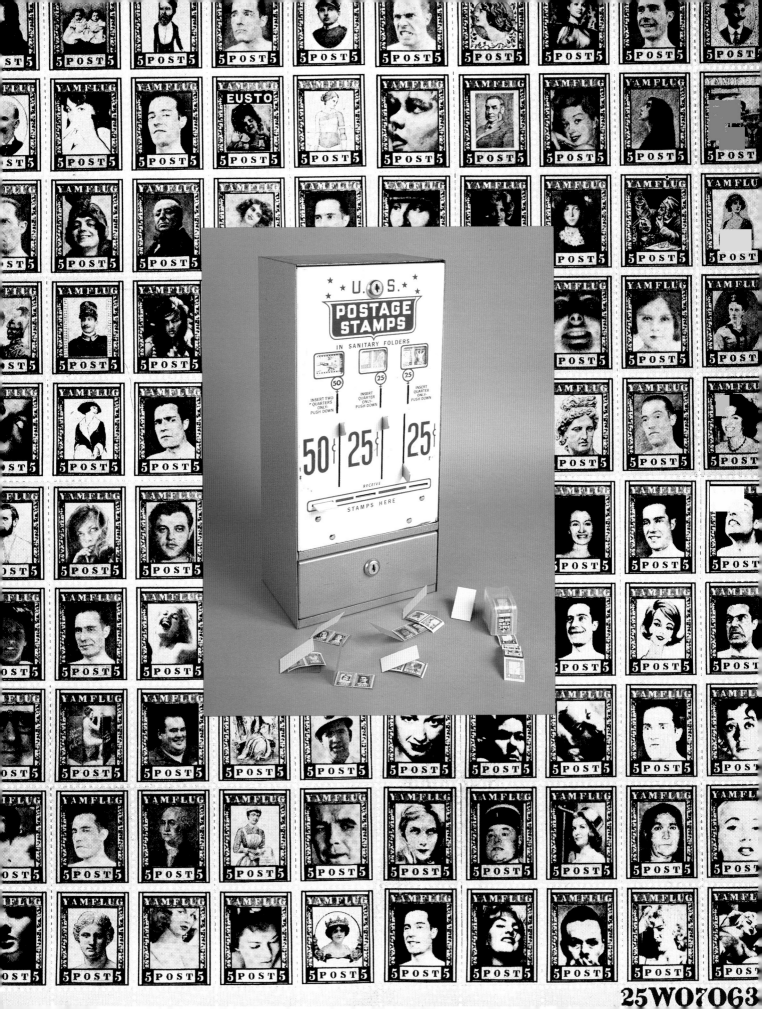

25W07063

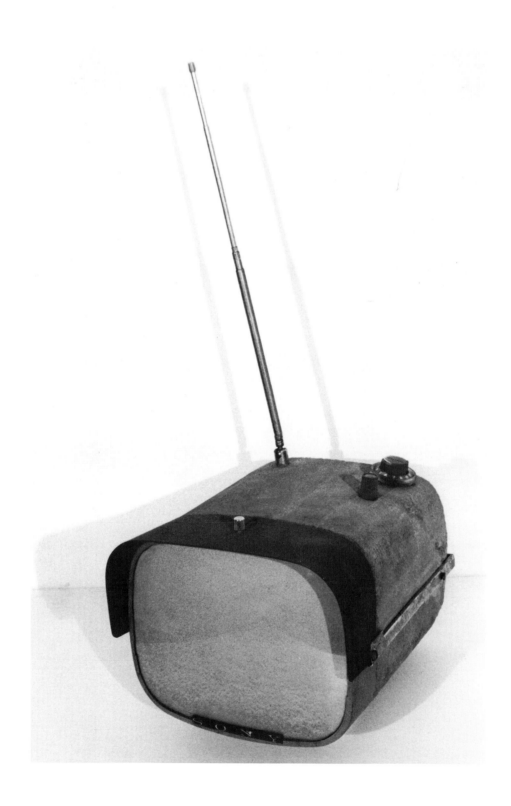

Edward Kienholz, *TV 8301 W,* 1967

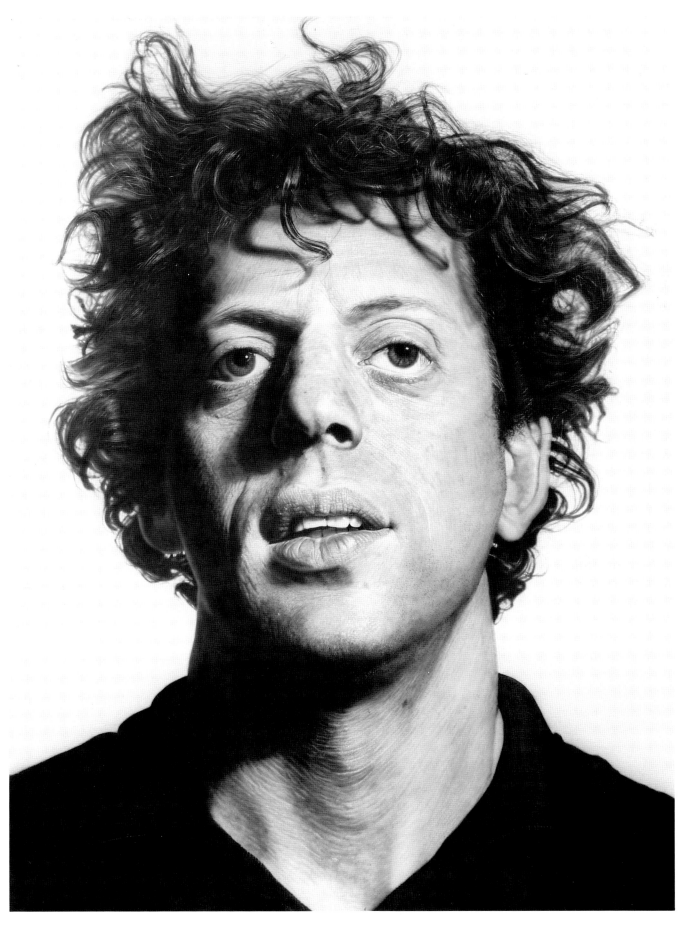

Chuck Close, *Phil,* 1969

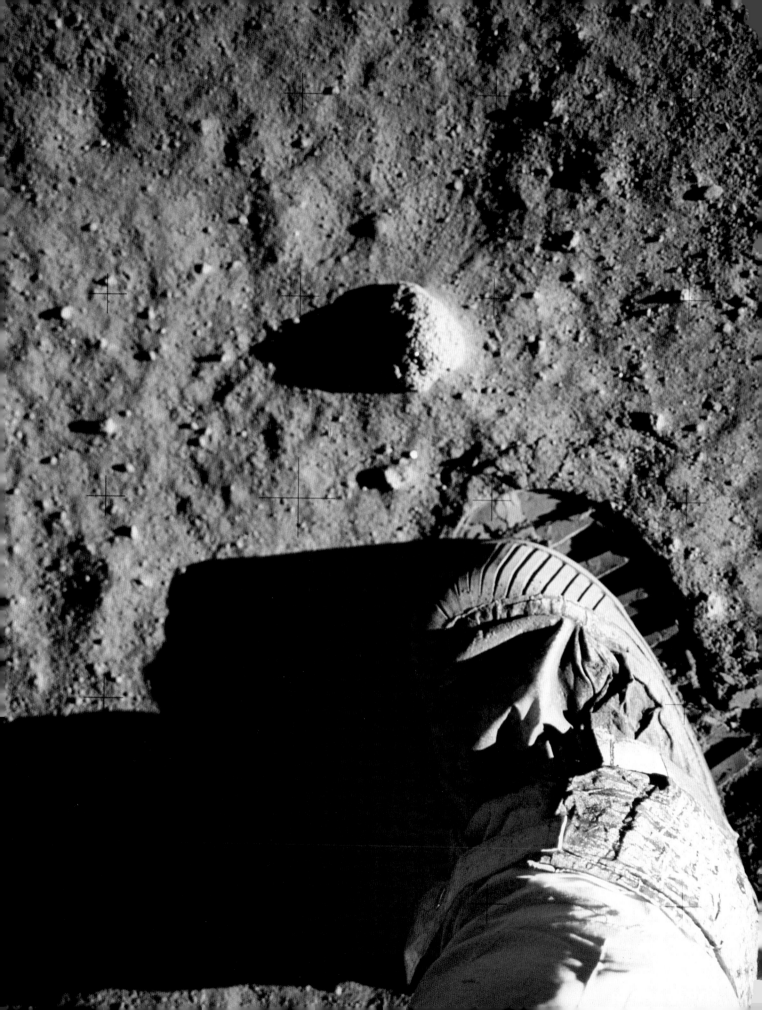

Everything is destined to reappear as
simulation. Landscapes as photogra-
phy, women as the sexual scenario,
thoughts as writing, terrorism as
fashion and the media, events as
television. Things seem only to exist
by virtue of this strange destiny. You
wonder whether the world itself isn't
just here to serve as advertising copy
in some other world. —Jean Baudrillard[1]

Art and Media Culture

Special Effects

Today we can speak of an Image World — a specific media culture of teletransmissions,
channels, feedback, playback, and interface that has produced a televisual environment.
TV is the ultimate object for our new era — the perfect "static vehicle."[2] Cinema was
the first of such vehicles to bring us sounds with moving pictures, the sensation of
speed, and condensation of time. Now the TV monitor is assuming every function —
everything will take place on the smooth, operational surface of the control screen
without our ever having to move. We can shop through it, do our banking, select a
date, meet new friends, tour faraway places, get a degree. The speed of transmission
has replaced the velocity of vehicular, physical transport. The intensive time of
instantaneity has replaced the extensive time of history. Philosopher Paul Virilio has
even predicted that our destiny is "to become film" by becoming teleactors —
circulated on the screen without ever circulating. And soon, with the aid of fiber
optics, we will receive information and images directly on our retinas, our bodies
becoming the screens.[3]

 Mass reproduction of the image and its dissemination through the media has
changed the nature of contemporary life. In a century that has seen the intrusion of
saturation advertising, glossy magazines, movie spectaculars, and TV, our collective
sense of reality owes as much to the media as it does to the direct observation of
events and natural phenomena. The media has also changed the nature of modern art.
As image makers, artists have had to confront the fact that this new visual mass
communication system has in some way surpassed art's power to communicate. Over
the past thirty years, they have come to terms with the mass media's increasing
authority and dominance through a variety of responses — from celebration to
critique, analysis to activism, commentary to intervention. The ascendancy of this new
visual order has raised a host of critical issues that many artists have felt obliged to
confront: Who controls the manufacture of images? Who is being addressed? What are
the media's strategies of seduction? Has the media collapsed time and history into a
succession of instants? What are the effects of image overload, fragmentation,

Apollo 11 moon landing, 1969.

repetition, standardization, dislocation? Is the photograph still a carrier of factuality? Where is the site of the real? Is understanding "reality" a function of representation? All of these questions have directed attention away from aesthetics to the nature of representation itself as the principal problem of our age. Since much of experience is mediated by images, the issue of how meaning is constructed through them has become central. Artists have also had to recognize that as our relationship to the visual world has changed so has the role we assign to art. This awareness has precipitated nothing less than a complete transformation of the function of art and the conventional guideposts used to define it.

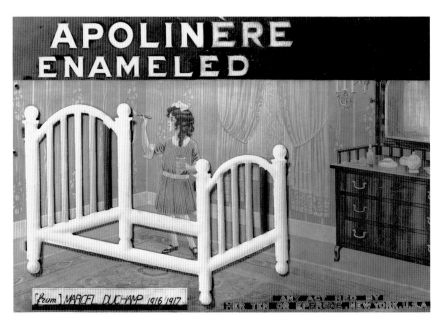

Marcel Duchamp, *Apolinère Enameled*, 1916–17. Painted tin, 9¼ × 13¼ inches. Philadelphia Museum of Art; Louise and Walter Arensberg Collection.

Historical Threshold

The effects of the Image World were beginning to make themselves felt in art during the first decades of the century, when a convergence of recent technical discoveries — electrical wiring, movie projection, portable cameras, and the automobile ushered in the new age with a vertiginous rate of change. When, in 1912-13, Braque and Picasso incorporated bits of newspaper into their Cubist collages, the range of acceptable materials and iconography for art was considerably widened to include elements of mass culture. In 1914, Marcel Duchamp pushed the issue further, selecting objects and images from the real world and re-presenting them as "readymade" art. Duchamp was actively interested in commercial imagery throughout his career. In an early example of a rectified readymade, *Apolinère Enameled* (1916–17), Duchamp used an actual

advertisement for Sapolin, a popular brand of paint. He altered the lettering slightly — [S]APOLIN[ÈRE] — and added the reflection of the girl's hair in the mirror. Some of his other artworks included a fake check and a wanted poster featuring his own face. Duchamp was the first to appropriate consumer objects and images as readymade art, recognizing that in a reproductive world uniqueness and singularity were diminishing and framing and context determined meaning. By relocating these objects in an art context, he conveyed a new message that defined art within the framework of commodity fetishism.

Berlin Dadaists John Heartfield, Raoul Hausmann, Hannah Höch, and George Grosz composed their agitprop works entirely of images cut from newspapers and magazines. They developed the concept of photomontage to express their political views in a compelling, filmic way. The practice of photomontage was common in Soviet art of the twenties, as it was at the Bauhaus. In the early twenties, Bauhaus artists established their well-known interdisciplinary program, which accorded graphic design and photography equal status with the so-called high arts of painting and sculpture. These artists, along with the Surrealists and Constructivists, extended the practices of collage and montage into mass forms of communication: photography, film, architecture, fashion, and theater. Salvador Dali, for instance, ready and willing to work with the mass media, art-directed segments of Hollywood movies, appeared in commercial advertisements, designed furniture, and created *Dali's Dream House* in the amusement area of the 1939 World's Fair in New York. A figure who straddled high and low art, he achieved celebrity for his eccentric and flamboyant personal style; his flawless painting technique and bizarre imagination epitomized certain popular myths of the artist as crazy, excessive, and extreme, but brilliant.

In 1939, Clement Greenberg wrote his prophetic essay "Avant-garde and Kitsch" to clarify the difference between high and low art, their social origins and effects. Both emerged in the nineteenth century, he pointed out, for different ideological purposes: high (authentic) culture to serve the rich and cultivated, kitsch — a synthetic art, a simulacrum of culture — to satisfy the new urbanized masses enjoying increased leisure time. Greenberg noted that kitsch, because it was mechanically produced, quickly became "an integral part of our productive system in a way in which true culture could never be," and that "[its] enormous profits are a source of temptation to the avant-garde itself."[4] Sensing the power of kitsch, he warned that it could contaminate high art. Even in 1939, therefore, some foresaw the breakdown of traditional distinctions between high and low culture.

Conditions in America following World War II conspired to produce irreversible social change. Mass-manufactured advertising images ran rampant as consumer spending increased. The hyperbole of postwar American advertising and packaging was invasive as we became image junkies addicted to visual consumption. "Image" alone counted — everything was in the "look."[5] With the advent of television we had direct access to a continual flow of visual information. "The individual," George Trow observed, "became a point on a grid of 200 million."[6]

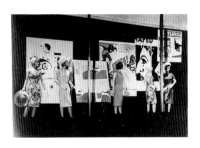

Andy Warhol, **Bonwit Teller display window, New York, 1960.**

Soon painting too took the screen as a new model. In 1962, Robert Rauschenberg and Andy Warhol independently began to silkscreen photographic images directly onto the surfaces of their canvases. Colliding and abundant fragments of real life from magazines, movies, and tabloids were not attached and glued but transferred mechanically — "received" on the surface of the "flatbed picture plane."[7]

The photo-silkscreen on canvas was a new hybrid form — part photograph, part painting, part print. It overturned the prejudice against photography as painting's poor relation. In these works and in many others by Pop artists, the photograph became the origin of the image. The appearance of this new technical-mechanical means not only modified art's forms but also art's very concept, destabilizing the aesthetic object and official taste. As British Pop artist Eduardo Paolozzi commented, "The unreality of the image generated by entirely mechanical means *is commensurate with* the new reality with which we have lived for half a century but which has yet to make serious inroads on the established reality of art."[8]

In the fifties, Rauschenberg had begun to activate the grounds of his paintings with newsprint; he then emphasized these found images through the transfer and silkscreen processes. He loaded his canvases with image shards, letting the world in with an inclusive Whitmanesque spirit of democracy. His scrapyard of images produces a buzz — a kind of visual interference on the pictorial surface that alludes to the space of the billboard, dashboard, and projection screen.[9]

James Rosenquist, **F-111** (detail), 1965. Oil on canvas with aluminum, 10 × 86 feet. Private collection.

Warhol went a step further: he internalized the very methods of the media, incorporating its processes into the construction and *conception* of his work. He emphasized the depersonalization of the media, its dependence on stereotypes and repetition and its fascination with surface. He fetishized the whole structure of mechanical reproduction; "I'd like to be a machine, wouldn't you?," he said. The image, for Warhol, became fact, signifying that it signifies nothing. He recognized that repetition had emptied images of meaning; they had become commodities — objects whose only value was exchange value.

To many, Warhol's attitude represented a rejection of the deepest values of modern art. He worked not like an artist but an art director, manipulating images and making

the kind of design decisions he had made as a commercial artist. And his repeated imagery — of commercial products, of Jacqueline Kennedy in mourning, of Marilyn Monroe's press photo — collapsed the antagonism between the unique and the reproduced, the original and the copy, an antagonism on which the integrity of high culture had always depended.

All of the Pop artists came under fire when Sidney Janis introduced the movement in 1962 with his "New Realists" exhibition. Warhol's cohorts James Rosenquist, Roy Lichtenstein, and Tom Wesselmann all drew their imagery and techniques from mass culture, painting a new landscape of promiscuous signs and consumer products that formed a collective portrait of America and its utopian vision of prosperity. Lichtenstein's *Image Duplicator* (p. 44) of the following year can be regarded as an apt symbol for the enchantment of the age with mechanical reproduction and manufactured images. Critics objected to Pop's fascination with materialism and brazen affirmation of commercial values. Hilton Kramer insisted that the social effects of Pop Art were indistinguishable from those of advertising art, "reconciling us to the world of commodities, banalities, and vulgarities."[10] Others, like Irving Sandler, mistrusted Pop's commercial success and the exposure it received in slick magazines because "it rendered the advertising ethos respectable."[11] The ambiguity of Pop's position and its voyeuristic detachment still provoke discussion today. During a recent symposium on Warhol held at the DIA Art Foundation, a debate broke out over the

imputed meaning of Warhol's selection of a photograph of Imelda Marcos for the cover of *Interview* magazine.[12] Did Warhol think she was a real star, or was he mocking stars and the possibility of exploiting them, or criticizing their exploitation?

One of the clearly political works of the period was James Rosenquist's *F-111* (1965), considered the apotheosis of Pop. While Warhol had been designing shoe ads and store displays in the fifties, Rosenquist was earning his living as a billboard painter. High above Times Square, he grew intimate with abstract patches of Kirk Douglas and Lynn Fontanne. He later drew on this experience and applied billboard techniques to his paintings — collapsed compositions of close-ups, body parts, disjointed fragments. *F-111*, his first environmental work, was a wrap-around picture

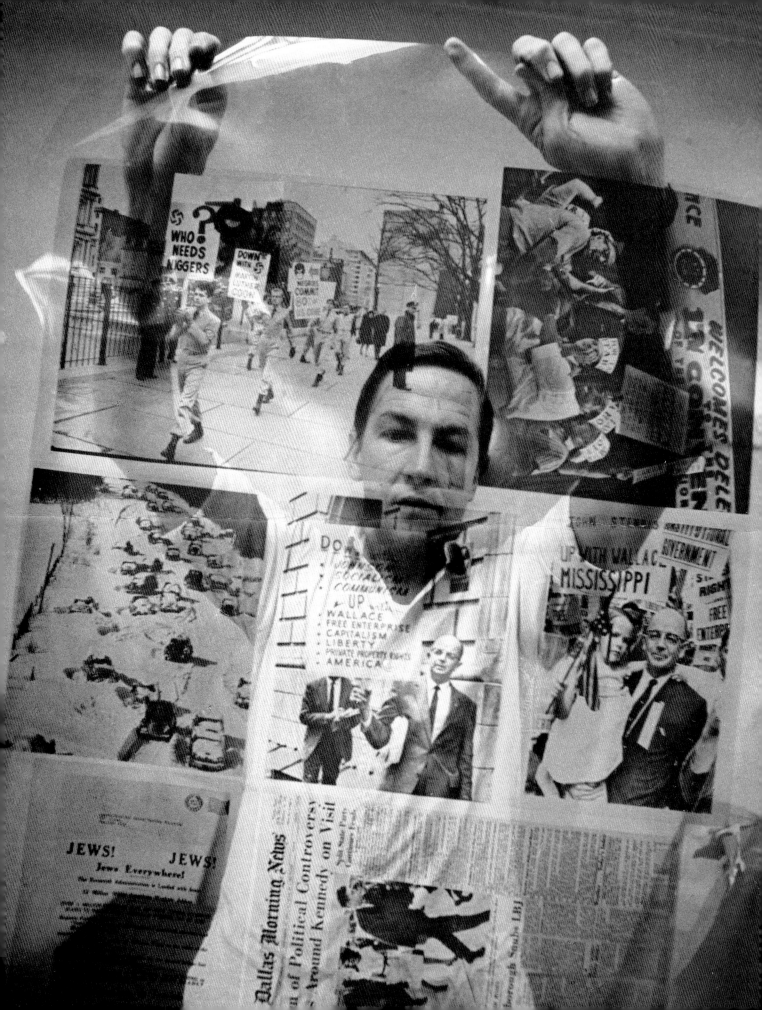

spread that directly commented on the sinister nature of military technology. Its sale in 1965 to Robert Scull for the then astonishing sum of $60,000 received front-page coverage in *The New York Times*.[13]

Pop Art not only made capital visible but exposed art as an industry. Resistance to the dominant culture eroded as avant-garde and kitsch crossed into each other's territories. In the early 1940s, Theodor Adorno and Max Horkheimer had already prophesied an age of universal publicity, when all aspects of Western society would be absorbed within the mass media.[14] With Pop, the prophecy was fulfilled. Maintaining a position outside the system no longer seemed germane as critical works were embraced by the very forces they criticized. Dissent was institutionalized and art moved into the center of the status quo.

The Apparatus

Other groups of artists held to their faith in an oppositional art that could offer an alternative to media culture. Fluxus, an international group of artists, recognized Pop's strategic acuity in anticipating cultural transformation, but found Pop's glibness, ambivalence, and lack of critical intervention objectionable. Fluxus artists used mass-culture forms — film, TV, postage stamps, newspapers, and commercial products — as vehicles for their art, referring directly to Dada and the Duchamp-Cage tradition in their anti-art, anti-taste stance. Unlike Pop artists, however, they took a counter-cultural position toward the commodity status of the art object and targeted the mass media as the most nefarious ideological prop. Pushing the limits of acceptability, they infused their works with political and sexual innuendos.[15] Compared to Pop Art, Fluxus remained deliberately marginal, peripheral, and never took a mainstream, mass-marketing approach. Fluxart was often ephemeral, made casually of inexpensive materials; and poetry, film, sound, movement, and photography played as significant a role as the objects. Some works, among them Nam June Paik's video sculpture, opened up whole new avenues for artists to explore. Other works, though prescient, were never realized, such as George Maciunas' visionary plan for a multimedia *Flux Amusement Center* in SoHo with film wallpaper (1968). The Fluxus artists' disavowal of expertise, glamour, quality, and even sometimes the object itself directly anticipated Conceptual Art, which came to the fore in the late sixties.

The photographic image *as fact* assumed a central place in Conceptual Art. In 1965, Joseph Kosuth made *One and Three Photographs* (p. 64), a three-part work consisting of a rather dull, prosaic, yet factual photograph of a lone tree on a barren hill, a copy of it (hence, a copy of a copy), and a photographically enlarged dictionary definition of the word "photograph." In putting the three together, he simultaneously provoked questions about originality and uniqueness and about the conventions through which representation is produced. Quoting Wittgenstein, he said, "the meaning is the use."[16]

John Baldessari burned his paintings at the end of the sixties in a ritualistic display of renunciation of the handmade object. He came to this renunciation after working

Fluxus Collective, *Fluxus cc V TRE Fluxus (Fluxus Newspaper No. 2)*, February, 1964, p. 3.

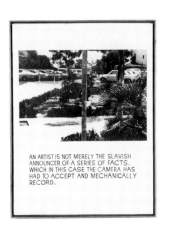

John Baldessari, *An Artist Is Not Merely the Slavish Announcer*, 1966–68.

Joseph Kosuth, *One and Three Photographs*, 1965.

on a series of photographic emulsions on canvas which ironically eliminated all signals that indicated "art." Mechanically made like Kosuth's, the works had a detached, alienated air that informed rather than formed. In these early works, Baldessari used photographs that contradicted the conventions of good photography combined with wry sardonic captions — for example, *"An Artist Is Not Merely the Slavish Announcer of a Series of Facts"* (1966–68). Despite, or perhaps because of, this contravention, he helped establish photography (and language) as independent vehicles for representation. He subsequently adopted a film storyboard format, developing purposefully disjointed and melodramatic narratives through the use of movie stills and images lifted right off the TV screen — all designed to avoid or submerge aesthetic decisions.

Conceptual Art established a new imperative for artists: that what must be investigated is "the apparatus the artist is threaded through."[17] Art had to be seen as part of a network of social relations constructed within a fluid interchange of cultural codes. Representation is an apparatus of power, realized in specific contexts that allow it to signify rather than to be constituted solely within the absolute domain of the individual imagination. Therefore, a work's "aesthetic qualities" and "autonomy" were no longer valued; it was the *framing* of the work that would reveal the social nature of artistic activity and the contingency of art's meaning.

Artists began actively seeking more diverse public forums and contexts in order to re-position the conditions of art's distribution and reception. Billboards, books, the magazine page, TV spots, and rock clubs became sites for works that created friction between the controlled public context and the intervention of an independent outside voice. Canadian artist Ian Wilson took out an "ad" of his printed name in the June 16, 1968, Sunday *New York Times*, and Dan Graham embarked on a series of works that used the magazine page to reflect on the nature of advertising. For a museum exhibition, Joseph Kosuth placed ads in dozens of magazines around the world, each containing a translated section heading from *Roget's Thesaurus*. Kosuth, Daniel Buren, and Les Levine rented billboard space for their art.[18] Most of these works were temporal, functioning as disruptions within the flow of editorial and advertising matter, while reflecting on the codification of language and image systems. The process of getting art out into the world, of changing art's frame and context, enabled artists to broaden their audience as they mediated between the privileged domain of

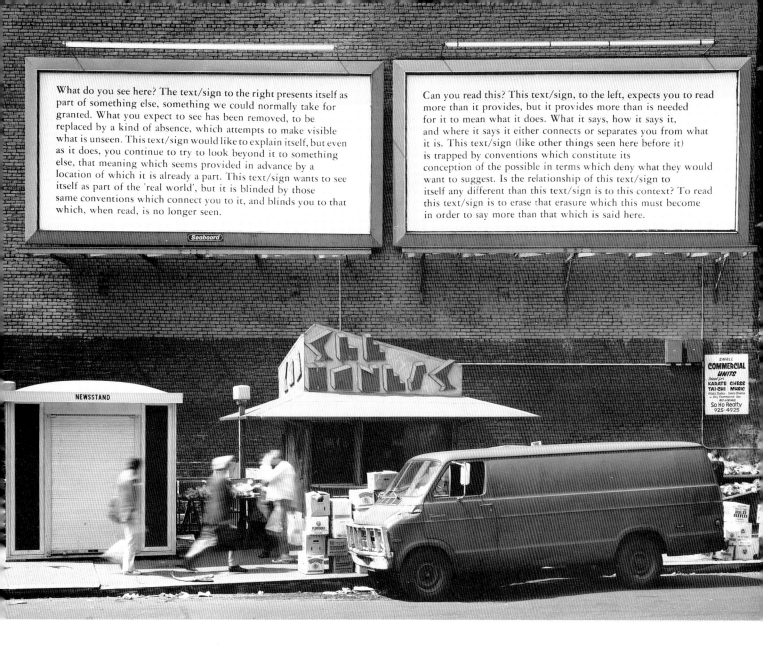

What do you see here? The text/sign to the right presents itself as part of something else, something we could normally take for granted. What you expect to see has been removed, to be replaced by a kind of absence, which attempts to make visible what is unseen. This text/sign would like to explain itself, but even as it does, you continue to try to look beyond it to something else, that meaning which seems provided in advance by a location of which it is already a part. This text/sign wants to see itself as part of the 'real world', but it is blinded by those same conventions which connect you to it, and blinds you to that which, when read, is no longer seen.

Can you read this? This text/sign, to the left, expects you to read more than it provides, but it provides more than is needed for it to mean what it does. What it says, how it says it, and where it says it either connects or separates you from what it is. This text/sign (like other things seen here before it) is trapped by conventions which constitute its conception of the possible in terms which deny what they would want to suggest. Is the relationship of this text/sign to itself any different than this text/sign is to this context? To read this text/sign is to erase that erasure which this must become in order to say more than that which is said here.

Joseph Kosuth, *Text/Context*, billboards installed at Houston and Broadway, New York, 1979.

culture and the commercial realm of the mass media.

By 1970, artists of different persuasions were moved to experiment with the media. Bruce Nauman, Richard Serra, Vito Acconci, and Keith Sonnier, to name a few, extended their interests to media forms by making films and tapes. Serra's tape *Television Delivers People* (1973) (p. 99) and Sonnier's video installation *Channel Mix* (1973) are evidence of the compulsion to address media issues even by process-oriented sculptors. This was a period of widespread institutional critique — and a shared belief in art's ability to dismantle myths and analyze institutional strategies by using their forms as a means of criticism. Marxist theory, as employed by the Frankfurt School, structuralism, and post-structuralism became favored methodologies by which to examine art and its history. The mass media, one of the most powerful institutions, came under heavy scrutiny. Artists now had access to the technology of the media, and they appropriated its language and forms — its art direction, its cool, "factual" distance — in order to make its codes and hidden devices visible. Hans

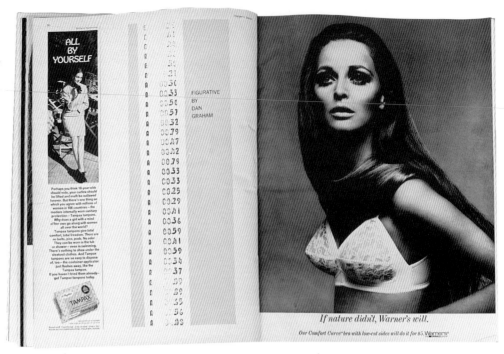

Haacke epitomized a clear, unequivocal political approach. Using the visual format of corporate advertising campaigns, as in *The Right to Life* (1979) (p. 87), he added his own subversive copy to expose the deceit and hidden agendas behind the anonymous, impersonal facade of the corporate public image. In this case, below the Breck Girl's radiant, innocent face we are told that pregnant female workers at American Cyanamid (Breck's parent company) are exposed to toxins that endanger their unborn children; they are given the choice of moving into lower paying jobs or having themselves sterilized.

An Uneasy Alliance

In the 1970s, a new generation was coming of age. Many of these young artists were working in the studios of the California Institute of the Arts, founded in 1961 by Walt Disney.[19] This was a TV, rock-and-roll generation, bred on popular culture, and it took images very seriously. The artists were media literate, both addicted to and aware of the media's agendas of celebrity making, violence-mongering, and sensationalism.

These artists had been trained to critically question their relationship to social institutions. But, unlike their predecessors and more like Pop artists, many became increasingly cynical about the real possibility of maintaining an oppositional position toward these institutions. What made it difficult was art's increasing public acceptance and absorption into the mainstream of American life. Artists who attempted to make anti-object art that would resist commodification found it necessary to seek some kind of institutional support from museums and alternative spaces in order to have an audience (and often their works were reclaimed by the market). No matter how artists tried, it proved almost impossible to resist institutional forces. The tradition of the

avant-garde as it had always been known came to an end. The only way for artists to engage it was as an image, a representation.[20]

The conceptual point of convergence for the emerging generation of artists was the recognition that there can be no reality outside of representation, since we can only know about things through the forms that articulate them. According to Douglas Crimp, who introduced some of these artists in the landmark "Pictures" exhibition at Artists Space in 1977: "To an ever greater extent our experience is governed by pictures, pictures in newspapers and magazines, on television and in the cinema. Next to these pictures firsthand experience begins to retreat, to seem more and more trivial. While it once seemed that pictures had the function of interpreting reality, it now seems that they have usurped it. It therefore becomes imperative to understand the picture itself, not in order to uncover a lost reality but to determine how a picture becomes a signifying structure of its own accord."[21] Pictures, once signs of the real, had been transformed into real objects by TV, advertising, photography, and the cinema.[22]

The premise that representation constructs reality has direct implications for theories of subjectivity. It means that gender roles and identity can be seen as the "effects" of representation.[23] This became a natural line of inquiry, particularly for artists involved with feminist issues. In a group of early collages, Sherrie Levine extracted images of female models from fashion spreads and advertisements and used them as the "background" material for silhouette portraits of George Washington and Abraham Lincoln. These mass-media depictions of women are literally inscribed and contained within the broader symbolic realm of mythological heroes and great male leaders. In her *Untitled Film Stills* (1977–80) (pp. 68, 89), Cindy Sherman takes active control of her own image as she directs herself acting out a series of canned film stereotypes for the camera. She inverts the logic of commodification by exposing self-expression as a limitless replication of existing models (in this case, models defined by masculine desire). In another serial work from the late 1970s, Sarah Charlesworth

67

Sherrie Levine, *Untitled (President: 1)* (detail), 1979.

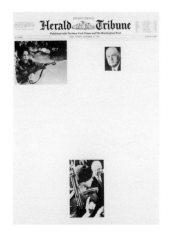

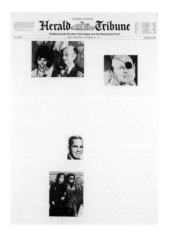

Sarah Charlesworth, *Herald Tribune/ Sept. 1977* (details), 1977.

photocopied the front pages of the *International Herald Tribune* for one month and then blocked out the texts, so that only the masthead, layout, and photo reproductions remained. The sequence of images as well as their sizes and relationship to each other on the page create a new story. The altered pages at first seem to reveal nonsensical, surrealistic conjunctions of images. But seen as an aggregate they show how the news is presented, who and what is deemed important, and the astonishing paucity of female representation. Deprived of its textual content, the autonomous system of the newspaper page becomes apparent.

Not only do found materials and their re-framing show how social reality and representation "subject" us, but the process again raises the issues of uniqueness, authorship, and originality, which had always been the defining characteristics of art and greatness. Like the myth of individual creativity, the original and the unique were now seen to be effects of a social fiction of mastery, control, and empowerment. This fiction is made patently manifest in the rephotography of Richard Prince and Sherrie Levine, for instance, where found reproductions were re-presented with little alteration. Only the image's context was changed — but that was enough to make its social codes and their peculiar unreality apparent.

Not only do found materials and their re-framing show how social reality and representation "subject" us, but the process again raises the issues of uniqueness, authorship, and originality, which had always been the defining characteristics of art and greatness. Like the myth of individual creativity, the original and the unique were now seen to be effects of a social fiction of mastery, control, and empowerment. This fiction is made patently manifest in the rephotography of Richard Prince and Sherrie Levine, for instance, where found reproductions were re-presented with little alteration. Only the image's context was changed — but that was enough to make its social codes and their peculiar unreality apparent.

By the end of the 1970s, it was increasingly clear that the deconstructive method had become dry and pedantic. American artists' direct experience of the media's special effects, their awareness of how the media affects our lives, set them off on a fantastic voyage through the media system — its unreality, artifice, immateriality, and replication. Art entered the spectacular realm, further exploiting the very strategies that made the media so powerful. The works grew dramatically in scale, the surfaces became glossier and more colorful, the imagery more grandiose, and the compositions more graphically arresting. And aesthetics reentered the art discourse, but with the revised notion of beauty — alienated and weird — offered by the media's spellbinding seductions. The younger generation, at home with this language, nevertheless approached it with a mixture of love and hatred, respect and fear, dependence and resentment.

Pictures of ambivalent and alienated desires emerged. Robert Longo's *Men in the Cities* series (1979–82) is a good example (pp. 69, 114, 115). In these monumental, larger-than-life drawings, conceived by Longo but executed by a commercial illustrator, men and women strike poses that alternately allude to pleasure or pain. The aesthetic was similarly ambiguous in its relation to the media. Was it distanced

Cindy Sherman, *Untitled Film Still*, 1979.

Jeff Koons, *Bob Hope*, 1986.

Robert Longo, *Untitled (Men in the Cities)*, 1980.

and critical in its alienated imagery or was it complicit — simply mimicking the media's techniques?

What made the situation confusing was that some artists seemed to combine the crowd-pleasing strategies of entertainment with the spirit of critical investigation.[24] This new politicized style quickly attracted media attention and was offered as an innovative and stimulating commodity. Artists were enlisted as members of the "research and development" team of commercial culture.[25] Not only was the "look" of art adopted by commerce, but in the eighties the concept of the avant-garde itself was used as a marketing strategy, most often by concentrating on the artist as personality. Companies such as Cutty Sark, Rose's Lime Juice, Absolut Vodka, Amaretto, and The Gap have featured endorsements by artists ranging from Philip Glass to Ed Ruscha. Over the past few years, the art and entertainment press have repeatedly featured artists, critics, and curators in fashion and life-style spreads as the latest chic commodity. Some artists, however, were quick to discover a newfound power in this development and began to reclaim public spaces usually occupied by the media for their own political messages. Bus shelters (Dennis Adams), electronic signage (Jenny Holzer), flyposters (Barbara Kruger, the Guerrilla Girls), and advertising placards (Gran Fury) are just some of the sites that artists have invaded, interrupting the expected channels of information with compelling visuals and independent voices.

The fame and success artists have acquired in the last decade have presented a dilemma. After analyzing and commenting on signs borrowed from the media, they now must encounter their own media image and consider the role they play in the construction of consent. Suddenly their position is unclear: are artists using media strategies in order to expose them or to expose themselves? Even when theoretical justification is vigorously offered, it is often quickly overshadowed by personal publicity and celebrity attention.

Jeff Koons is the hyperrealization of the contradictions of our age. After selecting

Richard Prince, *Untitled (watches)*, 1977–78.

sentimental chatchkes, images, and collectibles from pop culture, Koons has them sumptuously executed by expert craftsmen in stainless steel, porcelain, or polychromed wood and enlarged to near human scale. These images of American juvenilia — from TV, film stills, advertisements, and rock music — are themselves the sculptural embodiment of cinematic spectacle. Added to the effect of the works is Koons' carefully conceived PR campaign for his public persona: he has taken control of his own image in the media, packaging himself through a series of elaborately staged, airbrushed "advertisements" that feature the artist in a variety of situations. These situations — artist with buxom babes, artist at the head of the class, artist as animal trainer — successfully mock the ultraperfect world of advertising, where images of sex and power are used to dominate and control.

But no matter how sharply focused, such messages are far from clear. One is left with a sense of unreality and incredulity; aware of how images are deployed by the media, we are still held captive by their force and entranced by their narcotic magic. Even if at times it seems that the artist's involvement with media images has become an institution — a new academy of sorts which, by definition, has played itself out — the seductions and manipulations of the media remain so compelling and powerful that artists continue to reformulate them. With hindsight, the activities of this thirty-year period will be seen not as a passing phase but as the beginning of an epic scenario.

Notes

1. Jean Baudrillard, *America*, transl. Chris Turner (London: Verso, 1988), p. 32.

2. See Paul Virilio, "The Last Vehicle," in *Looking Back on the End of the World*, ed. Dietmar Kamper and Christoph Wulf, transl. David Antal (New York: Semiotext[e], 1989), pp. 107–19.

3. Ibid, pp. 115–16

4. Clement Greenberg, "Avant-garde and Kitsch" (1939), in *Art and Culture* (Boston: Beacon Press, 1961), p. 11.

5. See Susan Sontag, "The Image World," in *On Photography* (New York: Delta Books, 1977), pp. 153–80.

6. George Trow, *Within the Context of No Context* (Boston: Little, Brown and Company, 1981), p. 9.

7. Leo Steinberg, "Other Criteria," in *Other Criteria* (New York: Oxford University Press, 1972), pp. 85–91. Steinberg used this term to describe a reorientation of the painted surface, a shift from a vertical to a horizontal picture plane. In his view, this shift corresponded to a shift of subject matter from nature to culture, the space of representation changing from an analogue of visual experience to one of operational processes.

8. Quoted in Paul Taylor, ed., *Post-Pop Art* (Cambridge, Massachusetts: The MIT Press, 1989), p. 103.

9. For further description, see Steinberg, "Other Criteria," pp. 85–88.

10. Quoted in Peter Selz, ed., "A Symposium on Pop Art," *Arts Magazine*, 37 (April 1963), p. 36.

11. From Sandler's 1962 review of the Janis show, quoted in Dick Hebdige, "In Poor Taste," in Taylor, *Post-Pop Art*, p. 93.

12. Gary Garrels, ed., *The Work of Andy Warhol* (Seattle: Bay Press, 1989), pp. 131–33.

13. See Judith Goldman, *James Rosenquist* (New York: Penguin Books, 1985), p. 43.

14. Theodor W. Adorno and Max Horkheimer, "The Culture Industry: Enlightenment Is Mass Deception," in *Dialectic of Enlightenment*, transl. J. Cumming (New York: The Seaburg Press, 1972), pp. 120–67.

15. See Jon Hendricks, *Fluxus Codex* (Detroit: The Gilbert and Lila Silverman Fluxus Collection, 1988), p. 21–29.

16. Joseph Kosuth, "Art after Philosophy" (1969), in Ursula Meyer, *Conceptual Art* (New York: E.P. Dutton & Co., 1972), p. 158.

17. Robert Smithson, quoted in Craig Owens, "From Work to Frame, or Is There Life after 'The Death of the Author?,'" in *Implosion*, exhibition catalogue (Stockholm: Moderna Museet, 1988), p. 207.

18. For a more complete discussion of these conceptual projects, see Mary Anne Staniszewski, "Conceptual Supplement," *Flash Art*, no. 143 (November–December 1988), pp. 88–97.

19. Among the graduates were David Salle, Matt Mullican, Troy Brauntuch, Sherrie Levine, Allan McCollum, Jack Goldstein, Barbara Bloom, and Larry Johnson. John Baldessari, an original faculty member, taught for eighteen years and was a guiding force at Cal Arts, along with conceptualists Douglas Huebler and Michael Asher.

20. See Hal Foster, "Between Modernism and the Media," in *Recodings: Art, Spectacle, Cultural Politics* (Port Townsend, Washington: Bay Press, 1985), p. 35.

21. Douglas Crimp, *Pictures*, exhibition catalogue (New York: Artists Space, 1977), p. 3.

22. This commingling of art and commerce spawned a new type of exhibition in the late seventies and early eighties — exhibitions that incorporated materials from the mass media (food packaging, anonymous photographs, commercial advertisements). "It's a Gender Show" (1981), by the artists' collaborative Group Material, Barbara Kruger's "Pictures and Promises: A Display of Advertisings, Slogans and Interventions" (1981) at the Kitchen, and exhibitions organized individually by Marvin Heiferman and Carol Squiers at P.S. 1 testified to the global penetration of the mass media and naturally drew critical fire from purists. See Carol Squiers, "The Monopoly of Appearances," *Flash Art*, no. 132 (February–March 1987), pp. 98–100.

23. For further discussion, see Kate Linker, "When a Rose Only Appears to Be a Rose: Feminism and Representation," in *Implosion*, pp. 189–98.

24. See David Robbins, "Art After Entertainment," *Art Issues*, no. 2 (February 1989), pp. 8–13; no. 3 (April 1989), pp. 17–20.

25. See Richard Bolton, "Enlightened Self-Interest," *Afterimage*, 16 (February 1989), pp. 12–18.

ROBERT MAPPLETHORPE for Art Against AIDS... On The Road

Robert Mapplethorpe, bus shelter, San Francisco, 1989.

ED RUSCHA SAYS GOODBYE TO COLLEGE JOYS

Edward Ruscha, advertisement, *Artforum*, 5 (January 1967), p. 7.

have you sold your soul?

Komar and Melamid, *Komar and Melamid, Inc., We Buy and Sell Souls*, poster, 1978. Ronald Feldman Fine Arts, New York.

Hannah Wilke, *Marxism and Art*, poster, 1977. Ronald Feldman Fine Arts, New York.

Robert Morris, exhibition poster, 1974. Leo Castelli Gallery, New York.

Guerrilla Girls, *Guerrilla Girls Review the Whitney*, poster, 1987. Franklin Furnace, New York.

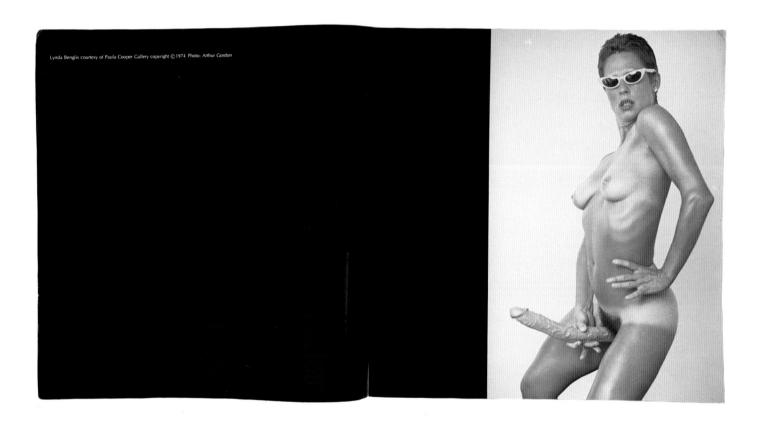

Lynda Benglis courtesy of Paula Cooper Gallery copyright © 1974 Photo: Arthur Gordon

Lynda Benglis, advertisement, *Artforum*, 13 (November 1974), pp. 4–5.

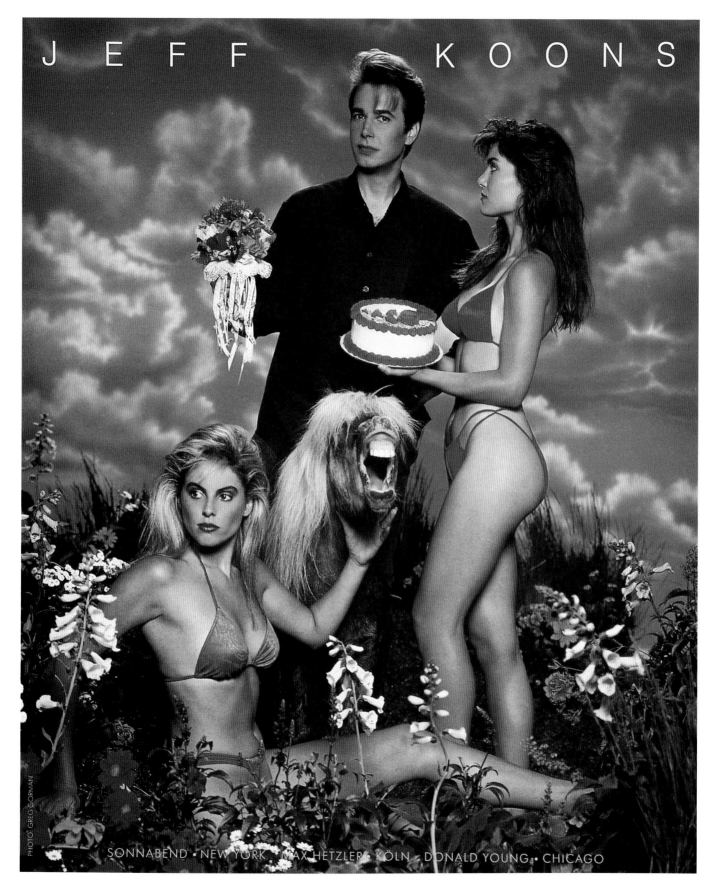

Jeff Koons, advertisement, *Artforum*, 27 (November 1988), p. 23.

Arab terrorist at the 1972 Munich Olympics.

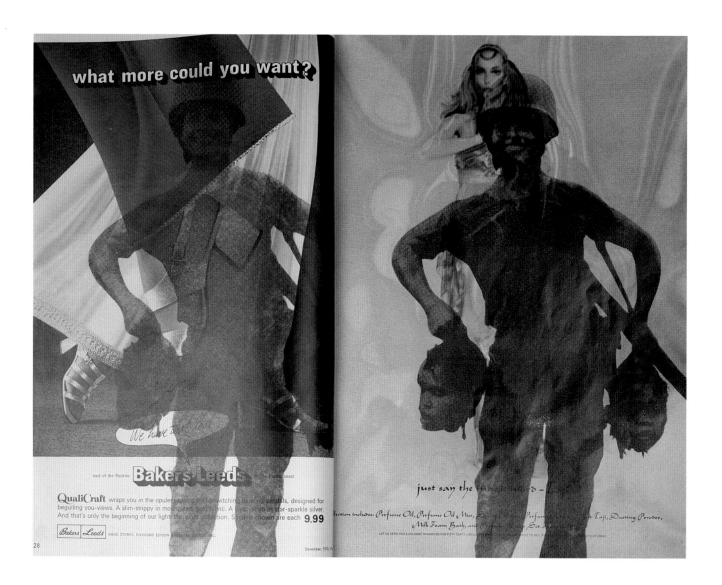

Robert Heinecken, *Periodical #5, February 1971, #1 of 6, 1971*

Peter Campus, *aen, 1977*

85

John Baldessari, *A Movie: Directional Piece Where People Are Looking,* 1972–73

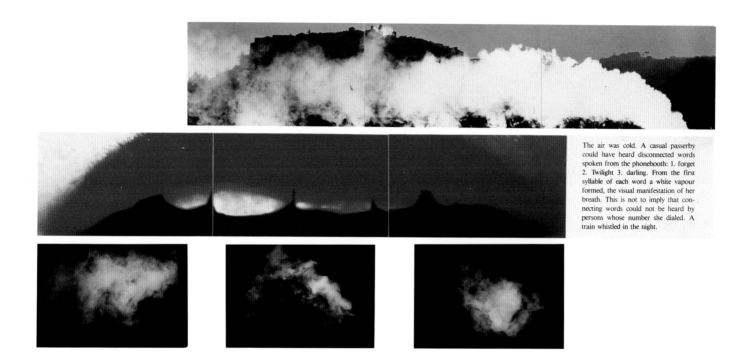

The air was cold. A casual passerby could have heard disconnected words spoken from the phonebooth: 1. forget 2. Twilight 3. darling. From the first syllable of each word a white vapour formed, the visual manifestation of her breath. This is not to imply that connecting words could not be heard by persons whose number she dialed. A train whistled in the night.

William Beckley, *Deirdre's Lip,* 1979

AMERICAN CYANAMID

AMERICAN CYANAMID is the parent of BRECK® Inc., maker of the shampoo which keeps the Breck Girl's hair clean, shining and beautiful.

AMERICAN CYANAMID does more for women. It knows: "We really don't run a health spa."

And therefore those of its female employees of child-bearing age who are exposed to toxic substances are now given a choice.

They can be reassigned to a possibly lower paying job within the company. They can leave if there is no opening. Or they can have themselves sterilized and stay in their old job.

Four West Virginia women chose sterilization. AMERICAN CYANAMID...

Where Women have a Choice

Hans Haacke, *The Right to Life,* 1979

Richard Prince, *Untitled (label),* 1977

Cindy Sherman, *Untitled Film Still*, 1978

Sherrie Levine, *Untitled (President: 2),* 1979

Sherrie Levine, *Untitled (President: 3)*, 1979

Les Levine, *We Are Not Afraid,* 1979

SPONSORED IN PART BY THE NATIONAL ENDOWMENT FOR THE ARTS, THE LOWER MANHATTAN CULTURAL COUNCIL, AND THE PUBLIC ART FUND © COPYRIGHT LES LEVINE FOR THE MUSEUM OF MOTT ART INC. 1981

Owen Land (a.k.a. George Landow), *Institutional Quality*, 1969

Art is the negative knowledge of the
actual world. —Theodor Adorno

Film and Video
in the Age of Television

Film and video as both technologies and art forms have played important roles in
facilitating and critiquing the increased circulation of images and ideas between artists
and the worlds of entertainment and commerce. Since the 1960s, the rapid expansion
of cultural industries — movies, television, music, radio, and advertising, as well as art
galleries and museums — has caused a shift from the oppositional stance toward mass
entertainment taken by modernism to a postmodernist appropriation of these media.
In statements, projects, critical writings, and exhibitions, artists increasingly view the
media as a cultural sphere within which to operate, appropriate images, and formulate
creative strategies. Independent film and video artists, working on the margins of both
the art world and mainstream media culture, have important critical roles to play in
today's debates about the relationship of art to mass media within the expanding
economy of late capitalism.

Art's association with the world around us is a complex and changing one. Since
the nineteenth century, the distinctions between high and low art, serious and popular
culture, have informed how we view art and the use we make of it as individuals and
as members of a social group. The development of photography and, later, film and
television, has further complicated the traditional artisanal definition of art making
and the distinction between original and reproduction, the real and the illusory.

Walter Benjamin, the German philosopher and cultural critic, saw the aura of the
original work of art being diminished or made problematic by the spread of multiple
reproductions to new audiences and publics. In "The Work of Art in the Age of
Mechanical Reproduction" (1936), he viewed the reciprocal and dialectical relation-
ships between evolving means of perception and depiction as fundamental to the
changing modes of representation in art. In this context, he recognized film and
photography as central catalysts, finding in film especially a redeeming radicalism and
potential. In 1944, Benjamin's colleague Theodor Adorno, a cofounder of the
Frankfurt Institute for Social Research, published *Dialectic of Enlightenment*, with Max
Horkheimer. The book offered a critical assessment of the spreading commodification
of the culture industry in Western capitalism. Unlike Benjamin, Adorno saw film as a

medium of mediocrity in mass culture. It is within this dialectic, presented here from the perspectives of two of this century's most influential thinkers, that we see the precarious yet critical position that film and the media occupy in our society and culture.

From the 1960s to the present, arguments have been raised against both an increasingly elitist modernism and the rapid expansion of the culture industry through the spectacular spread of commercial television. Two critical and art making agendas have emerged, one celebrating the possibilities of mass media as communication and the other exposing the role of media in society. Film and video artists have sought to embody both Benjamin's hope for an alternative and renewing media culture and Adorno's critique of commercial, mass-entertainment media.

In 1962, Marshall McLuhan published *The Gutenberg Galaxy*, the first of a series of books that argued for communication and its evolution as the engine that drives human progress. Television, as succinctly stated in McLuhan's celebrated aphorism "the medium is the message," was seen as an expression of change, a new, post-Gutenberg text of images and languages. Thus, at the time of commercial television's hegemonic consolidation in the 1960s, the medium was greeted as a powerful paradigm for a revolutionary reassessment of human communication.

Another view regarded the political, historical, and cognitive roles of the media as components of an ideological system. The Marxist Louis Althusser, writing in the late 1960s, coined the term "ideological state apparatuses" to identify the controlling forces of society. Under this rubric, he included not only obvious instruments of authority, such as the police and the courts, but also pervasive educational and cultural institutions. Michel Foucault was to employ the term panopticon as a metaphor for the omnipresent yet invisible hegemony of culture. Althusser and Foucault, in two very different bodies of thought, revealed the invisible controls of what Hans Magnus Enzensberger in 1974 called the "consciousness industry." Like a giant surveillance system, the media picks up and circulates opinion and history, co-opting oppositions and radical styles through a subtle system of controls that robs ideas of their power by focusing on surface as content.

The ideas of McLuhan, Althusser, Foucault, and Enzensberger have figured prominently in independent film and media arts' organizations and artwork. Artists have used these critical methods to refine their understanding of television and mass culture in the post–World War II era and to realize the possibilities of film and media through a critique of the role they play within corporate capitalism.

This essay will outline how the independent film and video movement from the 1960s to the present has fashioned a critical discourse with the culture industries of television and the movies, a discourse composed of many genres and expressed through a variety of aesthetic and formal strategies. In the hands of individual artists and collectives, film and video have created powerful texts that function on the peripheries of both the traditionally defined art world and the massive world of commercial media. The options created by these alternative expressions through their often abrasive form and nonprofessional look work against the controlling codes of expression, distribution, and exhibition to posit viable and compelling alternative aesthetics.

Appropriating the Movie and Television Text

The direct reaction by film and video artists to the consuming and omniscient worlds of commercial television and cinema is, in one sense, at the basis of all films and videotapes that reject the product which fills the cinema screen or television monitor. The entire culture industry, including advertising, film, television, radio, newspapers, magazines, and books, is tied into promoting and validating the capital-intensive film and video productions created for the marketplace. Independent film and video, which deliberately operate against the grain of dominant production formats and values, are thus shunted to the margins of the media and, with few exceptions, cannot be seen on commercial television or the cinema screen.

In the late 1950s and early 1960s, the independent cinema enjoyed a remarkable period of creativity and diversity. Filmmakers established new models for presenting their work through alternative presses, theaters, and distribution networks. A number of films from this period explored the phenomenon of the movies as popular culture, mythology, and ideology. Artists appropriated images, simulated the look of popular culture, and directly addressed its institutional forms in such a way as to develop their own aesthetic, which clearly differed from that of popular culture.

Bruce Conner's *Report* (1963–67), like his earlier film *A Movie* (1958), uses found footage, newsreels, off-air television, movies, and educational films to reconstruct a "report" on the assassination of President John F. Kennedy. With images taken from television coverage of the assassination and funeral and Jack Ruby's killing of Lee Harvey Oswald, Conner makes us see these images as images. There is no voice-over narration to comfort us with the omniscient perspective of television's authority; instead, the film disassembles the seamless construction of television news and jars us into seeing both history and television's interpretation of it as images that in fact tell us very little. What did we see on television and what did we learn from it? Conner's destabilization of meaning makes for a powerful and poetic commentary on the media and its methods.

Bruce Baillie's elegiac *Mass for the Dakota Sioux* (1964) mixes his own footage with images from television to create a lyrical commentary on the destruction of life and the environment within the culture of modern capitalism. In contrast to the staccato style of Conner's filmic commentary on contemporary history, Baillie effectively utilizes the subliminal electronic flow of television, its pervasive presence in our culture, to evoke the gradual destruction of Native Americans by the European settlers. Baillie's passionate mix of TV commercials with violence creates a compelling reflection on the medium by linking its technology and imagery to an ideological program that destroys human life and the environment.

Independent film — also called underground, avant-garde, or the New American Cinema — has always been a handmade cinema, fashioned by artists, which placed itself in opposition to Hollywood. Some of the independent cinema's most famous works were based on a critical fascination with the aura of myth embodied in the

Bruce Conner, *A Movie*, 1958

Kenneth Anger, *Scorpio Rising,* **1963**

Jack Smith, *Flaming Creatures,* **1963**

screen images of the stars and their real or imagined private lives. Kenneth Anger, who grew up in the shadow of Hollywood and achieved cult status as a practitioner of black magic, celebrated Hollywood's often violent and scandalous life in his exposé *Hollywood Babylon*, a book that began as an underground classic and was later published in a glossy edition by Straight Arrow Books in 1975. In his films, Anger created a rich and potent mixture of fantasy and violence, combining the magic of the movies with the magic of alchemy. One of his most renowned works, *Scorpio Rising* (1963), which is also one of the best-known avant-garde films, is a homoerotic fantasy about the perverse reality beneath the myths of Hollywood. He constructs an elegant and edgy vision of cultism and popular culture, overlaid with a soundtrack of pop hits. In one sequence, we hear the song "I Will Follow Him" over Hollywood movie footage of Jesus Christ with his followers; the next sequence is Anger's own footage of a Hell's Angels initiation party. The whole film is driven by formal juxtapositions of pop imagery with cult rituals to reveal connections and ironies in the commerical packaging of popular culture and its elevation of stars into potent deities. In his virtuosic editing and flamboyant celebration of the cult of culture, Anger exploits the seductive appeal and erotic subtext of the Hollywood narrative.

The apotheosis of stars and the melodramatic narratives that have been constructed around the Hollywood cinema have been satirized and appropriated within the gay aesthetic, as in the outrageous cinema of Jack Smith, perhaps best exemplified in his controversial *Flaming Creatures* (1963). In this fantasy of cross-dressing, transvestite flamboyance, and camp exaggeration, Smith establishes a riotous mise-en-scène that is a potent satire on the imaginary self of the movie star. In the frenzied scenes, nude and partially dressed actors play out an improvised hysteria of lust and sexual revolution that caricatures the conventional sexuality of the Hollywood narrative and implicates the imagination of the viewer. Smith subverts the stable middle-class world by rendering its most popular commodity, the movies, as a Rabelaisian carnival of excess.

The avant-garde filmmakers of the 1960s who attacked the codes of Hollywood and television worked on a parallel track with such art movements as Pop Art, Happenings, Minimalism, and Fluxus, which were experimenting with transforma-

tions of the everyday object. Thus Conner's found-footage films can be placed alongside his Assemblage objects, and Smith's films should be considered with his off-Broadway "camp" performance projects.

In the mid-1960s, both in America and Europe, a direct confrontation occurred between the art world and the institution of television. Within the adversarial and anti-high art program of Fluxus, two key figures — the Korean-born Nam June Paik and the German artist Wolf Vostell — turned to the television set as a means to fashion a new discourse within the media culture. In 1963 at the Galerie Parnass in Wuppertal, West Germany, Paik filled a gallery space with televisions whose technology had been modified so that distorted broadcast images or abstract electronic patterns appeared on the screen. In that same year at the Smolin Gallery in New York, Vostell filled a gallery with modified televisions that became a conduit for new imagery created from the distortion of the broadcast message.

Paik and Vostell reframed television discourse as a means to transform both technology and the world. Paik was to take a leading role in removing television from its context of corporate control and turning it into a tool for creative image making. With the introduction of the portable video camera and player in 1965, the electronic image-making system was placed in the hands of artists. Now they could exploit the video system from within to construct an alternative production, distribution, and exhibition program. An outstanding example of this practice is Richard Serra's *Television Delivers People* (1973). The videotape consists of a series of critical statements on the institution of commercial broadcast television. Statistics on the impact of television on American life and on TV as a selling tool roll up the screen like the credits at the end of a show. The text is seen against a blue background, the soothing color used by television productions; with Muzak soundtrack, Serra "sells" his opinion and in this way ironically subverts the idea of television as a commodity.

Ant Farm, a collective of artists and architects living in the San Francisco area, gave one of its most celebrated performances on and for television. *Media Burn* (1975) (pp. 100–101) was a public event staged on the Fourth of July that climaxed when a specially modified Cadillac was driven through a wall of burning televisions. A key aspect of this performance was a talk given to the crowd by a John F. Kennedy look-alike who was surrounded by Secret Service agents. His speech, a condemning critique of corporate capitalism and television, was ignored by all the local news shows, which focused on the car crash and not on the true message of the event. Ant Farm's documentation of this event and the ensuing news coverage are ironic and humorous indictments of broadcast television. They reveal the way television covers sensational events and that what the media records and presents is only a part of what "in fact" occurred. Fundamental to all Ant Farm projects is an exposé of how the media manipulates, distorts, and alters history and yet, through its pervasive presence, becomes a part of contemporary events.

A number of projects include the viewer in the image on the television monitor, thus using the "real-time" property of video, through which one sees on the monitor what the camera is presently recording. Ira Schneider and Frank Gillette's installation

You are the product of t.v.

You are delivered to the advertiser who is the customer.

Richard Serra, *Television Delivers People*, 1973

Other films pursued this analytic approach through an exploration of the processes of television. Robert Nelson's *Bleu Shut* (1970) is structured like a television game show in segments timed by a clock that appears in a corner of the screen. Images from television alternate with various types of found and original footage. A recorded dialogue of questions and answers to an audience is heard over the individual pictures. This production process highlights how we see and understand a picture as both fact and fiction. *Institutional Quality* (1969) (p. 94) by Owen Land (a.k.a. George Landow) exposes the material base of the recorded film image, inviting us to understand what we see. Once again, an imaginary dialogue is constructed between the filmmaker and the audience, with the addition of a voice-over. In both these films, the artists, by acknowledging the properties of film and video and the spectator's relationship to them, reveal the materialist processes behind the production. In addition, they examine the ideological support of the filmic text by exposing the photographic image as both information and as a malleable, imprecise representation.

The films of Andy Warhol, from his proto-Structural *Empire* (1964) to *Lonesome Cowboys* (1967), a parody of the western, constitute an extraordinary body of work, equal in achievement to his paintings and prints. The power of Warhol's films lies in the radical acknowledgment of the camera as a recording instrument in an aesthetic that relentlessly and directly confronts the viewer with the surface of the screen and the illusionary space of the projected image. The Structural cinema of the gaze in *Empire* and *Sleep* (1963), the minimal action and static camera set-up, reconceived the epistemology of looking.

The underground world through which Warhol moved, and for which his Factory became a stage, was a compelling subject for his camera. Under the influence of Jack Smith and his improvisational camp sensibility, the mise-en-scène of Warhol's precisely framed cinema unfolded within a real-time perspective. Warhol acknowledged with powerful honesty the myth of the consumer entertainment industry as he created within his Factory/Studio system a subversive miming of the culture of stardom. *The Chelsea Girls* (1966), in its epic length and two-screen format, became a summation of his effort to collapse experience, time, and space in a compulsive and elegant transformation of cinema into a multichannel real-time television. As the film juxtaposes images and moves on from story to story, it becomes Warhol's cinema of television.

During the years of Warhol's cinema, the political and oppositional film genres *cinema verité* and *cinema engagé* began to bring a real-time immediacy to film and to furnish documentation and interpretation of political realities not apparent on the television or movie screens. The Newsreel collective, the filmmaking arm of the student and civil rights movements of the sixties and seventies, established a model for innovative filmmaking that dealt with the issues of subject matter and information. Such films as *Columbia Revolt* (1968) galvanized support for the actions and words of the New Left. Its strategy of political opposition produced raw and immediate imagery that directly confronted the authority and power of the consciousness industry's news and information institutions.

Andy Warhol, *Lonesome Cowboys*, 1967

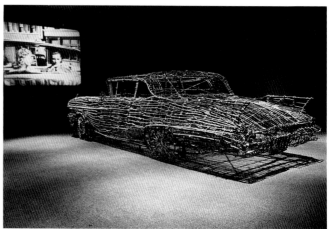

Paul Sharits, Study for *3rd Degree*, 1982. Ink and pastel on vellum, 18 × 23 inches. Collection of the artist.

Roger Welch, *Drive-In: Second Feature*, 1982.

Radical ways of exploring the properties and institutions of the cinema apparatus extended to a series of installation works that placed the film projector within the exhibition space. Like Nam June Paik's *Zenith (TV Looking Glass)*, Morgan Fisher's *North Light* project (1979) acknowledged the relationship of the production process to the installation site. A loop of film projected onto the gallery wall showed the view on the other side of the wall; thus the film image functioned both as a window and as a subtle commentary on the metaphor of cinema as a "window on the world." By implicitly exposing film's two-dimensional surface, which can only simulate a view out of a window, *North Light* exposed the illusionary nature of cinema. In Michael Snow's *Two Sides to Every Story* (1974), the film screen as the support of the projected image is transformed into a sculptural element. This installation comprised a scene filmed from opposite points of view and projected onto opposite sides of a metal rectangle which was painted white and suspended between facing projectors in the gallery. The arrangement demanded the viewer's active participation in completing the narrative: the story is seen from two points of view by a viewer moving back and forth from one side to the other. In Paul Sharits' seminal *3rd Degree* (1982), three film projectors were placed at varying distances from the gallery wall to create images of different sizes; at a certain point the images on the wall burst into flame while at the same time an image of a woman undergoing interrogation appeared and disappeared. Thus "third degree" referred to both the psychodrama of interrogation and the temperature of film's combustibility, twin forces of tension in the proto-narrative action and its commentary on the materiality of film. In Roger Welch's *Drive In: Second Feature* (1982), a sculpture of a 1960s Cadillac woven from branches was placed in the gallery facing a screen framed by branches onto which were projected trailers of Hollywood movies. Here the drive-in became a cultural and ethnographic phenomenon as Welch turned both the automobile and the cinema into cult relics of some "other" civilization.

Conceptual video of the early 1970s paralleled the structural and political content of independent film. The work of Bruce Nauman, Vito Acconci, Peter Campus, and Joan Jonas employed real-time video as the means to acknowledge both the presence of the viewer and the production process of recording and transmitting video images.

Vito Acconci, *Undertone*, 1972

Peter Campus, *Three Transitions*, 1973

Much as the film installations and Structural cinema can be read as epistemological and materialist critiques of the cinema, so Conceptual and process-based videotapes and installations exposed the material basis of video and television. Acconci's *Undertone* (1972) consists of a single shot showing the artist at the head of a table speaking directly to the viewer. His monologue describes his erotic fantasies, implicating and projecting them onto the viewer. In Joan Jonas' *Vertical Roll* (1972), such strategies as manipulating the camera and monitor to render our perception of the performer ambiguous directly acknowledge the limitations and illusionary perspective of the camera. Peter Campus' elegant *Three Transitions* (1973) becomes a video form of self-portraiture as Campus employs Chroma-Keying to replace one image with another in real time; thus we see him burning a sheet of paper on which his live image appears. Campus extended this real-time use of video in installations such as *mem* (1975), in which the spectator's video image is projected onto the gallery wall. Here we engage and acknowledge a form of self-projection through the placement of the video apparatus.

Just as in the early 1960s the independent film movement created alternative exhibition and distribution outlets, in the next decade artists developed alternative spaces for video exhibition and post-production, spaces where they could experiment with video's possibilities and show their work outside of broadcast television. The Kitchen, founded in 1971, and other organizations were supported by a combination of artistic vision and newly established federal and state organizations, such as the National Endowment for the Arts and the New York State Council on the Arts. These exhibition spaces, like the artwork they presented, were genuine alternatives that generated another form of critique and analysis of the cultural industries.

The movement to establish cable and low-power television networks, another aspect of alternative video, made important advances during the 1970s. Artists discovered a grass-roots potential in cable that could realize the utopian vision of McLuhan's Global Village. Such groups as the Alternate Media Center and Media Bus began to use public-access television to link different cultural communities through cable. Eschewing large budgets and advanced technologies, these independent producers acknowledged that their role was simply to gather information and

distribute opinion. Community-access programs rejected commercial television's myth of impartiality or objectivity, seeking instead to establish an active dialectic of communication between producers and audience. Thus later groups such as Paper Tiger Television fashioned programs about the culture and information industry that revealed rather than hid behind the production process. The formal critiques presented by independent film and video in the early 1970s were in part the basis for this radical, national program for cable.

The New Feature Cinema and High Technology Video

The 1980s have witnessed a narrowing of the technological and aesthetic gap between film and video. Increasingly, artists have begun to explore the potentials of both media, choosing whichever one best suits their project. Thus an artist may shoot a work on film and transfer it to video, or record on film and edit on video, or mix the two media together.

In addition to this intertextual fusion, the issues of the 1970s, ranging from alternative institutions and cable television to aesthetic debates on Conceptual Art and Structural film, have found their way into a new independent feature film. A cinema that is also addressing new critical and theoretical discourses, from feminism and gay rights to deconstruction and postmodern aesthetics, has gained strength, transforming cultural studies and enabling renewed critiques of the media industries.

Outstanding examples of work that combined aesthetic and critical issues began to emerge in such independent feature films as Yvonne Rainer's *Journeys from Berlin/1971* (1980), which employed the principles of Structural film to construct a narrative about the politics of information and interpretation. Other films, such as Lizzie Borden's *Born in Flames* (1983) (p. 109) and *Committed* (1984) by Sheila McLaughlin and Lynne Tillman, formulated feminist discourses that used the techniques of film and television documentaries and narratives. *Committed* appropriates the *film noir* genre of the 1950s to simulate both the fact and fiction of the actress Frances Farmer's persecution during the McCarthy era. It deliberately constructs scenes that reflect on the mise-en-scène itself as well as the narrative. *Born in Flames* constructs a witty commentary on an imagined future, when the issues of socialism and feminism have gained electoral victory in New York City. The resulting satire comments on both the role of media and the function of political opposition in America. All these films go beyond the traditional community of the avant-garde: by placing their "texts" in the venue of commercial cinema the artists sought out fissures in the dominant media through which to formulate a critical narrative about film and television.

Documentary film and video have been distinguished by two traditions, often shared within the same work — the personal and autobiographical style and the political and community-oriented production. Their origins can be located in the development of portable sound and film equipment used in such pathbreaking direct

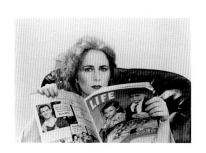

Sheila McLaughlin and Lynne Tillman, *Committed*, 1984

Ricky Leacock, *Primary*, 1960

Lizzie Borden, *Born in Flames*, 1983

cinema (*cinema verité*) films as Ricky Leacock's *Primary* (1960), which gave an intimate and personal view of the political process. In the video field, portable video cameras and sound systems helped realize tapes such as *The Fourth of July in Saugerties* (1969) by Ira Schneider and Beryl Korot, which followed a small town celebration of the national holiday.

The personal and the political documentary began to receive increasing recognition during the 1970s in theatrical exhibitions and from the public and commercial television sectors. Films such as *Janie's Janie* (1972) by Geri Ashur and Peter Barton, *Joyce at 34* (1973) by Joyce Chopra and Claudia Weill, and Judy Collins and Jill Godmilow's *Antonia: A Portrait of the Woman* (1974) were an important part of the personal documentary and feminist movements. Alan and Susan Raymond's *An American Family* (1973) transformed both television and family life in a dramatic revelation of the American family living with a television crew. TVTV, a collective of video makers, produced a series of documentaries, including *Adland* (1973) (p. 196) a satirical and incisive behind-the-scenes view of American television advertising. The Raymonds' *Police Tapes* (1976), broadcast on network television, presented the interaction of camera with reality in a vivid exposure of police life and action. Other independent producers during the 1980s brought to television styles that had been developed within the independent video movement. Jon Alpert's distinctive commentary began to appear on network television news shows. At the same time, Paper Tiger Television, through its national Deep Dish program, started to organize and facilitate the circulation of cable programming via satellite to public-access communities around the country. All of this work is characterized by its acknowledgment of the production process and the presence of the camera. The best of it avoids the pitfalls of appropriating ideas as a visual style; instead, it reflectively analyzes its own processes and ideological points of view.

New technologies for image-processing and artificial image-making systems were being developed by artists as well as within the commercial sector. The work of Nam

Ed Emshwiller, *Sunstone*, 1979

Kit Fitzgerald and John Sanborn,
Olympic Fragments, 1980

June Paik, Woody and Steina Vasulka, and Ralph Hocking was seminal in constructing artist-designed image-making tools that did not exist in the commercial realm. Ed Emshwiller's videotape *Sunstone* (1979) was produced in collaboration with the engineers at the New York Institute of Technology and is one of the first instances of an artist working with state-of-the-art commerical technologies to create new video images and techniques. Today, these image techniques developed by artists within and outside of the industry are commonly seen in television logos and in television advertising.

Novel strategies for exploiting the video medium, such as newly developed satellite and postproduction technologies, have led to a situation in which artists are too often driven by the technology. Two projects for television, John Sanborn and Kit Fitzgerald's *Olympic Fragments* (1980) and Nam June Paik's *Good Morning, Mr. Orwell* (1984) (p. 111), avoided this pitfall by creating a new form of imagery within the television frame. Sanborn and Fitzgerald utilized devices created by the commercial sector in postproduction facilities — instant replay, freeze-frame, dissolve, and computer editing — to offer their own view of the 1980 Olympic Games at Lake Placid, New York. The result was a series of short pieces that caught a gesture, a movement, the invisible moments of sports action that the artists discovered in the postproduction process. *Good Morning, Mr. Orwell*, Nam June Paik's first global satellite hook-up, used public television systems around the world to create a commentary on

Paper Tiger Television, *Herb Schiller Reads the New York Times—712 Pages of Waste: The Sunday Times*, 1981

Nam June Paik, *Good Morning, Mr. Orwell*, 1984

television and culture. By mixing live and recorded images through the international satellite system, Paik was able to realize the genuine global television production that he first broached in his videotape *Global Groove* (1973) (p. 103, 192–93), which mixed sequences of his own with global television footage.

The history of video and film since the 1960s is that of a struggle to create vehicles of expression outside the mainstream of commodity capitalism. It is ironic that the vast appetite of television and advertising for images and ideas has today resulted in the wholesale appropriation of oppositional genres, styles, and forms into a new mixed media. Thus mainstream Hollywood today appropriates and consciously plays with different genres and styles, commercial television co-opts documentary forms for its serial programs, and Music Television uses film and video's history as a selling tool for the record industry. Although such alternatives should be pursued within the mainstream, these commerical conflations tend to be superficial, designed as they are to sell a product rather than to create a significant vision for the future. The history of the alternative media that have engaged the energies of so many artists — video art, independent and underground film, avant-garde, *cinema verité*, the New American Cinema, public-access television, experimental video, and the Conceptual and Structural movements — has left a powerful legacy of exploration and self-criticism which will serve us well as we enter the ever expanding media culture of the new century.

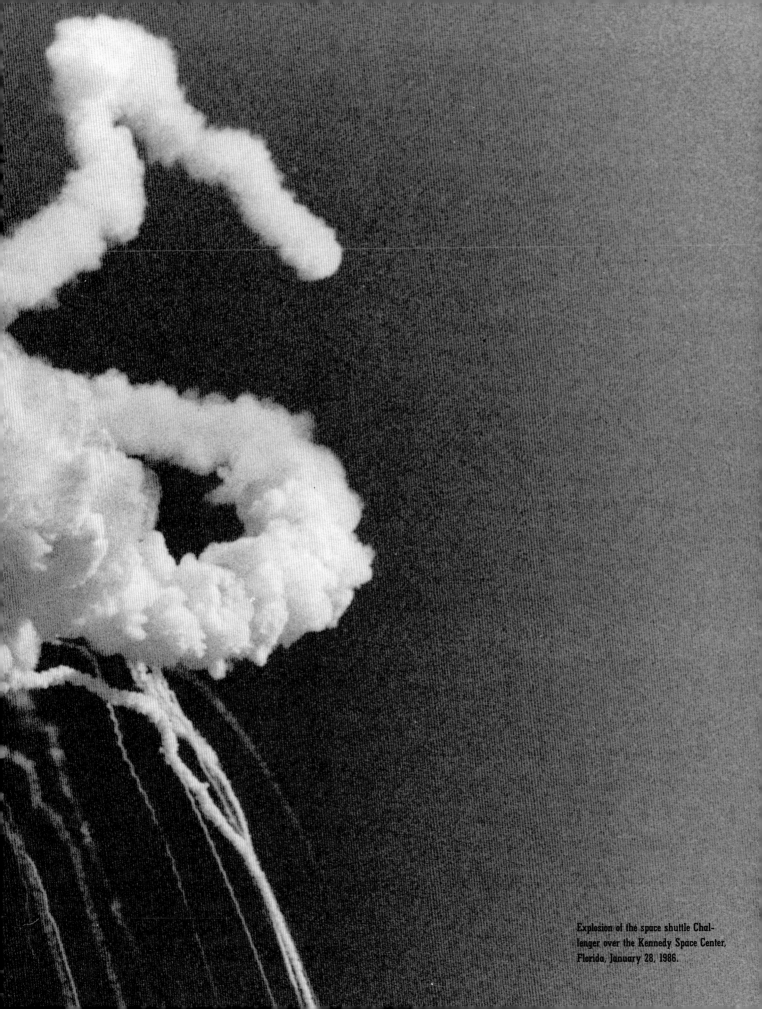

Explosion of the space shuttle Challenger over the Kennedy Space Center, Florida, January 28, 1986.

Robert Longo, *Untitled (Men in the Cities)*, 1980

115

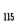

Robert Longo, *Untitled (Men in the Cities)*, 1980

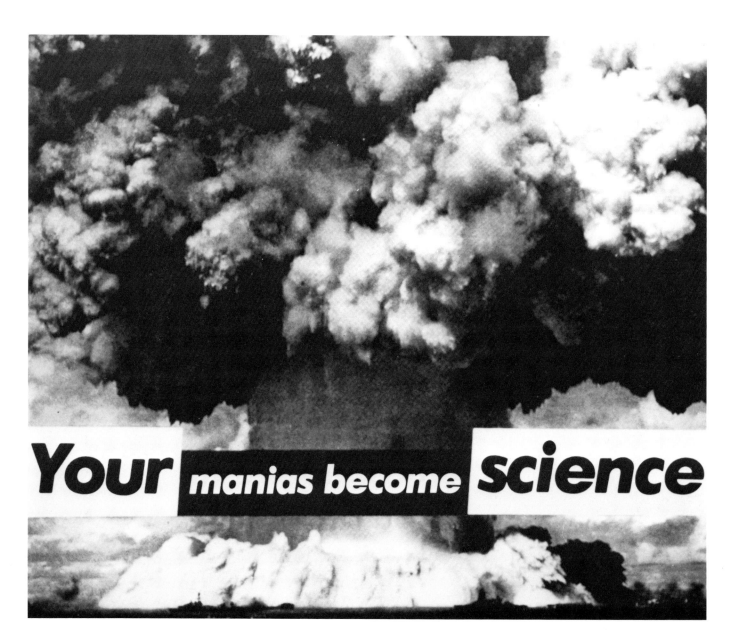

116

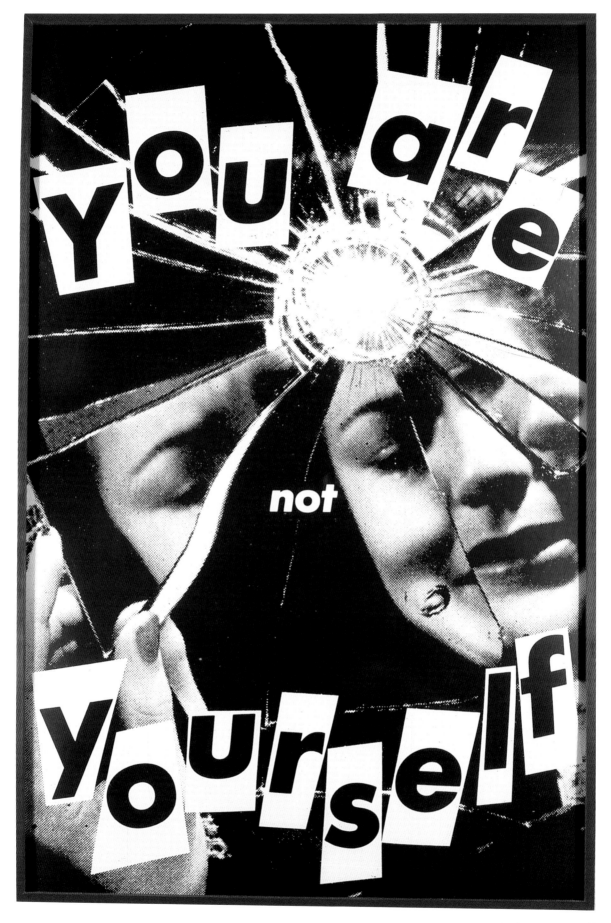

Barbara Kruger, *Untitled (You are not yourself)*, 1983

Andy Warhol, *New York Post Headliner, Oct. 24, 1983*, 1983

119

Matt Mullican, *Untitled (Bulletin Board),* 1979–89

William Wegman, *Ray and Mrs. Lubner in Bed Watching T.V.,* 1981

William Wegman, *With Dogs and Babies — Actor's Nightmare*, 1981

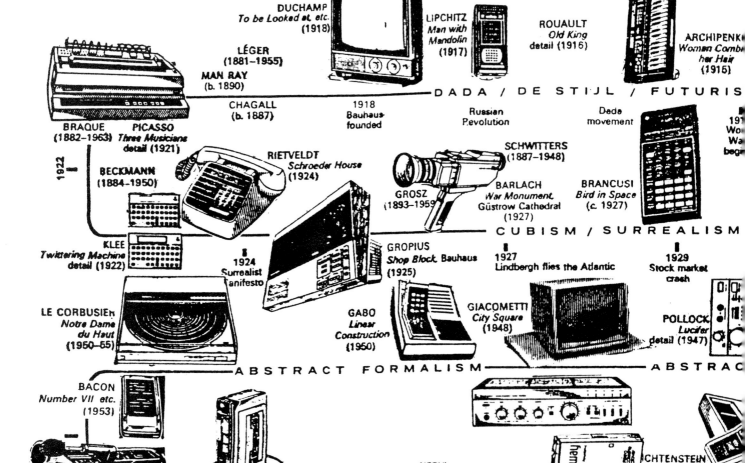

Movie camera
patented
1891

DUCHAMP
To be Looked at, etc.
(1918)

LÉGER
(1881–1955)

MAN RAY
(b. 1890)

CHAGALL
(b. 1887)

LIPCHITZ
*Man with
Mandolin*
(1917)

Freud's first
psychoanalytic work
1895

ROUAULT
*Old King
detail (1916)*

ARCHIPENK
*Woman Comb
her Hair*
(1915)

D A D A / D E S T I J L / F U T U R I S

1918
Bauhaus-
founded

Russian
Revolution

Dada
movement

19
Wo
Wa
beg

BRAQUE
(1882–1963)

PICASSO
Three Musicians
detail (1921)

1922

BECKMANN
(1884–1950)

RIETVELDT
Schroeder House
(1924)

SCHWITTERS
(1887–1948)

GROSZ
(1893–1959)

BARLACH
War Monument,
Güstrow Cathedral
(1927)

BRANCUSI
Bird in Space
(c. 1927)

KLEE
Twittering Machine
detail (1922)

1924
Surrealist
Manifesto

GROPIUS
Shop Block, Bauhaus
(1925)

C U B I S M / S U R R E A L I S M

1927
Lindbergh flies the Atlantic

1929
Stock market
crash

LE CORBUSIER
*Notre Dame
du Haut*
(1950–55)

GABO
*Linear
Construction*
(1950)

GIACOMETTI
City Square
(1948)

POLLOCK
Lucifer
detail (1947)

A B S T R A C T F O R M A L I S M

A B S T R A C

BACON
Number VII etc.
(1953)

NERVI
Palazzetto dello Sport
(1958)

TINGUELY
(b. 1925)

LICHTENSTEIN
Blam!
(1962)

KLINE
Painting 1952
(1955)

VAN DER ROHE
Seagram Building
(1956)

1957

JOHNS
Painted Bronze
(1960)

1959

O P / P O P

122

SULLIVAN
Carson, Pirie, Scott Building (1899)

Mediterranean
(c. 1901)

Die Brucke

HORTA
(1861–1947)

1905
Fauves at
Salon d'Automne

ENSOR
(1860–1949)

DERAIN
London Bridge
detail (1906)

LEHMBRUCK
Standing Youth
(1913)

KANDINSKY
Improvisation 28
detail (1912)

NOLDE
(1867–1956)

detail (1908)

MATISSE
Le Luxe
detail (1907)

1906

— C U B I S M / A R T N O U V E A U / E X P R E S S I O N I S M —

VANTONGERLOO
(1886–1965)

1911
Der Blaue
Reiter

1910
Futurist
Manifesto

DE CHIRICO
(b. 1888)

GAUDI
Casa Milá
(1907)

KOLLWITZ
(1867–1945)

MALEVICH
(1878–1935)

Yor?
?Y

LACHAISE
Standing Woman

DALI
*Persistence
of Memory*
detail (1931)

EIROS
–1974)

— P R E S S I O N I S M —

MIRÓ
Painting
detail (1933)

WRIGHT
Kaufmann House
(1936)

MONDRIAN
*Composition in Blue, Yellow,
and Black*
(1936)

HN
1969)

DUBUFFET
(b. 1901)

Nazis begin
rise

1938

CALDER
Horizontal Spine
(1942)

GONZALES
*Woman
Combing Hair*
(1940)

Commercial
TV and
World War II
begin

bombs devastate
ima and Nagasaki

— P R E S S I O N I S M —

First nuclear
reaction

1945
orld War II ends

1942

1939

RILEY
Current
detail (1964)

SMITH
Cubi XIX
(1964)

BLADEN
The X (1967)

ESTES
Nedick's (1970)

— K I N E T I C / M I N I M A L / C O N C E P T U A L —— N E W R E A L I S M —

123

1963
hn F. Kennedy
ssassinated

ENTERTAINMENT ERASES HISTORY © P. Nagy 1983 1970

Allan McCollum, Source for *Perpetual Photo (No. 126B)*, 1982–86

Perpetual Photo (No. 126B), 1982–86

Allan McCollum, Source for *Perpetual Photo* (*No. 119*), 1984–86

Perpetual Photo (*No. 119*), 1984–1986

Dara Birnbaum, *P.M. Magazine*, installation at The Museum of Contemporary Art, Los Angeles, 1989, and detail.

Chris Burden, *CBTV,* 1977

129

Bill Viola, *The Sleep of Reason*, 1988 (Installation views)

132

Troy Brauntuch, *Untitled,* 1982

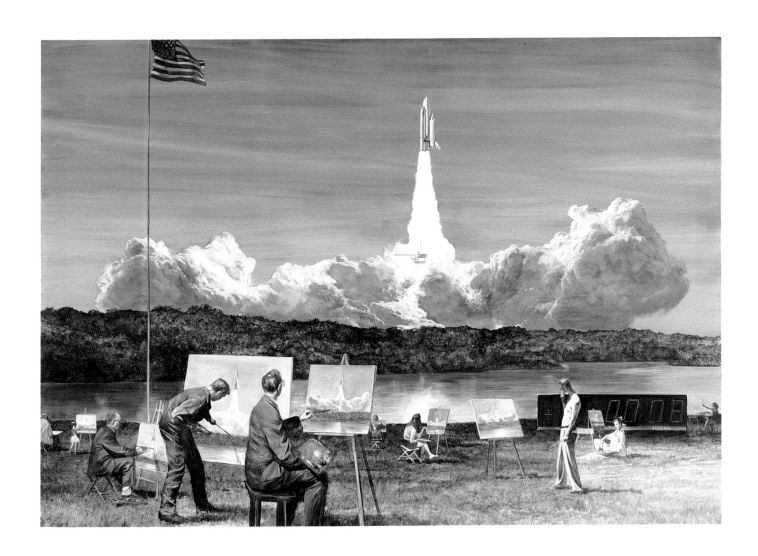

133

Richard Prince, *Untitled (entertainers)*, 1984

Richard Prince, *Untitled (cowboy)*, 1989

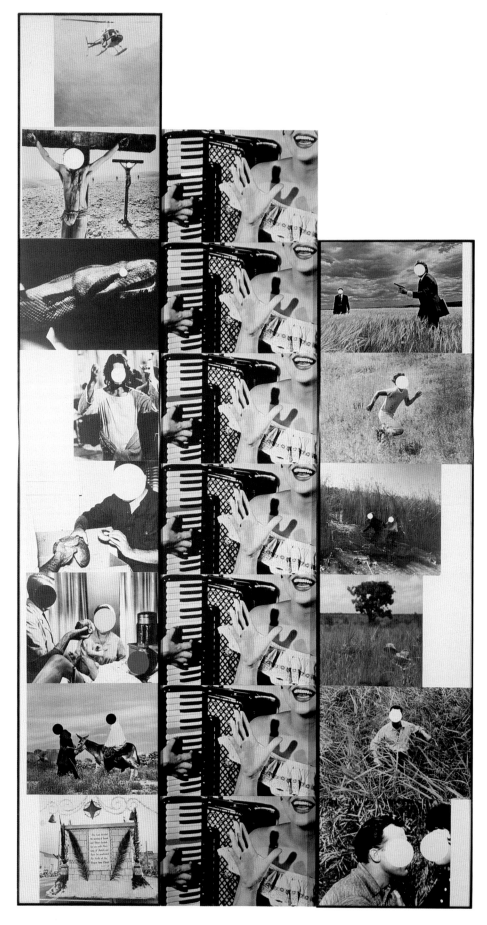

John Baldessari, *Two Stories,* 1987

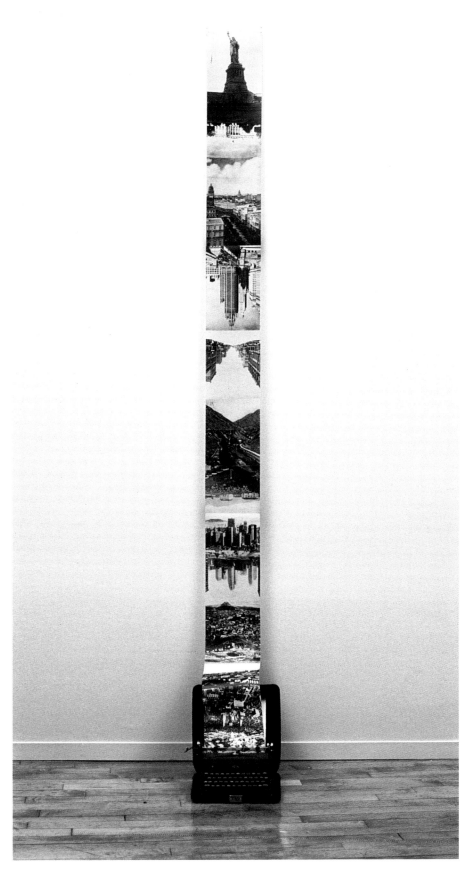

137

Annette Lemieux, *The Ascension*, 1986

Oliver Wasow, *Untitled*, 1989

Oliver Wasow, *Untitled*, 1989

140

Barbara Bloom, *Confession to Godard,* 1987

141

Clegg and Guttmann, *Our Production — The Production of Others*, 1986

142

Frank Majore, *Blue Martinis*, 1983

143

Carole Ann Klonarides, *Famous for 30 Seconds, Artists in the Media,* 1987 (4 stills)

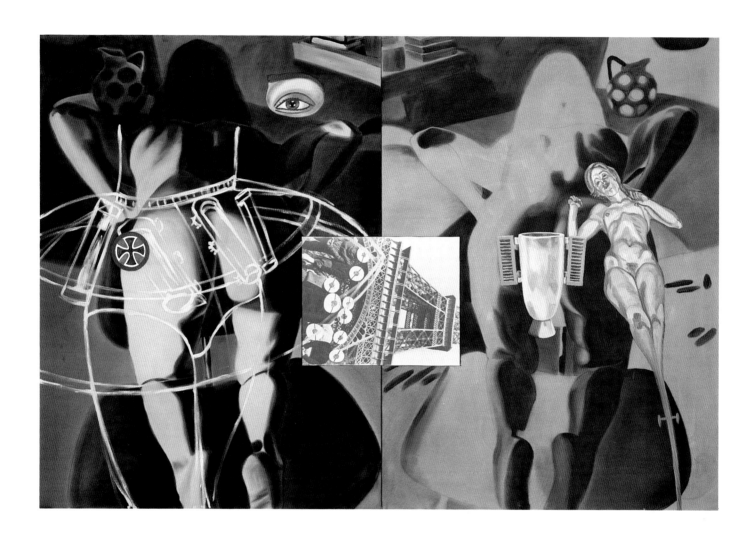

147

Alan Belcher

Jenny Holzer

Michael Byron

Joel Otterson

Clegg and Guttmann

Steven Parrino

Robert Longo

Robin Weglinski

Ashley Bickerton

David Robbins, *Talent,* 1986

Larry Johnson

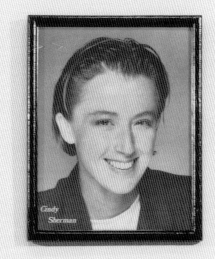

Cindy
Sherman

Allan McCollum

Thomas Lawson

Jeff Koons

Gretchen Bender

Peter Nagy

Jennifer Bolande

David Robbins

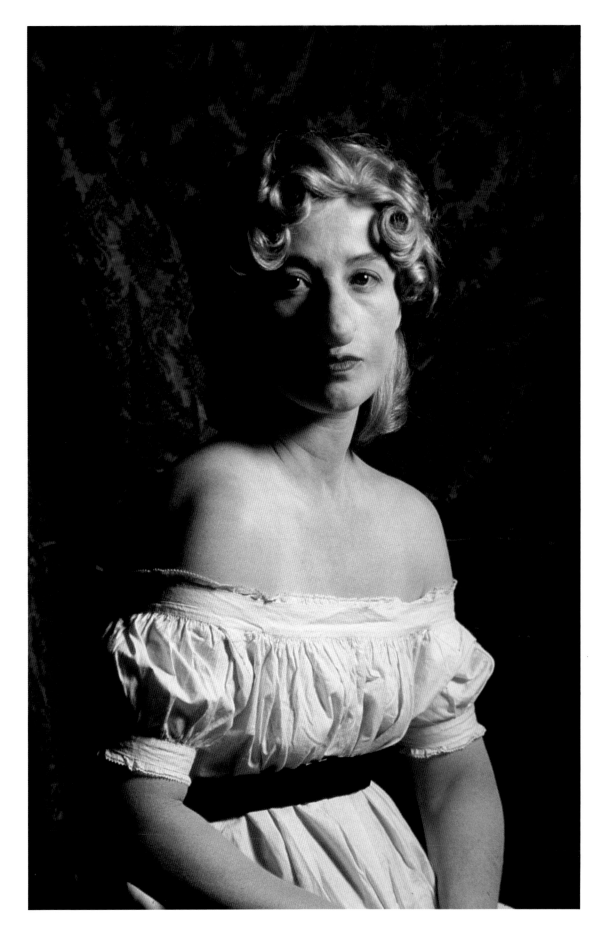

Cindy Sherman, *Untitled*, 1989

151

Cindy Sherman, *Untitled*, 1989

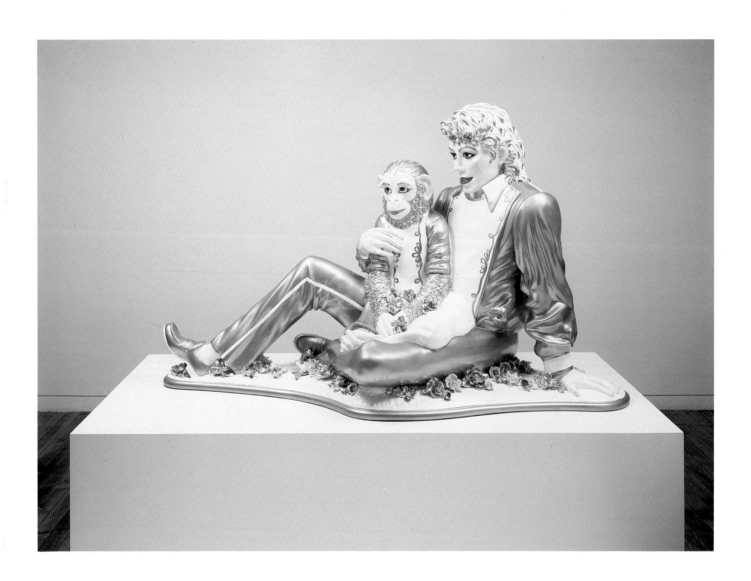

Jeff Koons, *Michael Jackson and Bubbles*, 1988–89

153

Jeff Koons, *Louis XIV,* 1986

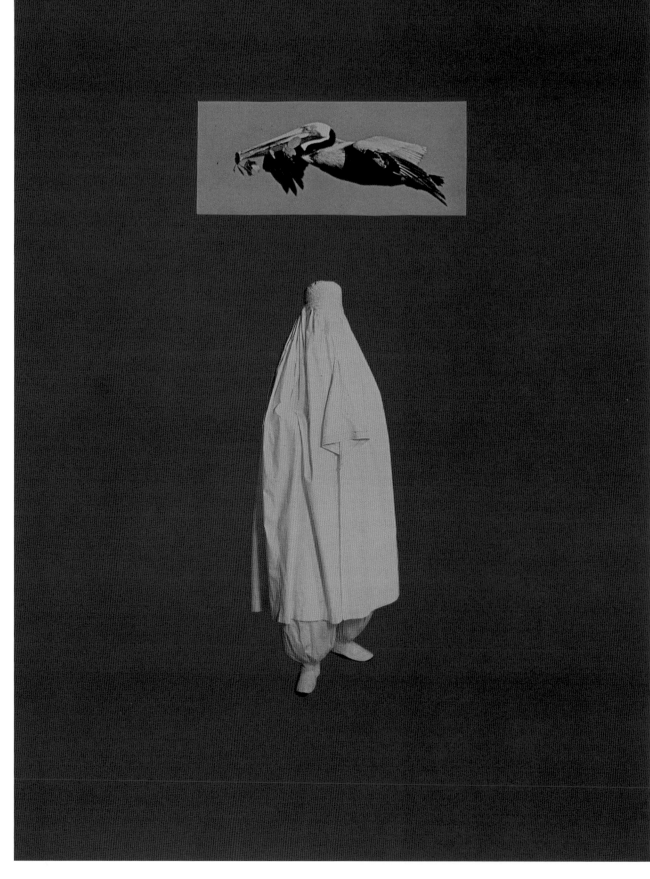

154

Sarah Charlesworth, *Bird Woman*, 1986

Sarah Charlesworth, *Bull*, 1986

MONDAY TUESDAY WEDNESDAY THURSDAY FRIDAY

MISDESCRIPTION | MISINFORMATION | MISIDENTIFY | MISDIAGNOSE | MISFUNCTION | MISTRANSCRIBE | MISREMEMBER | MISGAUGE | MISCONSTRUE | MISTRANSLATE

Lorna Simpson, *Five Day Forecast,* 1988

Silvia Kolbowski, *Here and There* (excerpt), 1986–89

Dennis Adams, *Bus Shelter VIII*, Toronto, 1988

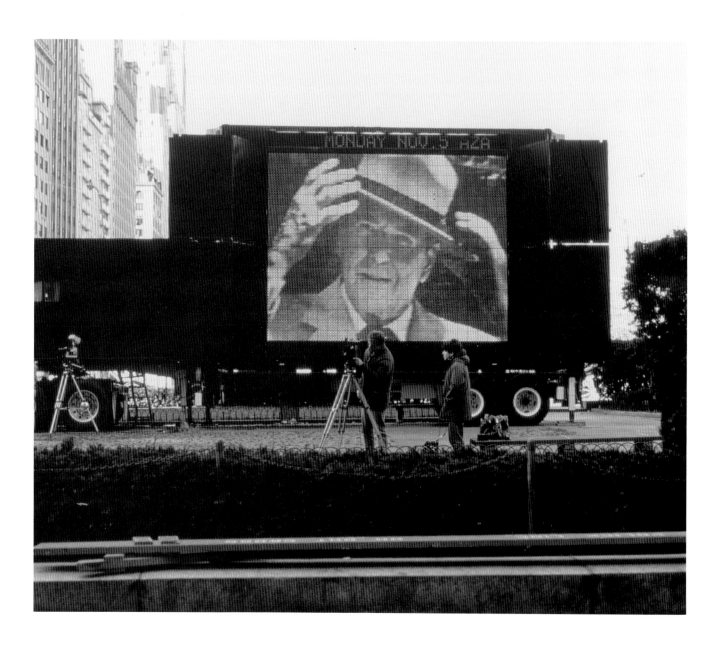

160

Jenny Holzer, *Sign on a Truck,* New York, 1984

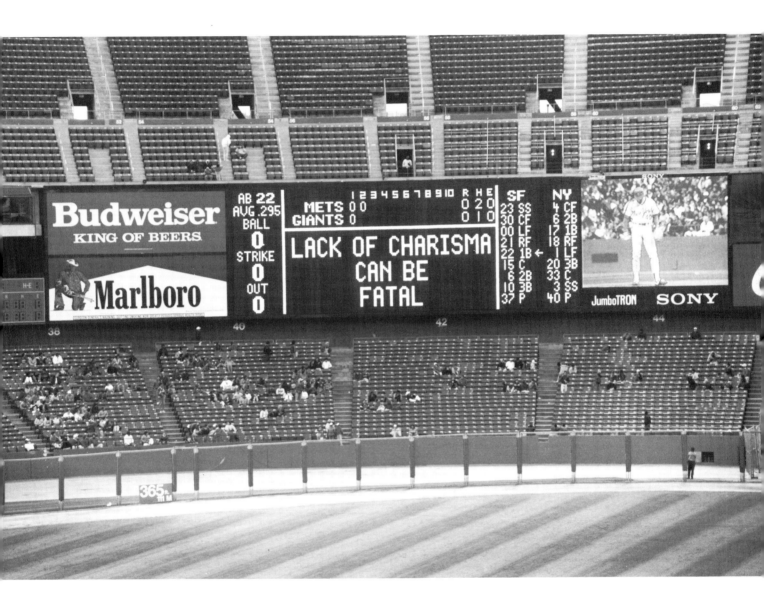

Jenny Holzer, *Lack of Charisma Can Be Fatal,* Candlestick Park, San Francisco, 1987

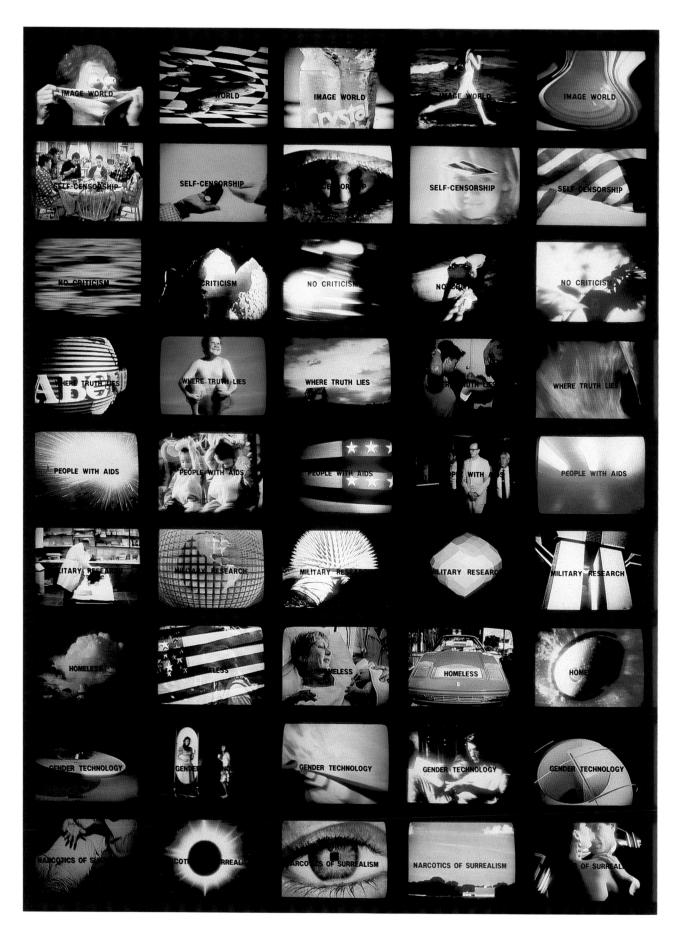

162

Gretchen Bender, *T.V. Text and Image,* 1989

163

Move arrow to choose a face.
Press SELECT

Nancy Burson and David Kramlich, *The Composite Machine*, 1988–89

Bruce Nauman, *Clown Torture*, 1987

all DEVASTATION, *all* DESTRUCTION ON AN EPIC SCALE, VIES WITH *all* CREATION TO DOMINATE THE LORE OF THE HUMAN RACE. IF *all* LIVING BEINGS FEAR DEATH, OR AT LEAST TRY INSTINCTIVELY, DESPERATELY, TO AVOID IT, *all* HUMANS ARE ALSO FASCINATED BY DEATH AND BY *all* THOSE DRAMATIC CONFRONTATIONS WITH DESTRUCTION WHEREIN DEATH IS THE PROBABLE OUTCOME.

Larry Johnson, *Untitled (All)*, 1987

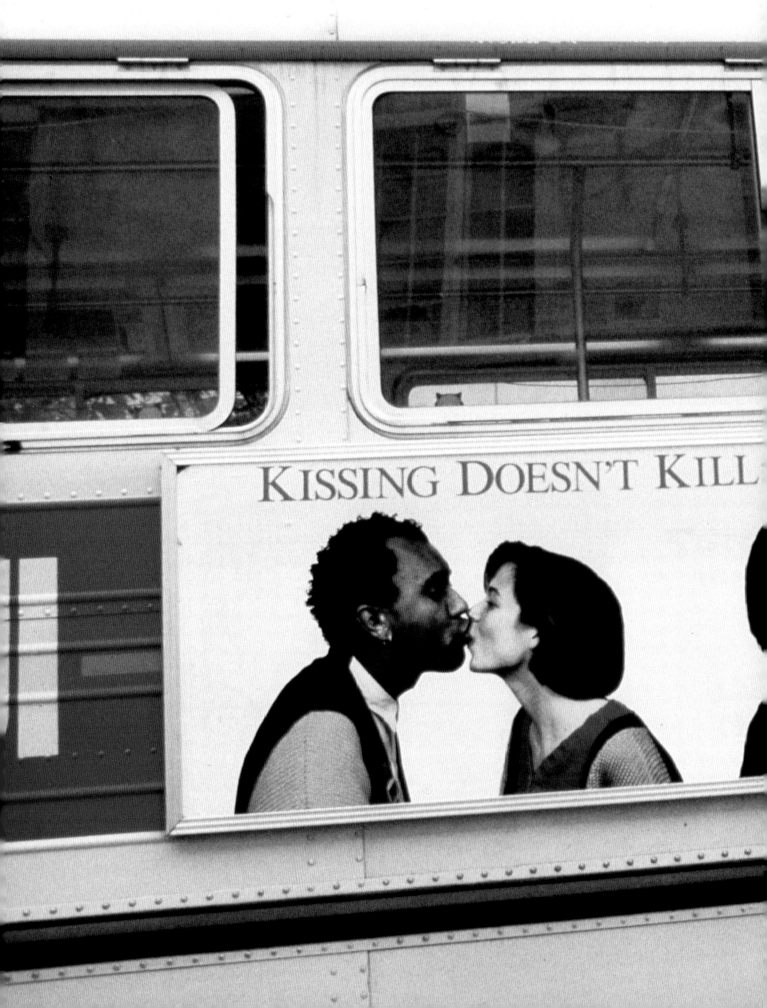

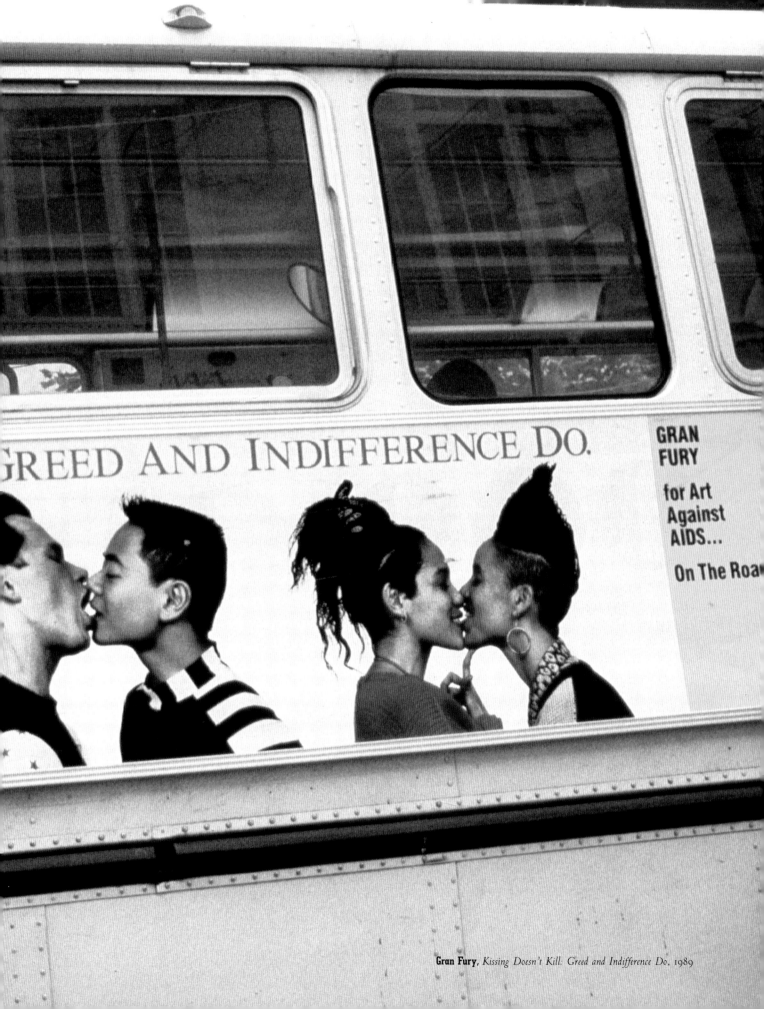

Gran Fury, *Kissing Doesn't Kill: Greed and Indifference Do,* 1989

Ashley Bickerton, *Commercial Piece No. 2,* 1989

Alexis Smith, *The Twentieth Century #19*, 1983

Construct a sentence to render the event in words.
Withdraw consciousness from the event.
Deny the previous steps, the next steps, and
the denials.
Change the subject, verb or object of the sentence
and form a new positive sentence.
Picture the new sentence with an image.
Project the image into perceptual space.

Nayland Blake, *Schatzman Hallucination Guide,* 1989

Laurie Simmons, *Walking Camera (Jimmy The Camera)*, 1987

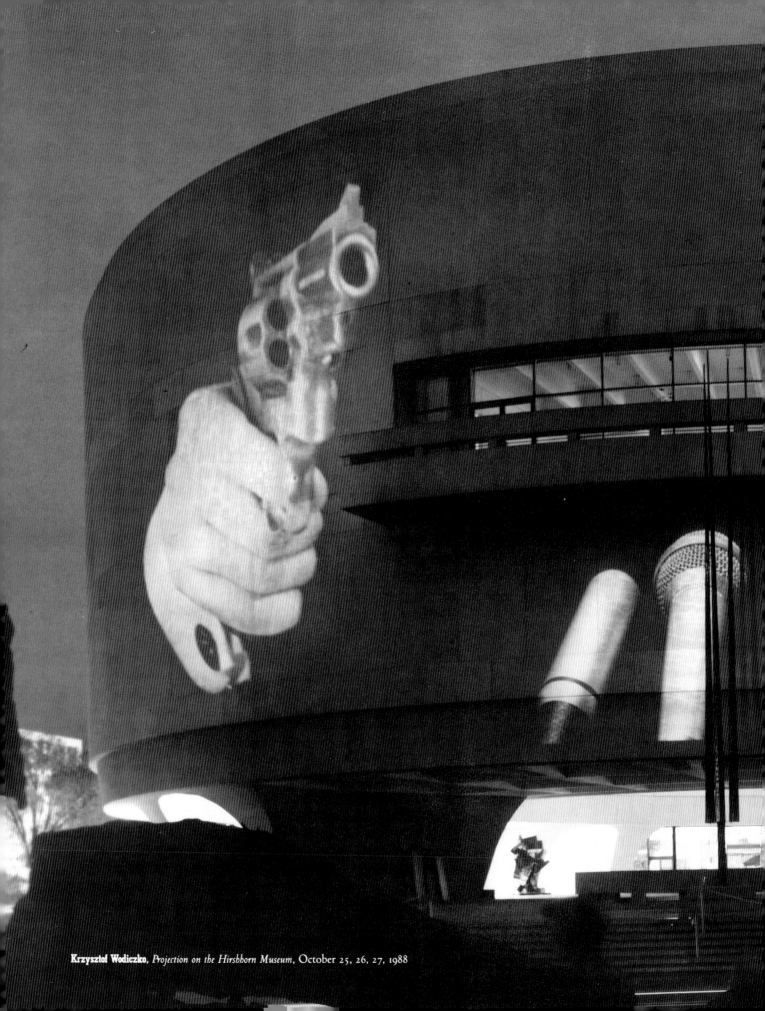

Krzysztof Wodiczko, *Projection on the Hirshhorn Museum*, October 25, 26, 27, 1988

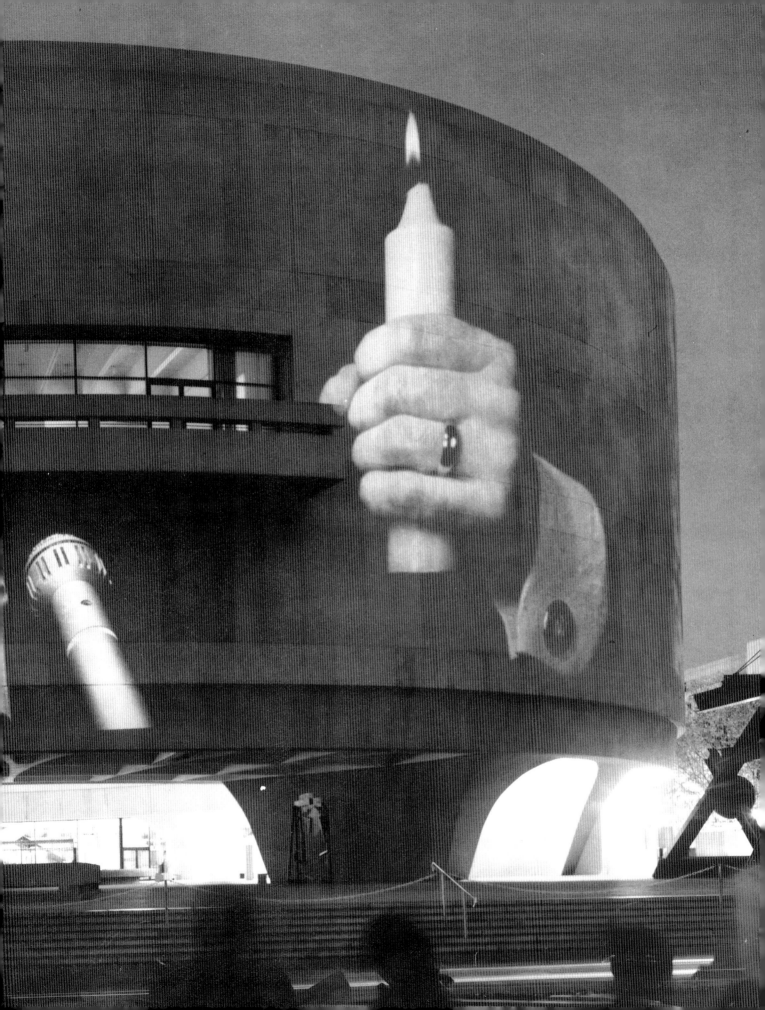

Image World Chronology

1839
Louis Daguerre's invention of the daguerreotype announced in Paris.

1841
First advertising agency founded by Volney B. Palmer in Philadelphia.

William Henry Fox Talbot patents the calotype, a paper negative capable of producing multiple copies.

1844
First telegraphic transmission of news by Samuel Morse, from Washington, D.C. to the *Baltimore Patriot.*

1854
The carte-de-visite, eight pocket-sized photographs on one negative, is patented by Adolphe-Eugène Disdéri.

1858
Talbot patents photoengraving.

1860
A tintype photographic portrait of Abraham Lincoln is used on political buttons.

1866
First transatlantic cable for telegraphic communication with Europe.

1867
Invention of the large-format lithograph press makes poster advertisements a common sight.

1872
Signage laws begin to regulate billposting (flyposting); the business of renting space gives rise to billboards.

1876
Telephone invented by Alexander Graham Bell.

1877
Eadweard Muybridge photographs a horse in motion by placing twelve cameras along a race track.

Camera on wheels, 1949.

1878
J. Walter Thompson is the first to use magazine space as a significant advertising tool.

1880
First commercial halftone photographic reproduction appears in the *New York Daily Graphic*.

1884
The invention of the Nipkow disk establishes a scanning technique that simulates eye movement, the first step toward the electronic transmission of images.

1888
Kodak introduces a hand-held camera with the slogan, "You press the button, we do the rest." The original cost for a 100-shot, preloaded camera was $25.

1890
Earnest Elmo Calkins, an advertising copywriter, recognizes the importance of visual appeal in ads and promotes the concept of art direction.

The term "ad smith" is coined to describe a copywriter whose creative use of jingles and humor was more effective than straight copy.

1891
First electric sign appears on Broadway. Within two years the avenue is called "The Great White Way."

1895
Louis and Auguste Lumière invent the first successful motion picture projector, the Cinématographe, and conduct the first public film screening.

Guglielmo Marconi transmits first radio signals.

Wilhelm Roentgen discovers the X-ray process, which records otherwise invisible rays of radiation.

1896
First photograph used in an advertisement, for H-O Cereal.

1900
Annual advertising expenditures in the U.S. total $500 million.

1903
Henry Ford begins standardization and mass production of the automobile.

1905
Nickelodeons, the first permanent movie theaters, spread across the country.

1907
Autochrome process introduced; creates a color transparency on a glass plate.

Scientific American introduces the term "television," also called "visual radio" and "visual wireless."

1908
The Psychology of Advertising by Walter Dill Scott urges advertisers to understand human desires, emotions, and motivations.

1910
Newsreels introduced in the US.

1911
Photoplay, the first of many movie fan magazines, is published.

1913
R.J. Reynolds launches a landmark national advertising campaign to introduce Camel cigarettes.

1914
The Strand, a 3,300-seat theater, opens on Broadway as the first "movie palace" or "dream house."

1915
Release of *Birth of a Nation*, D.W. Griffith's film epic, made for $125,000. The use of close-ups and editing within scenes advances film language.

1916
Total number of movie theaters in the US reaches 21,000.

1920
Scheduled radio broadcasting begins.

A record 6 million cars in the US. As driving speeds increase, billboards grow larger.

1924
Invention of the Leica, a small, 35mm camera with interchangeable lenses, rids the photojournalist of cumbersome equipment.

1925
Sergei Eisenstein's *Potemkin* introduces the theory of montage into film language.

Burma Shave highway billboard campaign initiated. Six signs placed at successive intervals along the roadside are read as one sentence.

1926
Annual advertising expenditures in the US reach $3.3 billion.

1927
The Jazz Singer by Alan Crosland, first synchronized sound film.

Philo T. Farnsworth applies for patent on his electronic television system. The first transmitted image is a dollar sign.

1929
The Depression economy forces advertisers to institute "market research."

1929
The first radio broadcast rating service, Crossley's Cooperative Analysis of Broadcasting (CAB), originates the concept of "prime time." Based on the public's listening habits, it is used to sell radio advertising.

1932
Eastman Kodak introduces the 8mm movie camera.

1933
First drive-in movie theater, in Camden, New Jersey.

1935
Beginning of *The March of Time*, a popular newsreel released monthly to film theaters (until 1951).

First three-color Technicolor feature film, *Becky Sharp* by Rouben Mamoulian.

Associated Press starts its International Wirephoto Service.

1936
First issue of *LIFE* magazine.

1938
Xerography invented by Chester F. Carlson.

Harold Edgerton invents stroboscopic illumination, allows photographic exposures of a millionth of a second.

80 million people, or 65 percent of the population, go to the movies each week.

1939
Television is demonstrated by RCA at the New York World's Fair.

1940
First museum photography department established by The Museum of Modern Art, New York.

1941
Scheduled television broadcasting begins with limited programming.

1942
Kodacolor, the first color negative roll film, is introduced.

1943
Meshes of the Afternoon, Maya Deren's low-budget, independent film, marks the beginning of American avant-garde cinema.

PHOTOGRAPHY

1945
Explosion of the atomic bomb on Hiroshima is photographed from the window of the "Enola Gay."

1947
Dr. Edwin Land announces the invention of the Polaroid Land 95 Camera, which produces a print in sixty seconds.

Hungarian scientist Dennis Gabor describes the theory of holography, a process that creates a three-dimensional image (he receives a Nobel Prize in 1971).

1950
The Xerox Model D, first commercial dry copier, is marketed.

1954
The public spends $442 million on photography materials, four times that spent in 1953.

ADVERTISING

1946
Early TV commercials take the form of product demonstrations in simulated home environments.

The Trademark Act (Lanham Act) protects names, symbols, slogans, and other distinctive features of advertising.

1947
Advertising pages account for approximately 65 percent of magazine content.

1949
TV advertising expenditures estimated at $57.8 million.

Total advertising expenditures for the year are $5.7 billion.

Maidenform's "I Dreamed" campaign, the first photographic advertisements in the United States for women's intimate apparel.

1951
"The Man in the Hathaway Shirt" campaign created by David Ogilvy.

1952
Eisenhower campaign makes first use of political TV spots.

1953
Irving Penn transforms a mundane product with his elegant photograph of Jell-O.

FILM

1946
Movie theater box office receipts reach an all-time high of $1.7 billion.

1947
The House Committee on Un-American Activities investigates the motion picture industry for Communist infiltration, resulting in widespread blacklisting.

Cinema 16 established in New York to distribute independent films.

Art in Cinema established at the San Francisco Museum of Art; first West Coast venue for avant-garde film.

1948
Supreme Court rules that major studios must divest themselves of theater holdings, thus weakening the studios' monopoly over the industry.

1950
Movie theater weekly attendance is 60 million. Major Hollywood studios release 263 films.

1951
First feature films shot on Eastman Color, which becomes the standard color film.

1952
Supreme Court rules that movies are protected under First Amendment right of freedom of expression.

TELEVISION

1945
With the end of wartime production, the manufacture of televisions begins.

1946
Television sets go on sale to the public; six stations are on the air.

1947
The first coaxial cable links New York and Boston.

1948
1 million television sets in use in the US.

Radio's *Candid Microphone* becomes television's *Candid Camera*.

The variety show is a success with Milton Berle's *Texaco Star Theater* and Ed Sullivan's *Toast of the Town*.

1949
The inauguration of Harry Truman is televised.

The Lone Ranger and *Hopalong Cassidy* initiate the TV western series.

1950
The first educational station, WOI-TV of Iowa State University, begins broadcasting.

Nielsen ratings begin measuring TV viewing habits.

1951
The first daytime soap opera, *Search for Tomorrow*, begins.

I Love Lucy, the first successful filmed (rather than live) TV series.

ART

1945
Joseph Cornell begins using movie-star portraits as elements in his box constructions and collages.

1947
Eduardo Paolozzi uses mass-media images, from postcards and advertisements, in his collages.

1949
Jackson Pollock is featured in a *LIFE* magazine article that asks, "Is he the greatest living painter in the United States?"

1950
Willem de Kooning uses a fragment of a pin-up poster in his study for *Woman*.

1955
Robert Rauschenberg starts his Combine paintings, which incorporate photographic images.

1940s

1950s

1955

"The Family of Man," an exhibition including art photography and photo-journalism, held at The Museum of Modern Art, New York, curated by Edward Steichen.

1955

Leo Burnett creates "Marlboro Man" campaign, transforming the image of the product, which had previously been a woman's cigarette.

1955

TV replaces radio as the number one national advertising medium.

Bwana Devil by Arch Oboler is the first commercial 3-D movie.

1953

Cinemascope uses an anamorphic distorting lens to create wide-screen cinema.

1955

Rebel Without a Cause, by Nicholas Ray, one of the most important social problem films of the period.

Disneyland opens in California.

Edward R. Murrow's radio program *Hear It Now* is brought to television as *See It Now*.

NBC begins the first coast-to-coast programming.

The Senate hearings on organized crime are the first such sessions televised; gangster Frank Costello demands that his face not be shown.

1952

Dragnet, the prototype of the documentary-style police detective series.

1956

"This Is Tomorrow," first exhibition of British Pop Art, Whitechapel Art Gallery, London.

1958

Rauschenberg uses photographic media images for his transfer drawings.

James Rosenquist paints advertising billboards in Times Square.

1958

Introduction of color infrared-sensitive film, used for scientific and technical photography.

1959

Agfa Optima, the first camera with automatic exposure control, put on the market.

book *The Hidden Persuaders*.

Rumors begin that Coca-Cola is experimenting with subliminal advertising in movie theaters, unnoticeably flashing the words "Drink Coke" at the audience and studying the response.

1958

Procter & Gamble's Cheer commercials

1956

Richard Avedon adds a narrative element to fashion photography in his series with Suzy Parker, which mimics the immediacy and vitality of news photos.

1957

The psychological manipulation used in advertising is brought to the public's attention by Vance Packard's

Film Culture, first journal of the American independent cinema movement.

Roger Corman makes his debut as producer/director of low-budget science-fiction and gangster films. In the 1960s and 1970s, he produces the first features by directors Francis Ford Coppola, Martin Scorsese, and George Lucas, among others.

RKO sells its entire film library to television programming syndicator.

The *Today Show* begins using a news-variety format.

1953

First issue of *TV Guide* is published.

1954

The first major study is conducted on the effects of television violence on children.

29 million television sets in use in the US.

Army-McCarthy hearings broadcast.

Discoverer I, first publicly acknowledged US satellite to carry photo-reconnaissance equipment, transmits photos to earth.

1956

Hollywood begins producing blockbuster films—Cecil B. DeMille's *The Ten Commandments* and King Vidor's *War and Peace*—to combat loss of audience to television.

1958

A Movie by Bruce Conner uses found footage from different film genres.

1959

Shadows by John Cassavetes and *Pull My Daisy* by Robert Frank and Alfred

Swanson introduces the TV dinner for 95 cents.

Disneyland, a Walt Disney production, the first significant venture of a Hollywood studio into TV production.

1956

The teaming of Chet Huntley and David Brinkley at NBC begins the rise of newscasters as celebrities.

Videotape recording system introduced by Ampex (commercially used in 1957).

use testimonials by supermarket shoppers.

1959

Advertising expenditures for all media doubled during the decade to $11 billion.

Leslie, two important Beat-inspired films made outside the studio system.

The modification of an Auricon Cine-Voice camera allows for synchronized sound recording without cable connection between camera and recorder.

French New Wave directors, influenced by film theory and having a love-hate relationship with American cinema, produce such films as *Breathless* (Jean-Luc Godard) and *The 400 Blows* (François Truffaut).

The Zenith Space Command, the first successful wireless TV remote control, is marketed.

1959

50 million television sets in use in the US; 300,000 in color.

Introduction of Chroma-Key, an electronic video matting technique.

The Annenberg School of Communications is established at the University of Pennsylvania, the first graduate program for communications.

Appliance store display, 1957

PHOTOGRAPHY

1960
4.6 million cameras sold in the United States.

Holography becomes practical with the invention of the laser.

1963
Kodak develops Instamatic camera with drop-in film cartridges.

Cibachrome, a dye-destruction method of color printing, introduced.

1965
Lennart Nilsson photographs human embryos at different stages of development.

US spacecraft Mariner 4 transmits first photographs of Mars.

1967
The first "drive-thru" Fotomat opens at the Loma Square Shopping Center in San Diego.

"New Documents" exhibition at The Museum of Modern Art, New York, includes works by fine art photographers and photojournalists.

1969
The term "photo opportunity" is coined by Ron Ziegler, Nixon's press secretary.

ADVERTISING

1960
Bill Bernbach's Volkswagen campaign marks the beginning of the Creative Revolution, in which copywriters and art directors work as a team.

During the sixties, color advertising increases with advances in four-color printing technology.

1962
Avis launches the "We Try Harder" comparative ad campaign.

1964
"Girl with Daisy" political TV spot, created for Lyndon Johnson's presidential campaign, features a girl pulling petals off a flower during a countdown that culminates in a nuclear explosion. The controversial spot is withdrawn

after one airing.

1966
Photographic ads outnumber others by a ratio of approximately six to one.

1967
Wells, Rich, Greene's campaign for Benson & Hedges 100's plays on the disadvantages of a long cigarette; within four years product sales in-

crease eightfold.

1968
Andy Warhol commissioned to make "The Underground Sundae," a 60-second commercial for Schrafft's Restaurant.

FILM

1960
Movie theater weekly attendance is 40 million. Major Hollywood studios release 184 films.

Twenty-three independent filmmakers attend first meeting of The New American Cinema Group and issue a manifesto that serves as a model for future generations of independent filmmakers.

Primary, by Ricky Leacock and Robert Drew, an important early

example of *cinema verité* in America, using the new synchronized sound 16mm equipment.

Alfred Hitchcock's *Psycho* released, a key work in the thriller genre.

1961
Stan VanDerBeek coins the term "underground" to refer to avant-garde filmmakers.

1962
Filmmakers' Cooperative is founded in

New York.

"Notes on the Auteur Theory" by Andrew Sarris, published in *Film Culture*, initiates both the debate over film authorship and a critical reconsideration of Hollywood cinema.

1964
Film-Makers' Cinematheque, New York, is founded.

First in-flight movies are shown.

1965
Studios begin to use 35mm film cameras with a video-assist, allowing accurate viewing and replay of shots on video.

1966
Michelangelo Antonioni's *Blow Up* plays on the myth of the photographer/hero.

The Chelsea Girls, Andy Warhol's first commercially successful feature-length

TELEVISION

1960
The first televised presidential debates, between Richard Nixon and John F. Kennedy.

1961
560 commercial stations and 50 educational stations are broadcasting.

FCC chairman Newton N. Minow characterizes television as "a vast wasteland" at a convention of the National Association of Broadcasters.

ABC's Wide World of Sports, the first

weekly sports series.

1962
First live coverage of a presidential press conference.

Launching of the Telstar I satellite allows television programs to be relayed globally.

John Glenn's orbital space flight receives worldwide live coverage.

TV plays a role in an international drama when President Kennedy deliv-

ers an ultimatum to Khruschev on the air and then briefs the nation on the Cuban Missile Crisis.

Jackie Kennedy gives a televised tour of the White House.

1963
Martin Luther King, Jr's "I Have a Dream" speech is televised during the Civil Rights March on Washington.

The assassination and funeral of President Kennedy and on-screen murder of Lee Harvey Oswald disrupt

all regular programming for four days. Oswald's murder is repeatedly aired, becoming the prototype of instant replay.

A study conducted by The Roper Organization reveals that television is the main source of news for Americans.

The first live telecast pictures of earth from space are shown during the Faith 7 voyage.

ART

1960
Yves Klein publishes *Dimanche* in Paris, a four-page newspaper parody, with a front-page photograph showing him flying.

Formation of the French group, the Nouveaux Réalistes; they issue a manifesto calling for an art based on a "fundamental gesture of appropriation."

1961
The California Institute of the Arts is founded by Walt Disney in Valencia, California.

1962
Rauschenberg and Warhol independently begin photosilkscreening images onto canvas.

Andy Warhol exhibits his Campbell Soup Can pieces.

"New Realists" exhibition at the Sidney Janis Gallery, New York, is first display of Pop Art in the US.

1963
Nam June Paik begins to use televisions as sculpture, first exhibited at the Galerie Parnass in Wuppertal, West Germany.

TV-Dé-Collage by Wolf Vostell, at the Smolin Gallery, New York, first installation in the US using a TV set.

Andy Warhol begins making films (*Sleep, Kiss*, and *Blow Job*).

Fluxus, an international artists group, begins publishing an illustrated monthly newspaper. In 1965, the group opens Fluxshop to sell its art.

1965
James Rosenquist's wrap-around painting *F-111*, depicting the dark side of technology, covers all four walls of the Castelli Gallery, New York. The

1960s

film, represents a crossover of avant-garde filmmaking to the commercial sector.

Paramount Pictures is bought by Gulf + Western, signaling an industrial shift toward conglomerate control of the film industry.

1967
Arthur Penn's *Bonnie and Clyde* is trend-setting for its depiction of violence and sexuality.

Wavelength, by Michael Snow, the most celebrated film of the 1960s Structural Film movement.

Canyon Cinema, Inc., San Francisco, is incorporated to distribute avant-garde films.

The Newsreel collective is founded in New York, producing radical interventionist documentaries such as *Black Panther* and *Columbia Revolt* (both 1968); in 1973, becomes Third World Newsreel.

Don't Look Back by D.A. Pennebaker begins the trend of rock music documentaries, followed by Michael Wadleigh's *Woodstock* (1970) and *Gimme Shelter* by the Maysles brothers (1970).

1968
Stanley Kubrick's *2001: A Space Odyssey*, an important science-fiction film with the most elaborate use of special effects to date.

Film rating system (G, M[PG], R, X) introduced by the Motion Picture Producers and Distributors of America in response to a wave of film censorship battles.

1969
Dennis Hopper's *Easy Rider*, the most important Hollywood representation of the counterculture points the way for what would become known as the New Hollywood.

Instant replay is used for the first time in sports coverage.

1964
Marshall McLuhan declares, "the medium is the message" in his book *Understanding Media*.

1965
TV network news switches to color; begins increased coverage of the Vietnam War.

Sony Corporation releases Portapak, the first inexpensive, nonbroadcast-

quality, portable black-and-white video camera.

1966
Boston station WGBH-TV inaugurates artist-in-residence program for experimental projects; followed by KQED-TV (1966), San Francisco, and WNET-TV (1972), New York.

Color television sales surpass sales of black-and-white sets.

1967
Anti-war marches and demonstrations

are covered by the news.

The Carnegie Commission issues a report on the need for public television; Corporation for Public Broadcasting (CPB) is founded.

1968
CBS debuts the weekly news show *60 Minutes*.

1969
Formation of video collectives such as Global Village and Raindance Corporation.

One-fifth of the world's inhabitants watch astronauts Neil Armstrong and "Buzz" Aldrin set foot on the moon.

The Medium Is the Medium, WGBH-TV, first presentation of works by independent video artists aired on television.

The Smothers Brothers Comedy Hour goes off the air after repeated run-ins with CBS censors.

panels are intended to be sold separately as souvenirs of the event.

Exhibitions begin of what is soon to be labeled Photo-Realism.

1966
Experiments in Art and Technology (EAT) produces *9 Evenings: Theater and Engineering*, collaborations between artists and engineers at the 69th Regiment Armory, New York.

1967
Robert Rauschenberg creates a silkscreen for a *Time* magazine cover, with a montage of images from *Bonnie and Clyde*. (In 1986, he makes the cover of another issue, "Man of the Year: Deng Xiaoping.")

1968
Bruce Nauman creates his *First Hologram Series (Making Faces)(a-h)*.

Joseph Kosuth makes his first outdoor and subway billboards for his series

Art as Idea as Idea.

1969
First American exhibition devoted to video art, "TV as a Creative Medium," at the Howard Wise Gallery, New York.

Massachusetts Institute of Technology (MIT) establishes The Center for Advanced Visual Studies for artists to explore technology.

Andy Warhol begins publishing *Interview* magazine.

Daniel Buren rents billboard space to display his art in Paris.

"Live in Your Head: When Attitudes Become Form (Works—Concepts—Processes—Situations—Information)," an early exhibition of Conceptual Art, opens at the Kunsthalle Bern, Switzerland.

The Visual Studies Workshop opens in Rochester, New York, as an experimental media workshop.

1970
10.8 million cameras sold in the United States; 4.75 billion photographs produced.

1972
The demise of *LIFE* magazine attributed to the popularity of television.

Diane Arbus retrospective at The Museum of Modern Art.

Introduction of Polaroid SX-70 Land Camera, which produces prints that self-develop in daylight.

1976
Canon is the first manufacturer to use microprocessors in cameras.

1977
The market for photography booms; Ansel Adams' *Moonrise over Hernandez* sells for a record figure at auction.

1978
Konica introduces the first automatic focus camera.

1970
Total advertising expenditures reach $19.6 billion.

1971
Cigarette ads are banned from television.

Frank Perdue begins to represent his company in a "positioning" campaign with the slogan, "It takes a tough man to make a tender chicken."

Alka-Seltzer campaign uses humorous lines with effective repetition, such as "Try it, you'll like it" and "I can't believe I ate the whole thing."

1973
Fuji develops the Scanamural, which reproduces and enlarges an image using a computerized airbrush system.

1975
Helmut Newton and Guy Bourdin add an aggressive air of sexuality and violence to their fashion photographs for French *Vogue*.

Slice-of-life commercials begin to display products in seemingly real environments and narrative situations.

1977
The Supreme Court rules that lawyers and, by association, doctors may advertise their services under First Amendment protection.

1970
Movie theater weekly attendance is 18 million. Major Hollywood studios release 153 films.

Hiroshima—Nagasaki, August 1945, by Erik Barnouw and Paul Ronder, the first public release of US Government footage of the atomic bomb devastation.

Anthology Film Archives founded in New York.

Jim McBride's *David Holzman's Diary*, a fictional film shot in the style of *cinema verité*, challenges the conventions of the documentary genre.

1971
Melvin Van Peebles' *Sweet Sweetback's Baadasssss Song*, a landmark black independent film that became a model for Hollywood "blaxploitation" films.

1972
First International Festival of Women's Films.

Janie's Janie by Geri Ashur and Peter Barton, *Joyce at 34* (1973) by Joyce Chopra and Claudia Weill, and *Film About a Woman Who . . .* (1974) by Yvonne Rainer are key works in the women's filmmaking movement.

Women Make Movies, New York, is founded.

Francis Ford Coppola's *The Godfather* has enormous Hollywood success and generates a sequel in 1974; signals a return to traditional genres such as the gangster film.

1973
The Quad Cinema, New York, is the first multiplex theater, with four separate screening rooms under one roof.

1974
Super-8 sound camera goes on the market.

1970
Color videotape recorders become available.

Nam June Paik and Shuya Abe develop the Paik/Abe Video Synthesizer, one of the first electronic image processors.

The Mary Tyler Moore Show features a single, professional woman as protagonist.

1971
Media Bus, first low-power artist-run TV station, produces weekly community programs.

All in the Family, produced by Norman Lear, addresses working-class issues and prejudice in a family sitcom.

1972
First successful cable programming (HBO) begins in Wilkes-Barre, Pennsylvania.

Top Value Television (TVTV), an independent documentary production group, forms to provide alternative coverage of the Democratic and Republican conventions; first use of half-inch videotape on broadcast television.

Federal Communications Commission (FCC) requires that all cable franchises have at least one public-access channel.

1973
The televised Watergate hearings receive record ratings.

1974
Nixon delivers his resignation statement on TV.

PBS airs *An American Family* (1973), a *cinema verité* documentary on the Loud family by independent producers Alan and Susan Raymond.

1970
"Information" exhibition at The Museum of Modern Art, New York, addresses artists' use of communications systems.

"Vision and Television," the first American museum exhibition devoted to video, opens at the Rose Art Museum, Brandeis University, Waltham, Massachusetts.

1971
Electronic Arts Intermix, a pioneering media center, is the first distributor of artists' videotapes.

Everson Museum of Art, Syracuse, New York, establishes first video department in a major museum; followed by the Whitney Museum and others.

The Electronic Kitchen (The Kitchen) is established in New York as a screening and performance center for the electronic arts.

1972
Castelli-Sonnabend Videotapes and Films is founded as a distribution service for artists, including Bruce Nauman, Richard Serra, and Keith Sonnier.

1973
Chris Burden buys TV airtime in Los Angeles to broadcast a series of self-promotions as Conceptual artworks.

Nam June Paik's *Global Groove* is broadcast.

1974
Lynda Benglis' sexually explicit, two-page ad in *Artforum* prompts a disclaimer from the magazine's editors.

1970s

1979

The Scitex Color System is developed; it allows color corrections to be made and images, text, and layout to be generated and manipulated by computer.

1976

Network, by Sidney Lumet, a black comedy about the television industry.

The Omen, developed by David Seltzer, starts Hollywood packaging trend, with simultaneous release of film and novel based on the script.

1977

The first feature films available on video cassettes.

George Lucas' *Star Wars*, one of the highest grossing films of all time, spurs the computer-generated special effects industry; as a result, Industrial Light and Magic is founded.

Barbara Kopple wins an Oscar for *Harlan County, U.S.A.* (1976); the award signals the rebirth of the American independent political documentary.

1978

John Carpenter's *Halloween* triggers an explosion of horror films.

Michael Cimino's *The Deer Hunter* and Hal Ashby's *Coming Home* begin Hollywood trend toward revisionist view of Vietnam War. The following year *Apocalypse Now*, by Francis Ford Coppola, is released. (The Vietnam War is readdressed almost ten years later in Oliver Stone's *Platoon* [1986] and Stanley Kubrick's *Full Metal Jacket* [1987]).

1979

Independent Feature Project begins in New York as a festival and as a marketing network for independent films.

1975

Worldwide audiences watch the American evacuation of Cambodia and South Vietnam.

Betamax, the first home video recorder, is introduced.

1976

The Police Tapes, Alan and Susan Raymond's controversial independent "video verité" documentary, aired on ABC. Shooting and editing style later emulated in *Hill Street Blues*.

1977

The ABC miniseries *Roots* reaches a record 80 million viewers.

America Held Hostage (ABC), a temporary program to deal with the hostage crisis, becomes the regularly scheduled *Nightline* the following year.

150 million TV sets in use in 98 percent of American households; 60 million homes have color sets.

NBC Nightly News begins broadcasting reports by independent producer

Jon Alpert, whose stories are later featured on the *Today Show*.

Christian Broadcasting Network (CBN) begins as a forum for televangelism; by 1981 CBN is aired 24 hours a day.

QUBE, the first interactive cable TV system, is tested in Columbus, Ohio.

1978

Magnavox introduces a laser video disc player.

1979

Militant Iranian students dominate TV news as they seize the American Embassy in Tehran. *The Iran Crisis:*

1975

Ant Farm, a San Francisco multimedia collective founded in 1968, produces *Media Burn*, an event that advocates the destruction of television.

1976

Printed Matter, a publisher and distributor for artist-produced books, is incorporated in New York.

1977

"Pictures" exhibition opens at Artists Space, New York, with Troy Brauntuch, Jack Goldstein, Sherrie Levine, Robert Longo, and Philip Smith.

Richard Prince and Sherrie Levine begin "re-photographing" pictures, appropriating them with almost no transformation or alteration.

Satellite transmissions are used to create live international performances in works by Nam June Paik, Joseph Beuys, Douglas Davis, Liza Bear, and Keith Sonnier.

Sidney Lumet, *Network*, 1976

1980
16.6 million cameras sold in the United States; 10.25 billion photographs produced.

1982
National Geographic stirs controversy when it uses a Scitex image processor to shift one of the Giza Pyramids to fit its cover format.

The Sony Mavica, the first video still camera, records images on a magnetic computer disc (mass-marketed in 1989).

1984
The largest backlit transparency, measuring 18 x 60 feet, hung in Grand Central Station, New York.

Mitsubishi video printer introduced; prints images from television signals.

1987
Americans click their shutters 15 billion times.

Fuji produces the first disposable 35mm camera.

1988
Fax machines are mass marketed.

1980
Total advertising expenditures reach $54.6 billion, with $11.4 billion spent on TV ads.

During the eighties, point-of-purchase displays in stores begin to change drastically with the introduction of LED signs, interactive video, and large video walls.

1981
The Army's $80 million "Be all you can be" campaign changes the dynamics of enlistment, with 50 percent of applicants influenced by the positive image of commercials.

1982
Cutty Sark ad featuring composer Philip Glass begins advertising trend of artists' endorsements.

The National Association of Broadcasters (NAB) code regulating the number of minutes per hour of television advertisements is deemed a restriction of trade by the Federal Trade Commission (FTC); the Reagan Administration lifts the regulations.

1983
Americans watch approximately 30,000 TV commercials a year.

TV commercials begin to shift to 10-second spots, "shoe-horning" down from 60-second and 30-second spots.

1984
Bruce Weber's billboard for Calvin Klein underwear looms over Times Square. The giant male figure, in briefs, presents a reversal of sexual stereotypes.

1980
Movie theater weekly attendance is 19 million. Major Hollywood studios release 137 films.

Former movie star Ronald Reagan is elected President.

1982
E.T. The Extra-Terrestrial by Steven Spielberg becomes the largest grossing film ever, with $680 million in box office receipts and video rentals.

First Blood, by Ted Kotcheff, the first Rambo film with Sylvester Stallone; the hero becomes a cultural icon during Reagan's administration.

Francis Ford Coppola's use of video as a tool during the filming and editing of *One from the Heart* marks a change in the process of filmmaking.

1983
The cultural effects of video and computers are reflected in such Hollywood films as David Cronenberg's *Videodrome* and John Badham's *WarGames*.

1984
Independent films begin crossover to wide distribution with Jim Jarmusch's *Stranger Than Paradise* and Joel and Ethan Coen's *Blood Simple*, followed by Spike Lee's *She's Gotta Have It* (1986).

1985
Cineplex Odeon theater chain forms partnership with MCA, reuniting major powers in production and exhibition and all but reversing Supreme Court decision of 1948.

1987
Eight Hollywood studios earn 87 percent of combined box office revenues.

1980
Ted Turner launches the Cable News Network (CNN), a 24-hour news service.

83 million people watch *Dallas* to see "Who Shot J.R.?" The show is syndicated in 99 countries.

1.1 percent of American homes have VCRs.

1981
Polls show that Walter Cronkite is the most trusted man in America.

1 billion people watch the televised marriage of Prince Charles and Lady Diana Spencer.

Private satellite dishes are approved by the FCC. By the end of the decade there will be 2 million in use in the US.

MTV starts the first rock video cable channel.

Paper Tiger TV, a low-budget public-access television show, critiques the communication industry.

1982
Portable Watchman introduced by Sony.

High-definition television developed in Japan, is demonstrated in the US.

The Home Shopping Club starts; by 1987 it reaches more than 10 million cable households with estimated sales of $1 billion.

1983
The Day After, a TV movie, depicts a dramatic representation of nuclear disaster.

1984
Sony introduces the JumboTRON, a monumental outdoor video display screen used in sports stadiums.

Supreme Court rules that home taping of TV shows does not violate copyright laws.

1980
Metro Pictures Gallery opens in SoHo; exhibits a new generation of artists who address media issues.

1982
"A Fatal Attraction: Art and the Media" exhibition at The Renaissance Society at the University of Chicago.

The Public Art Fund initiates a program of artists' spots on the Spectacolor Board in Times Square.

1983
Laurie Anderson premieres the complete *United States* (Parts I-IV), a multimedia performance at The Brooklyn Academy of Music.

1984
Jenny Holzer produces *Sign on a Truck*, incorporating artists' work and man-on-the-street comments on the presidental election, exhibited on a portable computerized electronic sign.

The Guerrilla Girls, an anonymous artists' collective, use posters to advertise discrimination within the art world.

1985
Andy Warhol appears on the television show *Love Boat*.

"Talking Back to the Media," a city-wide exhibition in Amsterdam, includes gallery exhibitions as well as mass-media events.

MTV commissions artists to produce 30-second spots called Art Breaks.

"ArtSide Out," a presentation of billboards, provides eight artists with an outdoor urban gallery, sponsored by First Banks and Film in the Cities, Minneapolis.

1980s

1989
The first direct image of a strand of DNA, seen through a scanning tunnel microscope, recorded by computer.

US spacecraft Voyager 2 transmits images of Neptune from the farthest reaches of the solar system.

Apple's "1984" commercial introduces the Macintosh computer, with an emphasis on the totalitarian control of information. The 60-second spot airs only once, but is replayed as a news item.

Pepsi-Cola's Michael Jackson commercial brings pop musical extravagance to its TV campaign.

1988
Studio 28, the largest multiplex movie theater in the world, with twenty separate screens, opens in Grand Rapids, Michigan.

1989
Outlets for video rentals reach 27,000, excluding supermarkets, pharmacies, and mass merchandisers.

1985
The National Coalition on TV Violence says that the average American child will see approximately 50,000 attempted murders on TV by the age of 16.

Alive from Off Center, KTCA-TV, Minneapolis/St. Paul, with the Walker Art Center, a series of programs bringing together performance artists and video artists.

1986
"Art & Advertising," organized by the International Center for Photography, explores the crossover of artists into advertising.

"TV Generations" opens at Los Angeles Contemporary Exhibitions (LACE).

Photographs by Robert Mapplethorpe and Andres Serrano trigger government debate on public funding for the arts.

The Nike billboard campaign stresses action narratives over text.

1986
MegaPrint, a laser scanning computer airbrush system, produces billboard-scale prints.

1987
AT & T commercials push the negative effects of not using their services,

45.7 percent of American homes wired for cable.

1,206 TV stations broadcasting in the US.

Average television viewing peaks at seven hours and ten minutes per day per household.

1986
The explosion of the space shuttle Challenger is replayed repeatedly for the viewing public.

1987
"Implosion: A Postmodern Perspective" exhibition at the Moderna Museet, Stockholm.

1988
Group Materials' booklet *Inserts* (a collection of one-page projects by artists) distributed as an advertising supplement in the Sunday, May 22 issue of *The New York Times*.

in what come to be known as "slice-of-death" campaigns.

1988
$118.3 billion spent on domestic advertising.

Total number of billboards in the US is 260,000.

1989
A study by the Association of American Advertising Agencies finds that the average person is exposed to 1,600 ads a day; of these eighty are consciously noticed and only twelve provoke some reaction.

Chris Whittle introduces satellite *Channel One* into the school system, placing news spots and corporate ads before a captive student body.

First consumer video telephone marketed.

Deep Dish TV, the first public-access satellite distribution network. Organized by Paper Tiger TV, it creates a pilot series played on 300 cable systems in forty-one states.

1989
In his twenty-seven years on *The Tonight Show*, Johnny Carson has interviewed more than 20,000 guests, presided over 6,500 shows, and told 700,000 jokes to a weekly audience of 75 million viewers.

162 million TV sets in the US in 90 million homes.

TV evening news attracts 47 million viewers per night.

64.6 percent of homes in the US have VCRs.

The average American household can receive 27.7 channels.

1989
"A Forest of Signs: Art in the Crisis of Representation" opens at The Museum of Contemporary Art, Los Angeles.

"Art Against AIDS/On the Road" begins in San Francisco, initiating a public awareness program using artists' billboards, bus signs and shelters, and magazine inserts.

Jeff Koons is profiled in *People* magazine.

Eric Bogosian's performance piece *Talk Radio* is transformed into a Hollywood film.

Selected Bibliography

General Cultural Studies

Althusser, Louis. "Ideology and the Ideological State Apparatuses," in *Lenin and Philosophy and Other Essays*. Translated by Ben Brewster. New York and London: Monthly Review Press, 1972.

————. *Essays on Ideology*. London: Verso, 1984.

Bagdikian, Ben H. *The Media Monopoly*. Boston: Beacon Press, 1987.

Barthes, Roland. *Mythologies* (1957). Translated by Annette Lavers. New York: Hill and Wang, 1972.

Benjamin, Walter. *Illuminations* (1955). Edited by Hannah Arendt, translated by Harry Zohn. New York: Schocken Books, 1969. Including "The Work of Art in the Age of Mechanical Reproduction."

Berger, John, et al. *Ways of Seeing*. London: British Broadcasting Corporation; Middlesex, England: Penguin Books, 1972.

Berman, Marshall. *All That Is Solid Melts into Air: The Experience of Modernity*. New York: Simon and Schuster, 1982.

Bourdieu, Pierre. *Distinction: A Social Critique of the Judgement of Taste*. Translated by Richard Nice. Cambridge, Massachusetts: Harvard University Press, 1984.

Brantlinger, Patrick. *Bread & Circuses: Theories of Mass Culture as Social Decay*. Ithaca, New York: Cornell University Press, 1983.

Bürger, Peter. *Theory of the Avant-Garde*. Translated by Michael Shaw. (Theory and History of Literature, 4) Minneapolis: University of Minnesota Press, 1984.

Collins, Jim. *Uncommon Cultures: Popular Culture and Post-Modernism*. New York: Routledge and Kegan Paul, 1989.

Danto, Arthur C. *The Transfiguration of the Commonplace*. Cambridge, Massachusetts: Harvard University Press, 1981.

Debord, Guy. *The Society of the Spectacle*. Detroit: Black and Red, 1970.

Eco, Umberto. *Travels in Hyper Reality*. Translated by William Weaver. New York: Harcourt Brace Jovanovich, 1986.

Enzensberger, Hans Magnus. *The Consciousness Industry: On Literature, Politics and the Media*. New York: Seabury Press, 1974. Selected and with a postscript by Michael Roloff.

Foster, Hal, ed. *The Anti-Aesthetic: Essays on Postmodern Culture*. Port Townsend, Washington: Bay Press, 1983.

Gardner, Carl, ed. *Media, Politics and Culture: A Socialist View*. London: Macmillan, 1979.

Habermas, Jürgen. *The Philosophical Discourse of Modernity: Twelve Lectures*. Translated by Frederick Lawrence. Cambridge, Massachusetts: The MIT Press, 1987.

Horkheimer, Max, and Theodor W. Adorno. *Dialectic of Enlightenment*. Translated by John Cumming. New York: The Seabury Press, 1972.

Huyssen, Andreas. *After the Great Divide: Modernism, Mass Culture, Postmodernism*. Bloomington: Indiana University Press, 1986.

Kaplan, E. Ann. *Postmodernism and its Discontents*. London: Verso, 1988.

Kroker, Arthur, and David Cook. *The Postmodern Scene: Excremental Culture and Hyper-Aesthetics*. New York: St. Martin's Press, 1986.

Lippard, Lucy, ed. *Conceptual Art*. New York: Praeger Publishers, 1973.

Lyotard, Jean-François. *The Postmodern Condition: A Report on Knowledge*. Translated by Geoff Bennington and Brian Massurmi. (Theory and History of Literature, 10) Minneapolis: University of Minnesota Press, 1984.

Nelson, Cary, and Lawrence Grossberg, eds. *Marxism and the Interpretation of Culture*. Urbana and Chicago: University of Illinois Press, 1988.

Poster, Mark, ed. *Jean Baudrillard: Selected Writings*. Stanford, California: Stanford University Press, 1988. Including "For a Critique of the Political Economy of the Sign" (1972) and "The Masses: The Implosion of the Social in the Media" (1985).

Susman, Warren. *Culture as History: The Transformation of American Society in the Twentieth Century*. New York: Pantheon Books, 1973.

Robert Watts, *McLuhan Sweatshirt*, 1967

Trow, George W.S. *Within the Context of No Context.* Boston: Little, Brown and Company, 1978.

Venturi, Robert, Denise Scott Brown, and Steven Izenour, eds. *Learning from Las Vegas: The Forgotten Symbolism of Architectural Form.* Cambridge, Massachusetts: The MIT Press, 1977.

Williamson, Judith. *Consuming Passions: The Dynamics of Popular Culture.* London: Marion Boyars, 1986.

Media Culture

Advertising

Ewen, Stuart. *Captains of Consciousness: Advertising and the Social Roots of the Consumer Culture.* New York, St. Louis, etc.: McGraw-Hill Book Company, 1976.

Fox, Stephen. *The Mirror Makers: A History of American Advertising and Its Creators.* New York: William Morrow and Company, 1984.

Goffman, Erving. *Gender Advertisements.* Cambridge, Massachusetts: Harvard University Press, 1979.

Henderson, Sally, and Robert Landau. *Billboard Art.* San Francisco: Chronicle Books, 1980. Introduction by David Hockney.

Packard, Vance. *The Hidden Persuaders.* New York: Pocket Books, 1957.

Williamson, Judith. *Decoding Advertisements: Ideology and Meaning in Advertising.* (Ideas in Progress). London: Marion Boyars, 1978.

Communications

Boorstin, Daniel J. *The Image: A Guide to Pseudo-Events in America.* New York: Atheneum, 1961.

Ellis, John. *Visible Fictions: Cinema, Television, Video.* London: Routledge & Kegan Paul, 1982.

Ewen, Stuart, and Elizabeth Ewen. *Channels of Desire: Mass Images and the Shaping of American Consciousness.* New York, St. Louis, etc.: McGraw-Hill Book Company, 1982.

Hebdige, Dick. *Hiding in the Light: On Images and Things.* New York: Comedia Books, 1988.

McLuhan, Marshall. *The Gutenberg Galaxy.* Toronto: University of Toronto Press, 1962.

———. *Understanding Media: The Extensions of Man.* New York: McGraw-Hill Book Company, 1964.

McLuhan, Marshall, and Quentin Fiore. *The Medium Is the Message.* New York: Bantam Books, 1967.

Meyrowitz, Joshua. *No Sense of Place: The Impact of Electronic Media on Social Behavior.* New York and Oxford: Oxford University Press, 1985.

Schiller, Herbert. *The Mind Managers.* Boston: Beacon Press, 1973.

———. *Communication and Cultural Domination.* White Plains, New York: International Arts and Sciences Press, 1976.

Schwartz, Tony. *Media: The Second God.* New York: Random House, 1981.

Woodward, Kathleen, ed. *The Myths of Information: Technology and Postindustrial Culture.* Madison, Wisconsin: Coda Press, 1980.

Film

Balio, Tino, ed. *The American Film Industry.* Rev. ed. Madison: The University of Wisconsin Press, 1976.

Bordwell, David. *Narrative in the Fiction Film.* Madison: The University of Wisconsin Press, 1985.

Burch, Noël. *Theory of Film Practice.* Translated by Helen R. Lane. New York: Praeger Publishers, 1973.

De Lauretis, Teresa. *Alice Doesn't: Feminism, Semiotics, Cinema.* Bloomington: Indiana University Press, 1984.

Gledhill, Christine, ed. *Home Is Where the Heart Is: Studies in Melodrama and the Woman's Film.* London: British Film Institute, 1987.

Gomery, Douglas. *The Hollywood Studio System.* New York: St. Martin's Press, 1986.

Heath, Stephen. *Questions of Cinema.* Bloomington: Indiana University Press, 1981.

James, David E. *Allegories of Cinema: American Film in the Sixties.* Princeton, New Jersey: Princeton University Press, 1989.

Kuhn, Annette. *The Power of the Image: Essays on Representation and Sexuality.* London: Routledge and Kegan Paul, 1985.

Lovell, Terry. *Pictures of Reality: Aesthetics, Politics, Pleasure.* London: British Film Institute, 1980.

McCarthy, Todd and Charles Flynn. *Kings of the B's: Working Within the Hollywood System.* New York: E.P. Dutton, 1975.

Volkswagen campaign by Doyle Dane Bernbach, 1960

Mekas, Jonas. *Movie Journal.* New York: Collier Books, 1972.

Modleski, Tania, ed. *Studies in Entertainment: Critical Approaches to Mass Culture.* Bloomington: Indiana University Press, 1986.

Nichols, Bill. *Ideology and the Image: Social Representation in the Cinema and Other Media.* Bloomington: Indiana University Press, 1981.

Rogin, Michael. *Ronald Reagan, the Movie, and Other Episodes in Political Demonology.* Berkeley: University of California Press, 1987.

Sarris, Andrew. *The American Cinema: Directors and Directions 1929–1968.* New York: E.P. Dutton, 1968.

Sitney, P. Adams. *Visionary Film.* New York: Oxford University Press, 1974.

———, ed. *Film Culture Reader.* New York: Praeger Publishers, 1970.

Wollen, Peter. *Readings and Writings: Semiotic Counter-Strategies.* London: Verso and NLB, 1982.

———. *Signs and Meaning in the Cinema.* London: Secker & Warburg, 1969.

Youngblood, Gene. *Expanded Cinema.* New York: E.P. Dutton, 1970.

Video store, New York, 1989

Photography

Appell, Alfred, Jr. *Signs of Life.* New York: Alfred A. Knopf, 1983.

Barthes, Roland. *Camera Lucida: Reflections on Photography.* Translated by Richard Howard. New York: Hill and Wang, 1981.

Burgin, Victor, ed. *Thinking Photography.* London: Macmillan Press, 1982. Essays by Victor Burgin, Walter Benjamin, Umberto Eco, Allan Sekula, John Tagg, and Simon Watney.

Coke, Van Deren. *The Painter and the Photograph: From Delacroix to Warhol.* Rev. ed. Albuquerque: University of New Mexico Press, 1972.

Evans, Harold. *Pictures on a Page.* New York: Holt, Rinehart and Winston, 1978.

Scharf, Aaron. *Art And Photography.* London: A. Lane, 1968.

Sontag, Susan. *On Photography.* New York: Farrar, Straus and Giroux, 1973.

Television

Allen, Robert C., ed. *Channels of Discourse: Television and Contemporary Criticism.* Chapel Hill: University of North Carolina Press, 1987.

Arlen, Michael. *The Camera Age: Essays on Television.* New York: Farrar, Straus and Giroux, 1981.

Barnouw, Eric. *The Sponsor: Notes on a Modern Potentate.* New York: Oxford University Press, 1978.

———. *Tube of Plenty: The Evolution of American Television.* New York: Oxford University Press, 1975.

Fiske, John. *Television Culture.* New York: Methuen, 1987.

Fiske, John, and John Hartley. *Reading Television.* London: Methuen, 1978.

Gans, Herbert. *Deciding What's News: A Study of CBS Evening News, NBC Nightly News, Newsweek, and Time.* New York: Vintage Books, 1979.

Gitlin, Todd. *Inside Prime Time.* New York: Pantheon Books, 1983.

———, ed. *Watching Television: A Pantheon Guide to Popular Culture.* New York: Pantheon Books, 1986.

Kaplan, E. Ann. *Rocking Around the Clock: Music Television, Postmodernism and Consumer Culture.* New York and London: Methuen, 1987.

———, ed. *Regarding Television: Critical Approaches — An Anthology.* (The American Film Institute Monograph Series, 2). Frederick, Maryland: University Publications of America, 1983.

Kruger, Barbara, ed. *TV Guides.* New York: The Kuklapolitan Press, 1985. Twenty-one essays on television.

MacCabe, Colin, ed. *High Theory/Low Culture: Analyzing Popular Television and Film.* New York: St. Martin's Press, 1986.

Mander, Jerry. *Four Arguments for the Elimination of Television.* New York: Morrow Quill, 1978.

Mueller, Roswitha, Kathleen Woodward, and Patrice Petro, eds. *Discourse*, no. X.2 (Spring–Summer 1988).

Newcomb, Horace, ed. *Television: The Critical View.* New York: Oxford University Press, 1976.

Postman, Neil. *Amusing Ourselves to Death: Public Discourse in the Age of Show Business.* New York: Penguin Books, 1986.

187

Schneider, Cynthia, and Brian Wallis, eds. *Global Television.* Cambridge, Massachusetts: The MIT Press; New York: Wedge Press, 1988.

Shambergs, Michael, and Raindance Corporation, eds. *Guerrilla Television.* New York: Holt, Reinhart and Winston, 1971.

Sklar, Robert. *Prime Time America: Life On and Behind the Television Screen.* New York: Oxford University Press, 1980.

Williams, Raymond. *Television: Technology and Cultural Form.* New York: Schocken Books, 1974.

Winston, Brian. *Misunderstanding Media.* London: Routledge and Kegan Paul, 1986.

A newspaper press, 1989

<section>

Art and Media Culture

Anthologies and Collected Essays

Alloway, Lawrence, et al. *Modern Dreams: The Rise and Fall and Rise of Pop* New York: The Institute of Contemporary Art; Cambridge, Massachusetts: The MIT Press, 1988.

Battcock, Gregory, ed. *Idea Art: A Critical Anthology.* New York: E.P. Dutton, 1973.

————, ed. *New Artists Video: A Critical Anthology.* New York: E.P. Dutton, 1979.

Buchloh, Benjamin H.D., Serge Guilbaut, and David Solkin, eds. *Modernism and Modernity: The Vancouver Conference Papers.* Halifax, Nova Scotia: The Press of the Nova Scotia College of Art & Design, 1983.

D'Agostino, Peter, ed. *Transmission.* New York: Tanam Press, 1985.

Davis, Douglas. *Artculture: Essays on the Post-Modern.* New York: Harper & Row, 1977.

Foster, Hal. *Recodings: Art, Spectacle, Cultural Politics.* Seattle: Bay Press, 1985.

Hanhardt, John, ed. *Video Culture: A Critical Investigation.* Rochester, New York: Visual Studies Workshop; Layton, Utah: Peregrine Smith Books, 1986.

Hendricks, Jon. *Fluxus Codex.* Detroit: The Gilbert and Lila Silverman Fluxus Collection, 1988. Introduction by Robert Pincus-Witten.

Lovejoy, Margot. *Postmodern Currents: Art and Artists in the Age of Electronic Media.* Ann Arbor, Michigan, and London: U.M.I. Research Press, 1989.

Michelson, Annette, et al. *October: The First Decade, 1976–1986.* Cambridge, Massachusetts: The MIT Press, 1987.

Nairne, Sandy, in collaboration with Geoff Dunlop and John Wyver. *State of the Art: Ideas and Images in the 1980s.* London: Chatto & Windus and Channel Four Television Co., 1987.

Schneider, Ira, and Beryl Korot, eds. *Video Art: An Anthology.* New York: Harcourt, Brace, Jovanovich, 1976.

Taylor, Paul, ed. *Post-Pop Art.* Cambridge, Massachusetts: The MIT Press, 1989.

Wallis, Brian, ed. *Art After Modernism: Rethinking Representation.* (Documentary Sources in Contemporary Art). New York: The New Museum of Contemporary Art; Boston: David R. Godine, 1984. Twenty-four essays.

————, ed. *Blasted Allegories: An Anthology of Writings by Contemporary Artists.* (Documentary Sources in Contemporary Art, 2). New York: The New Museum of Contemporary Art; Cambridge, Massachusetts: The MIT Press, 1987.

Exhibition Catalogues (chronological)

New York, The Museum of Modern Art. *Information* (exhibition catalogue), 1970. Essay by Kynaston L. McShine.

New York, Whitney Museum of American Art. *American Pop Art* (exhibition catalogue), 1974. Text by Lawrence Alloway.

New York, The American Federation of Arts. *A History of the American Avant-Garde Cinema* (exhibition catalogue), 1976. Essays by John Hanhardt, Lucy Fisher, Stuart Liebman, Paul Arthur, Lindley Hanlon, Fred Camper, and Ellen Feldman.

New York, Artists Space. *Pictures* (exhibition catalogue), 1977. Text by Douglas Crimp.

Chicago, The Renaissance Society at the University of Chicago. *A Fatal Attraction: Art and the Media* (exhibition catalogue), 1982. Text by Thomas Lawson.

Philadelphia, Institute of Contemporary Art, University of Pennsylvania. *Image Scavengers: Painting* (exhibition catalogue), 1982. Text by Janet Kardon.

Philadelphia, Institute of Contemporary Art, University of Pennsylvania. *Image Scavengers: Photography* (exhibition catalogue), 1982. Essays by Janet Kardon, Paula Marincola, and Douglas Crimp.

</section>

<section>

Amsterdam. *Talking Back to the Media* (exhibition catalogue), 1985. Sixteen essays by artists and critics. Participating institutions: Aorta, Stichting de Appel, Kriterion, Shaffy Theater, Time Based Arts, and VPRO-Radio.

Atlanta, Georgia, Nexus Contemporary Art Center. *Public Art* (exhibition catalogue), 1985. Essay by Ronald Jones.

New York. *Infotainment* (exhibition catalogue), 1985. Essays by George W.S. Trow and Thomas Lawson.

New York, The New Museum of Contemporary Art. *The Art of Memory/The Loss of History* (exhibition catalogue), 1985. Essays by David Deitcher, William Olander, and Abigail Solomon-Godeau.

New York, The New Museum of Contemporary Art. *Difference: On Representation and Sexuality* (exhibition catalogue), 1985. Essays by Kate Linker, Craig Owens, Lisa Tickner, Jacqueline Rose, Peter Wollen, and Jane Weinstock.

Paris, Musée National d'Art Moderne, Centre Georges Pompidou. *Les Immatériaux* (exhibition catalogue), 1985. Essays by Jean Mahue and Jean-François Lyotard.

Boston, The Institute of Contemporary Art. *Endgame: Reference and Simulation in Recent Painting and Sculpture* (exhibition catalogue), 1986. Essays by Thomas Crow, Yve-Alain Bois, Elisabeth Sussman, David Joselit, Hal Foster, and Bob Riley.

Flushing, New York, The Queens Museum. *The Real Big Picture* (exhibition catalogue), 1986. Text by Marvin Heiferman.

Flushing, New York, The Queens Museum. *Television's Impact on Contemporary Art* (exhibition catalogue), 1986. Text by Marc H. Miller.

Los Angeles Contemporary Exhibitions (LACE). *Resolution: A Critique of Video Art* (exhibition catalogue), 1986. Text by Patti Podesta.

Los Angeles Contemporary Exhibitions (LACE). *TV Generations* (exhibition catalogue), 1986. Essays by John Baldessari, Peter D'Agostino, John G. Hanhardt, and Bruce Yonemoto.

New York, International Center of Photography. *Art & Advertising: Commercial Photography by Artists* (exhibition catalogue), 1986. Text by Willis Hartshorn.

New York, The New Museum of Contemporary Art. *Damaged Goods: Desire and the Economy of the Object* (exhibition catalogue), 1986. Essays by Brian Wallis, Hal Foster, Deborah Bershad, and the artists participating in the exhibition.

San Francisco, SF Camerawork. *Products and Promotion: Art, Advertising and the American Dream* (exhibition catalogue), 1986. Text by Donna Stein and Lynn Zelevansky.

Berkeley, California, University Art Museum, University of California. *Made in U.S.A.: An Americanization in Modern Art, the '50s & '60s* (exhibition catalogue), 1987. Text by Sidra Stich, James E.B. Breslin, Thomas Schaub, and Ben H. Bagdikian.

Los Angeles County Museum of Art. *Photography and Art: Interactions Since 1946* (exhibition catalogue), 1987. Essays by Andy Grundberg and Kathleen McCarthy Gauss.

Madrid, Fundación Caja de Pensiones. *Art and Its Double: A New York Perspective* (exhibition catalogue), 1987. Essay by Dan Cameron.

Stockholm, Moderna Museet. *Implosion: A Postmodern Perspective* (exhibition catalogue), 1987. Essays by Germano Celant, Kate Linker, and Craig Owens. Introduction by Lars Nittve.

Boston, Institute of Contemporary Art. *Utopia Post Utopia: Configurations of Nature and Culture in Recent Sculpture and Photography* (exhibition catalogue), 1988. Essays by Fredric Jameson, Eric Michaud, Elisabeth Sussman, David Joselit, Abigail Solomon-Godeau, and Alice Jardine.

New York, Scott Hanson Gallery. *Media Post Media* (exhibition catalogue), 1988. Essay by Tricia Collins and Richard Milazzo.

Rochester, New York, International Museum of Photography at George Eastman House. *A History of Advertising Photography* (exhibition catalogue), 1988. Text by Robert A. Sobieszek.

Los Angeles, The Museum of Contemporary Art. *A Forest of Signs: Art in the Crisis of Representation* (exhibition catalogue), 1989. Essays by Mary Jane Jacob, Ann Goldstein, Anne Rorimer, and Howard Singerman.

Washington, D.C., National Museum of American Art. *The Photography of Invention: American Pictures of the 1980s* (exhibition catalogue), 1989. Essay by Joshua P. Smith. Introduction by Merry A. Foresta.

Newsstand, Grand Central Station, New York, 1989

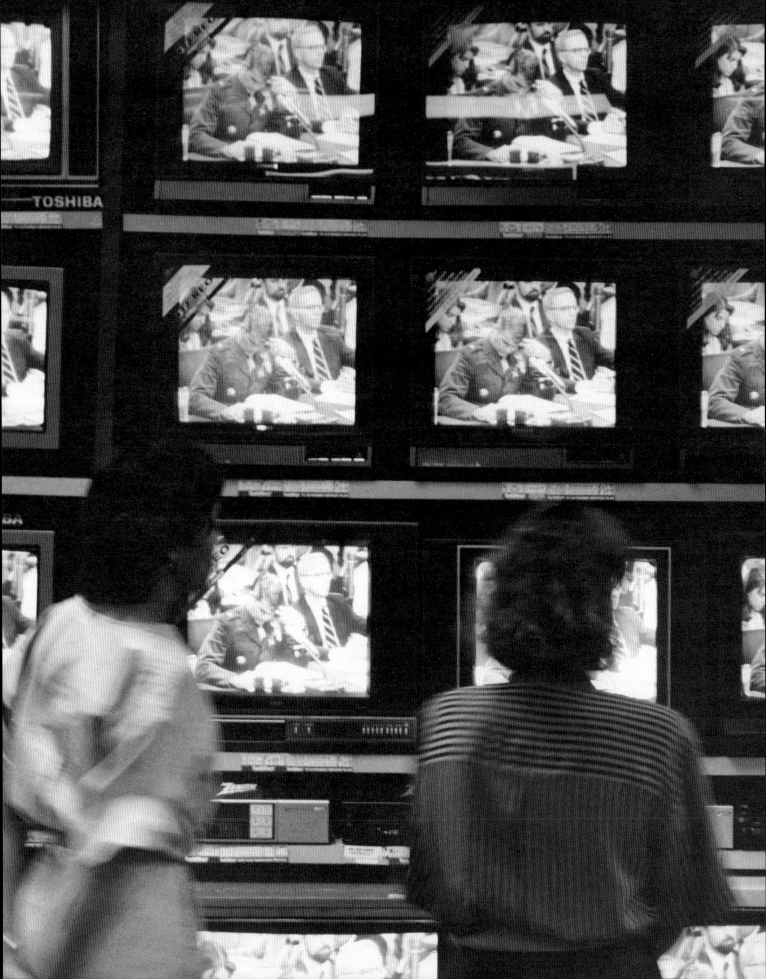

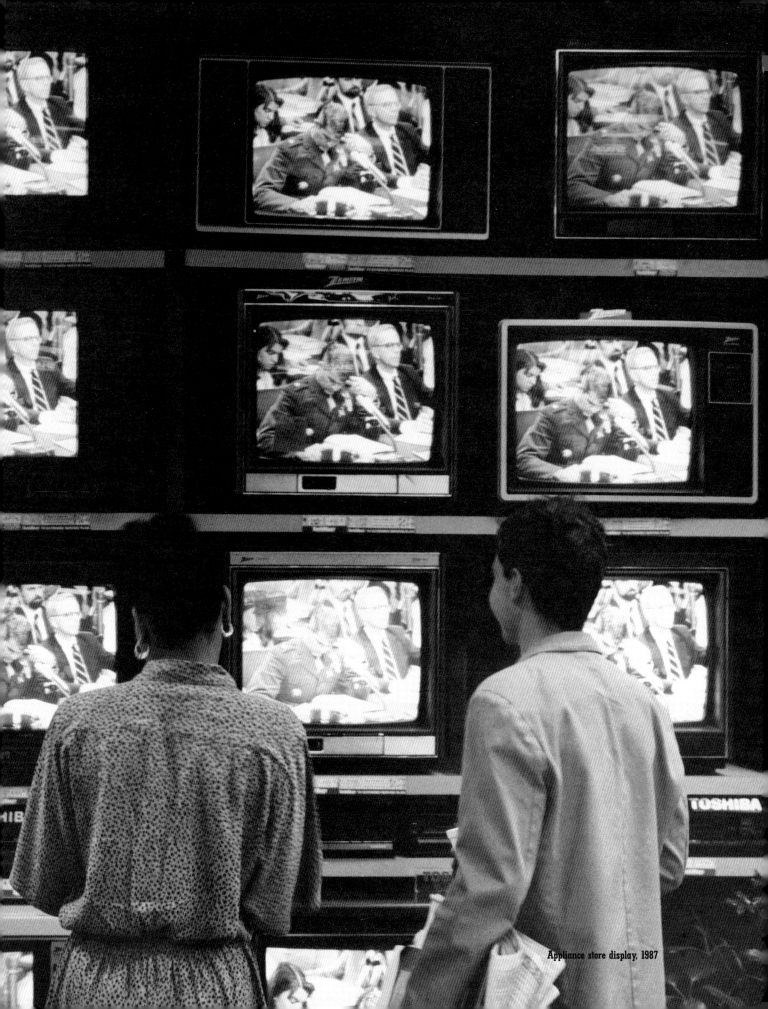

Appliance store display, 1987

Metamedia

Films and Videotapes in the Exhibition

Nam June Paik, *Global Groove*, 1973

The Twilight Zone

Showman

Sins of the Fleshapoids

Rowan and Martin's Laugh-In

The following checklist consists of documentaries, avant-garde films, artist's videotapes, and independent features that celebrate and critique the history, genres, styles, and institutions of broadcast television and Hollywood cinema.

Complementing the programs of independent films and videotapes are two additional surveys of works from 1960 to the present: one of broadcast television, including the key entertainment programs, news events, and documentaries from network television, public broadcasting, and cable; the other of Hollywood feature films that use self-referential strategies to reconsider the major film genres.

This four-part exhibition series will be presented in the Film/Video Gallery. The contributing consultants are: Paul Arthur (assistant professor of film and literature, Montclair State College), independent and Hollywood film; Lucinda Furlong (assistant curator, Film and Video, Whitney Museum of American Art), independent video; Ronald C. Simon (curator of television, The Museum of Broadcasting, New York), broadcast television.

1960

TV **The Twilight Zone** (1959–64), Rod Serling, creator and host
Route 66 (1960–64), Herbert B. Leonard, executive producer
CBS Reports: Harvest of Shame, Edward R. Murrow, reporter
Vice-President Richard Nixon and Senator John F. Kennedy debate

1961

🎥 **Cosmic Ray**, Bruce Conner

TV **ABC's Wide World of Sports** (1961–present), Roone Arledge, creator
Kovacs Specials (1961–62), Ernie Kovacs, writer, producer, and director
The Dick Van Dyke Show (1961–66), Carl Reiner, creator and executive producer

1962

🎥 **Blue Moses**, Stan Brakhage

☆ **The Man Who Shot Liberty Valance**, John Ford
The Errand Boy, Jerry Lewis
Two Weeks in Another Town, Vincente Minnelli

TV **The Tonight Show Starring Johnny Carson** (1962–present), Fred De Cordova, producer
A Tour of the White House with Mrs. John F. Kennedy, Franklin Schaffner, director
First transmission of images from the United States to Europe via Telstar I satellite

1963

🎥 **Scorpio Rising**, Kenneth Anger
Blonde Cobra, Ken Jacobs
Happy Mother's Day, Richard Leacock and Joyce Chopra
Showman, Albert Maysles and David Maysles
Flaming Creatures, Jack Smith
Blow Job, Andy Warhol
Kiss, Andy Warhol

TV **Crisis: Behind a Presidential Commitment**, Robert Drew and Associates, producers
The assassination and funeral of President John F. Kennedy
Civil Rights March on Washington led by Dr. Martin Luther King, Jr.

1964

🎥 **Point of Order!**, Emile de Antonio
Mass for the Dakota Sioux, Bruce Baillie
Breathdeath, Stan VanDerBeek

TV **That Was the Week That Was** (1964–65), Leland Hayward, executive producer

1965

🎥 **Fire of Waters**, Stan Brakhage
Sins of the Fleshapoids, Mike Kuchar
Meet Marlon Brando, Albert Maysles and David Maysles
Don't Look Back, D.A. Pennebaker

Bonnie and Clyde

Runaway

Videotape Study No. 3

The Mary Tyler Moore Show

1966

🎥 **The Secret Cinema**, Paul Bartel
The Flicker, Tony Conrad
Hold Me While I'm Naked, George Kuchar
Film in Which There Appear (Sprocket Holes, Edge Lettering, Dirt Particles, Etc.), Owen Land

☆ **What's Up, Tiger Lily?**, Woody Allen

📺 **Batman** (1966–68), William Dozier, executive producer
Mission: Impossible (1966–73), Bruce Geller, executive producer
The Monkees (1966–68), Robert Rafelson and Bert Schneider, producers

1967

🎥 **Report**, Bruce Conner
The Great Blondino, Robert Nelson
Lonesome Cowboys, Andy Warhol

☆ **Valley of the Dolls**, Mark Robson
Bonnie and Clyde, Arthur Penn

📺 **The Smothers Brothers Comedy Hour** (1967–69), Saul Ilson, Ernest Chambers, Chris Bearde, and Allan Blye, producers
Our World, Robert Squier, executive producer
Dragnet (1967–70), Jack Webb, producer, director, and actor

1968

🎥 **OffOn**, Scott Bartlett
The Director and His Actor Look at Footage Showing Preparations for an Unmade Film, Morgan Fisher
Columbia Revolt, Newsreel collective
T,O,U,C,H,I,N,G, Paul Sharits
Know Your Enemy—The Vietcong, United States Army

☆ **Targets**, Peter Bogdanovich
The Party, Blake Edwards

📺 **Black Journal** (1968–77), William Greaves and Tony Brown, executive producers

Gimme Shelter

60 Minutes (1968–present), Don Hewitt, executive producer
Rowan and Martin's Laugh-In (1968–73), George Schlatter, executive producer
Coverage of the 1968 Democratic convention

1969

🎥 **In the Year of the Pig**, Emile de Antonio
Moon 1969, Scott Bartlett
Reverberation, Ernie Gehr
Tom, Tom, the Piper's Son, Ken Jacobs
Institutional Quality, Owen Land
Runaway, Standish Lawder
Rape, Yoko Ono and John Lennon
Electronic Moon No. 2, Nam June Paik and Jud Yalkut
Frame, Richard Serra

☆ **Putney Swope**, Robert Downey
The Comic, Carl Reiner
Who's That Knocking at My Door?, Martin Scorsese
Medium Cool, Haskell Wexler

🜨 **Videotape Study No. 3**, Nam June Paik and Jud Yalkut
The Medium Is the Medium, WGBH-TV, Boston

📺 **Sesame Street** (1969–present), Joan Ganz Cooney, creator
Coverage of lunar landing during the Apollo 11 voyage

1970

🎥 **Hiroshima—Nagasaki, August 1945**, Erik Barnouw and Paul Ronder
Production Stills, Morgan Fisher
Zorns Lemma, Hollis Frampton
Remedial Reading Comprehension, Owen Land
Dangling Participle, Standish Lawder
Horseopera, Charles Levine
The Liberal War, Nick MacDonald
Gimme Shelter, Albert Maysles, David Maysles, and Charlotte Zwerin
David Holzman's Diary, Jim McBride
Bleu Shut, Robert Nelson

195

All in the Family

Animation I

Adland

The Day of the Locust

☆ **M*A*S*H**, Robert Altman
Alex in Wonderland, Paul Mazursky

⊕ **Mayday Realtime**, David Cort

📺 **The Mary Tyler Moore Show** (1970–77), James
L. Brooks and Allan Burns, executive producers
Hollywood Television Theatre (1970–78),
Lewis Freedman and Norman Lloyd,
executive producers
The World of Charlie Company, Ernest Leiser,
executive producer

1971

🎥 **Millhouse: A White Comedy**, Emile de Antonio
Microcultural Incidents in Ten Zoos, Ray Birdwhistell
and Jacques D. Van Vlack
Televisionland, Charles Braverman
Runs Good, Pat O'Neill
Newsreel of Dreams (Parts I and II),
Stan VanDerBeek

☆ **McCabe and Mrs. Miller**, Robert Altman
Sweet Sweetback's Baadasssss Song,
Melvin van Peebles

⊕ **I Will Not Make Any More Boring Art**,
John Baldessari
Media Primer, Raindance Corporation,
edited by Michael Shamberg

📺 **CBS Reports: The Selling of the Pentagon**,
Peter Davis, writer and producer
All in the Family (1971–79), Norman Lear, creator
and executive producer
Banks and the Poor, Alvin H. Perlmutter,
executive producer
The Great American Dream Machine (1971–72),
Alvin H. Perlmutter, executive producer

1972

🎥 **Moment**, Bill Brand
Gulls and Buoys, Robert Breer
Hapax Legomena, Hollis Frampton
Reminiscences of a Journey to Lithuania,
Jonas Mekas

Red Squad, Pacific St. Film Collective
Lives of Performers, Yvonne Rainer

☆ **The Last Movie**, Dennis Hopper
Maidstone, Norman Mailer
Pink Flamingos, John Waters

⊕ **Undertone**, Vito Acconci
Scapemates, Ed Emshwiller
Vertical Roll, Joan Jonas
The Selling of New York, Nam June Paik
Selected Body Works, William Wegman

📺 **M*A*S*H** (1972–83), Gene Reynolds and Larry
Gelbart, original producers
Four More Years, TVTV (Top Value Television)
producers

1973

🎥 **No Lies**, Mitchell Block
Five Times Marilyn, Bruce Conner
Ganja and Hess, Bill Gunn
Speaking Directly: Some American Notes, Jon Jost

☆ **The Long Goodbye**, Robert Altman

⊕ **Three Transitions**, Peter Campus
Global Groove, Nam June Paik
Television Delivers People, Richard Serra
Animation I, Keith Sonnier

📺 **An American Family**, Craig Gilbert,
creator and producer
Adland, TVTV (Top Value Television), producers

1974

🎥 **Pasadena Freeway Stills**, Gary Beydler
Cue Rolls, Morgan Fisher
The Print Generation, J.J. Murphy

☆ **Phantom of the Paradise**, Brian de Palma
Andy Warhol Presents Flesh for Frankenstein,
Paul Morrissey
That's Entertainment, Jack Haley, Jr.

⊕ **Cuba: The People**, Jon Alpert, Keiko Tsuno,
and Yoko Maruyama
The Matter, Woody Vasulka

The Eternal Frame

The Rocky Horror Picture Show

Take the 5:10 to Dreamland

Raw Nerves: A Lacanian Thriller

The Rockford Files (1974–80), Stephen J. Cannell and Roy Higgins, creators
Lord of the Universe, TVTV (Top Value Television), producers
Watergate impeachment hearings — President Nixon's resignation

1975

Eadweard Muybridge, Zoopraxographer, Thom Andersen
Studies in Chronovision, Louis Hock

☆ **Farewell, My Lovely**, Dick Richards
The Day of the Locust, John Schlesinger
The Rocky Horror Picture Show, Jim Sherman
Hearts of the West, Howard Zieff

Media Burn, Ant Farm (Chip Lord, Doug Michels, Curtis Schreier)
The Tube and the Eye, Peter Crown and Bill Etra
The Eternal Frame, T.R. Uthco (Doug Hall, Jody Proctor, Diane Hall) and Ant Farm

Saturday Night Live (1975–present), Lorne Michaels, creator and executive producer

1976

Projection Instructions, Morgan Fisher
Metro-Goldwyn-Mayer, Jack Goldstein
Viewmaster, George Griffin
Sidewinder's Delta, Pat O'Neill
Tails, Paul Sharits

☆ **Silent Movie**, Mel Brooks
Inserts, John Bynum
Network, Sidney Lumet
Deal, E.J. Vaughn and John Schott

Greetings from Lanesville, Media Bus

Mary Hartman, Mary Hartman (1976–78), Norman Lear, executive producer
On Location: Steve Martin
The Police Tapes, Alan and Susan Raymond, producers and directors
Coverage of the Bicentennial Celebration

Saturday Night Live

1977

Inside Broadcasting, Karen Back
Take the 5:10 to Dreamland, Bruce Conner
Angel City, Jon Jost
Frame, Ken Kobland
I, An Actress, George Kuchar

☆ **New York, New York**, Martin Scorsese

Chris Burden Promotion, Chris Burden
Full Financial Disclosure, Chris Burden
Documenta 6 Satellite Telecast, Nam June Paik, Joseph Beuys, and Douglas Davis
About Media, Tony Ramos
How TV Works, Dan Sandin
Birth of an Industry, TVTV (Top Value Television)
Objects, Steina Vasulka and Woody Vasulka

1978

(A)Drift of Politics, Dara Birnbaum
LMNO, Robert Breer
Mongoloid, Bruce Conner
The Doctor's Dream, Ken Jacobs
Charmed Particles (Part IV from the series, **The Adventures of the Exquisite Corpse**), Andrew Noren
Foregrounds, Pat O'Neill
Sappho and Jerry, Bruce Posner
Filming Othello, Orson Welles

☆ **Hardcore**, Paul Schrader

Technology/Transformation: Wonder Woman, Dara Birnbaum
Frankie Teardrop, Paul Dougherty, Walter Robinson, and Edit de AK

Dallas (1978–present), Philip Capice, Lee Rich, Leonard Katzman, and Larry Hagman, executive producers

1979

Grand Opera, James Benning
Valse Triste, Bruce Conner
Gloria!, Hollis Frampton
Eureka, Ernie Gehr

197

Smothering Dreams　　　*The King of Comedy*　　　*U.S. Sweat / Sign Off*　　　*Videodrome*

The War at Home, Glen Silber and
Alexander Brown
Loose Ends, Chick Strand

☆ **Real Life**, Albert Brooks

Ⓐ **Sunstone**, Ed Emshwiller
Interpolation, Kit Fitzgerald and John Sanborn
The Marshall Klugman Show, Mitchell Kriegman

1980

Ⓧ **Raw Nerves: A Lacanian Thriller**, Manuel DeLanda
Demon Lover Diary, Joel DeMott
Life Dances On, Robert Frank

☆ **Airplane!**, Jim Abrahams, Jerry Zucker,
and David Zucker
The Stunt Man, Richard Rush

Ⓐ **Third Avenue: Only the Strong Survive**, Jon Alpert
and Keiko Tsuno
Towards A New World Information Order, produced
by Liza Bear, Communications Update
Pop-Pop Video: Kojak/Wang, Dara Birnbaum
Olympic Fragments, Kit Fitzgerald and John
Sanborn
Freedom of Information Tape 1: Jean Seberg,
Margia Kramer
The Amarillo News Tapes, Chip Lord, Doug Hall,
and Jody Procter
Instant This: Instant That, Twin Art
(Ellen and Lynda Kahn)

Ⓣ **Nightline** (1980–present), Ted Koppel, anchor
US vs. USSR Olympic Hockey Game at the XIII
Winter Olympic Games

1981

Ⓧ **Murder Psalm**, Stan Brakhage
Not a Love Story, Bonnie Klein
**On the Marriage Broker Joke As Cited by Sigmund
Freud in Wit and Its Relation to the Unconscious or
Can the Avant-Garde Artist be Wholed?**, Owen Land

☆ **Halloween II**, Rick Rosenthal
S.O.B., Blake Edwards
Pennies from Heaven, Herbert Ross

Ⓐ **Some of These Stories Are True**, Peter Adair
O Superman, Laurie Anderson
Casual Shopper, Judith Barry
Pick Up Your Feet: The Double-Dutch Show,
Skip Blumberg
The Looking Glass, Juan Downey
Cindy Sherman: An Interview, MICA-TV
(Carol Ann Klonarides and Michael Owen)
**Herb Schiller Reads The New York Times—712
Pages of Waste: The Sunday Times**,
Paper Tiger Television
Smothering Dreams, Dan Reeves

Ⓣ **Hill Street Blues** (1981–87), Steven Bochco,
Michael Kozoll, Gregory Hoblit, and Anthony
Yerkovich, executive producers
SCTV Network (1981–84), John Candy, Andrea
Martin, Catherine O'Hara, Robin Duke, Joe
Flaherty, Eugene Levy, Dave Thomas, Rick
Moranis, Tony Rosato, Martin Short, and
Eugenie Ross-Leming, writers and performers
Dynasty (1981–89), Aaron Spelling, Douglas
Cramer, Richard and Esther Shapiro,
executive producers
Attempted assassination of President Reagan
Premier of MTV (Music Television)

1982

Ⓧ **Da Fort**, Rob Danielson
Illusions, Julie Dash
The Atomic Cafe, Kevin Rafferty, Jayne Loader,
and Pierce Rafferty
Filmmaker: A Diary, George Lucas
Born to Film, Danny Lyon

☆ **My Favorite Year**, Richard Benjamin
Poltergeist, Tobe Hooper
The King of Comedy, Martin Scorsese

Ⓐ **Disarmament Video Survey**, Skip Blumberg,
project director
Ear to the Ground, Kit Fitzgerald and John Sanborn

Perfect Lives

A Simple Case for Torture, or How to Sleep at Night

The Cosby Show

Peggy and Fred in Hell, the Prologue

Windfalls: New Thoughts on Thinking, Matthew Geller
U.S. Sweat/Sign Off, Shalom Gorewitz
The Very Reverend Deacon b. Peachy, Milli Iatrou and Ron Morgan, Communications Update
30-Second Spots, Joan Logue
It Starts at Home, Michael Smith

📺 **St. Elsewhere** (1982–88), Bruce Paltrow, executive producer
Late Night with David Letterman (1982–present), Jack Rollins and David Letterman, executive producers
CBS Reports: The Uncounted Enemy: A Vietnam Deception, George Crile, producer

1983

🎥 **Born in Flames**, Lizzie Borden
Variety, Bette Gordon
Adynata: Murder Is Not a Story, Leslie Thornton

☆ **Zelig**, Woody Allen
Videodrome, David Cronenberg

⊛ **Perfect Leader**, Max Almy
It's a Dictatorship, Eat!, Carlos Anzaldua
Perfect Lives: The Bank, Robert Ashley
The Live! Show, Jaime Davidovich
Bill Boddy Reminds the FCC of the Telecommunications Act of 1934, Paper Tiger Television
Brian Winston Reads TV Guide: Journal of the Wasteland, Paper Tiger Television
A Simple Case for Torture, or How to Sleep at Night, Martha Rosler
Why I Got into TV and Other Stories, Ilene Segalove

📺 **Andy Warhol's TV**, Vincent Fremont, producer
Special Bulletin, Don Ohlmeyer, executive producer

1984

🎥 **Routine Pleasures**, Jean-Pierre Gorin
Standard Gauge, Morgan Fisher
Committed, Sheila McLaughlin and Lynne Tillman
Frame Line, Gunvor Nelson

☆ **Repo Man**, Alex Cox

⊛ **Social Studies, Part 2: Academy**, Lyn Blumenthal
Face Fear and Fascination, Tony Cokes
The Double, Ken Feingold
Why Do Things Get in a Muddle? (Come on Petunia), Gary Hill
Political Advertisement: 1954–1984, Antonio Muntadas and Marshall Reese
Good Morning, Mr. Orwell, Nam June Paik
Race against Prime Time, David Shulman
Go for It, Mike, Michael Smith
Reverse Television—Portraits of Viewers, Bill Viola
Uh-Oh Plutonium!, Ann Waldman
Vault, Bruce Yonemoto and Norman Yonemoto

📺 **The Cosby Show** (1984–present), Marcy Carsey, Tom Werner, and Earl Pomerantz, executive producers
Miami Vice (1984–89), Michael Mann and Anthony Yerkovich, executive producers

1985

🎥 **Peggy and Fred in Hell, the Prologue**, Leslie Thornton

⊛ **Interviews with Interviewers**, Skip Blumberg
Made for TV, Ann Magnusun and Tom Rubnitz
If It's Too Bad To Be True, It Could Be DISINFORMATION, Martha Rosler
Two Moon July, produced by Carlota Schoolman

📺 **Moonlighting** (1985–89), Glenn Gordon Caron, executive producer
Alive from Off Center (1985–present), Melinda Ward and John Schott, executive producers
Live Aid concert

199

1986

🎥 **The Family Album**, Alan Berliner
Bang!, Robert Breer
No No Nooky T.V., Barbara Hammer
Thy Kingdom Come, Thy Will Be Done, Anthony Thomas
Precious Images, Chuck Workman

Damned If You Don't

Production Notes: Fast Food for Thought

Endangered

Who Framed Roger Rabbit?

Joan Does Dynasty, Joan Braderman,
Paper Tiger Television
My TV Dictionary: The Helicopter, Hans Breder
Racism on Main Street: A Look Around Your Corner,
produced by Shu Lea Cheang and Roy Wilson,
Deep Dish TV
Buzz Box, David Daniels
Reggie's World of Soul, Reginald Hudlin
Bombs Aren't Cool, Joan Jubela and Stan Davis
Scenes from the Micro-War, Sherry Millner
Bye Bye Kipling, Nam June Paik
I Do Not Know What It Is I Am Like, Bill Viola

Pee-wee's Playhouse (1986–present), Paul Reubens,
executive producer
Coverage of the Space Shuttle Challenger disaster

1987

I Ride a Pony Named Flame, Peggy Ahwesh
Mayhem (Part 6 from the series, Is This What You
were Born For?), Abigail Child
Damned If You Don't, Su Friedrich
Her Fragrant Emulsion, Lewis Klahr

☆ Broadcast News, James Brooks

The Philippines: Life Death and Revolution,
Jon Alpert and Keiko Tsuno
Superstar: The Karen Carpenter Story, Todd Haynes
Cross-Cultural TV, Antonio Muntadas and
Hank Bull
Judith Williamson Consumes Passionately in Southern
California, Paper Tiger Television
Ethnic Notions, Marlon Riggs
Production Notes: Fast Food for Thought, Jason Simon
Hitchcock Trilogy: Vertigo, Psycho, Torn Curtain,
Rea Tajiri
Testing the Limits, The Testing the Limits
Collective (Gregg Bordowitz, Jean Carlomusto,
Sandra Elgear, Robin Hutt, Hilery Joy Kipnis)
Art of Memory, Woody Vasulka

The Tracey Ullman Show (1987–present),
Jerry Belson, James L. Brooks, Heide Perlman,
and Ken Estin, executive producers

thirtysomething (1987–present),
Marshall Herskovitz and Edward Zwick,
co-creators and executive producers

1988

Lightning Over Braddock: A Rustbowl Fantasy,
Tony Buba
Endangered, Barbara Hammer

☆ Who Framed Roger Rabbit?, Robert Zemeckis

An I for an I, Lawrence Andrews
Seize Control of the FDA, Gregg Bordowitz
and Jean Carlomusto
30 Second Spot/Reconsidered, Joan Braderman
Doctors, Liars, and Women, Jean Carlomusto
and Maria Maggenti
Free Society, Paul Garrin
Albert Pastor's First Video Project, Juan Garza
and Daniel Villareal
AIDS News: A Demonstration, Robert Huff
The Bombing of Osage Avenue, Louis Massiah
Joyride™, Tony Oursler and Constance DeJong
Born to Be Sold: Martha Rosler Reads the Strange
Case of Baby S M, Martha Rosler,
Paper Tiger Television

America's Most Wanted (1988–present),
John Walsh, host
The Wonder Years (1988–present), Carol Black and
Neal Marlens, co-creators

1989

"Out"takes, John Goss
They Are Lost to Vision Altogether, Tom Kalin
Desperately Seeking Reality: Herb Schiller Reads
Trash TV, Paper Tiger Television
The Man in the Mirror, Aimee Rankin
Everyone's Channel, David Shulman

Coverage of student protest in Tiananmen Square,
Beijing, China

The Tracey Ullman Show

Two Weeks in Another Town

The Reverend Dr. Robert Schuller's "Hour of Power," Crystal Cathedral, California, 1987

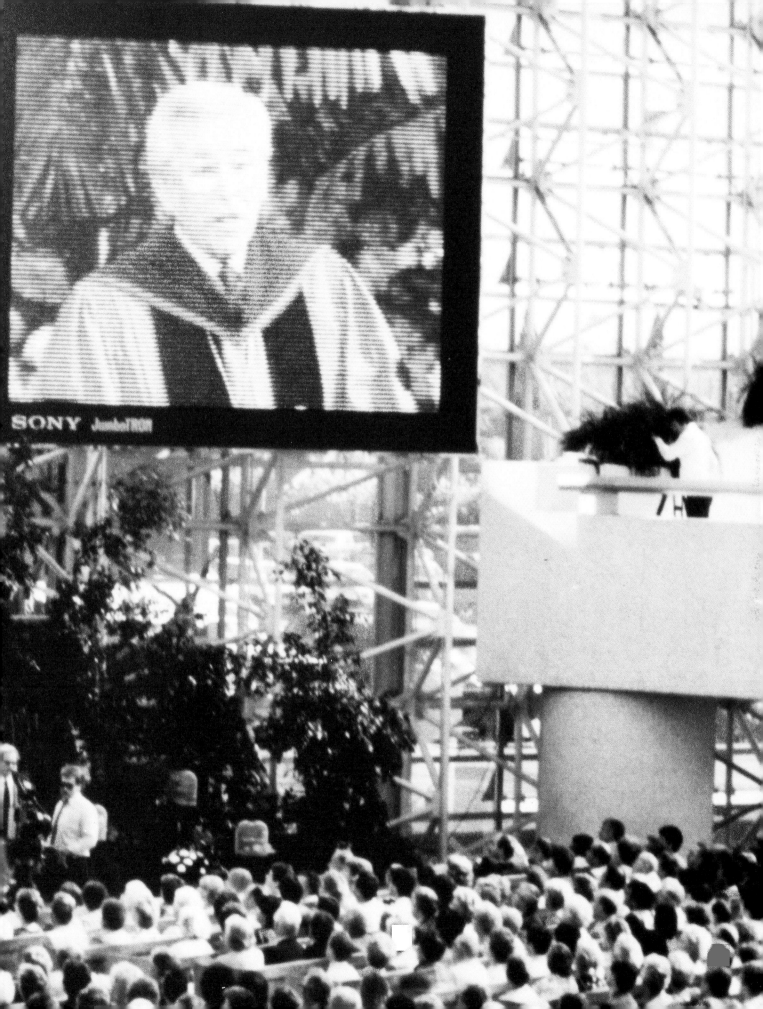

Works in the Exhibition

Dimensions are in inches, followed by centimeters; height precedes width precedes depth; page numbers refer to the location of illustrations.

Vito Acconci (b. 1940)

Coming to Rest, 1969
4 gelatin silver prints, chalk, chalkboard spray, marker, and text on foam-core panels,
64 x 48 (162.6 x 121.9)
Brooke Alexander Gallery, New York (p. 84)

Dennis Adams (b. 1948)

Ticket Booth, 1989
Installation, 67½ x 142½ x 91½
(171.5 x 362 x 232.4)
Kent Fine Art, New York (p. 206)

Laurie Anderson (b. 1947)

September 20, New York Times, Horizontal/China Times, Vertical, 1971–79
Woven newsprint, 30 x 22 (76.2 x 55.9)
Holly Solomon Gallery, New York (p. 81)

New York Times, Horizontal/China Times, Vertical (1971), 1976
Woven newsprint, 22½ x 14½ (57.2 x 36.8)
Holly Solomon Gallery, New York

John Baldessari (b. 1931)

An Artist Is Not Merely the Slavish Announcer, 1966–68
Acrylic and photoemulsion on canvas,
89 x 45 (226.1 x 114.3)
Collection of the artist; courtesy
Sonnabend Gallery, New York (p. 49)

A Movie: Directional Piece Where People Are Looking, 1972–73
28 gelatin silver prints, 3½ x 5 (8.9 x 12.7) each; overall dimensions variable
Jedermann Collection, N.A., Princeton, New Jersey
(p. 85)

Two Stories, 1987
Gelatin silver prints and chromogenic color prints (C-prints) with acrylic and oil,
96 x 51 (243.8 x 129.5)
Collection of Dakis Joannou (p. 136)

William Beckley (b. 1946)

Deirdre's Lip, 1979
Silver dye bleach print (Cibachrome),
90 x 160 (228.6 x 406.4)
Collection of Edward R. Downe, Jr. (p. 86)

Gretchen Bender (b. 1951)

T.V. Text and Image, 1989
Nine 13″ television sets, with silkscreen on acetate and metal shelves; TVs, 15 x 20 x 15 (38.1 x 50.9 x 38.1) each; 96 x 96 (243.8 x 243.8) overall
Metro Pictures, New York (p. 162)

Wallace Berman (1926–1976)

Untitled (Chesterfield People), 1964
Verifax collage, 12 ⅝ x 9½ (32.2 x 24.1)
James Corcoran Gallery, Los Angeles (p. 48)

Untitled, 1967
Verifax collage, 49¼ x 46½ (125.1 x 118.1)
The Grinstein Family Collection

Ashley Bickerton (b. 1959)

Commercial Piece No. 2, 1989
Mixed-media construction, 75 x 102 x 20
(190.5 x 259.1 x 50.8)
Sonnabend Gallery, New York (p. 168)

Dara Birnbaum (b. 1946)

P.M. Magazine, 1982–89
5-channel color video with 6-channel sound,
2 gelatin silver print enlargements, and painted walls, dimensions variable
The Israel Museum, Jerusalem; Collection of the American Friends of The Israel Museum (pp. 126–127)

Nayland Blake (b. 1960)

Schatzman Hallucination Guide, 1989
Silkscreen on blackboard, 18 x 24 (45.7 x 61)
Collection of Richard Kuhlenschmidt (p. 170)

Barbara Bloom (b. 1951)

Confession to Godard, 1987
Mixed-media installation, dimensions variable
Collection of F.C. Gundlach (p. 140)

Troy Brauntuch (b. 1954)

Untitled, 1982
Graphite on canvas, 96 x 68 (243.8 x 172.7)
Speyer Family Collection (p. 132)

**Winston advertisement, New York,
1974**

Dennis Adams, *Ticket Booth*, 1989

Chris Burden (b. 1946)

Man of the Seventies, 1975
Collage on paper, 30 x 40 (76.2 x 101.6)
Galerie 1900-2000, Paris; courtesy Josh Baer
Gallery, New York, and Kent Fine Art, New York

CBTV, 1977
2 synchronous motors, lens, photoelectric cell,
and 2 disks; disks, 32 (81.3) diameter each;
overall dimensions variable
Collection of the artist; courtesy
Kent Fine Art, New York (p. 128)

Breakthrough, 1982
Collage on paper with metal, 31½ x 39½
(80 x 100.3)
Collection of Nicole Klagsbrun; courtesy
Kent Fine Art, New York, and Josh Baer Gallery,
New York

Nancy Burson (b. 1948) and
David Kramlich (b. 1954)

The Composite Machine, 1988–89
Interactive portrait compositor, consisting of a
computer, video camera, frame buffer, and video
monitor, 54 x 24 x 48 (137.2 x 61 x 122)
Face Software Inc., New York; courtesy
Jayne H. Baum Gallery, New York (p. 163)

Peter Campus (b. 1937)

aen, 1977
Video installation with camera and projector,
240 x 180 (609.6 x 457.2)
Paula Cooper Gallery, New York (p. 79)

Sarah Charlesworth (b. 1947)

Herald Tribune/Sept. 1977, 1977
26 photostats, 16½ x 22½ (41.9 x 57.2) each
Jedermann Collection, N.A., Princeton, New Jersey
(p. 68)

Bird Woman, 1986
Silver dye bleach print (Cibachrome),
40 x 30 (101.6 x 76.2)
The Arthur and Carol Goldberg Collection
(p. 154)

Bull, 1986
Silver dye bleach print (Cibachrome),
40 x 30 (101.6 x 76.2)
Collection of Liz Koury (p. 155)

John Clem Clarke (b. 1937)

Peyton Place Credits, 1968
Oil on canvas, 72 x 96 (182.9 x 243.8)
Collection of the artist; courtesy
Louis K. Meisel Gallery, New York (p. 51)

Clegg and Guttmann

Michael Clegg (b. 1957) and
Martin Guttman (b. 1957)
Our Production — The Production of Others, 1986
Silver dye bleach print (Cibachrome),
120 x 120 (304.8 x 304.8)
Jay Gorney Modern Art, New York (p. 141)

Chuck Close (b. 1940)

Phil, 1969
Synthetic polymer on canvas, 108 x 84 (274.3 x 213.4)
Whitney Museum of American Art, New York;
Purchase, with funds from Mrs. Robert
M. Benjamin 69.102 (p. 55)

Bruce Conner (b. 1933)

Untitled, 1954–62
Collage on masonite, 64 x 50 x 3
(162.6 x 127 x 7.6)
Collection of Robert Shapazian (pp. 36, 37)

Robert Cumming (b. 1943)

Backyard flat; the "Nancy Drew" Series sets, stage #29,
from the series *Studio Still Lifes*, 1977
Gelatin silver print, 11 x 14 (27.9 x 35.6)
Castelli Graphics, New York

*Drugstore and street; feature film, "The Great Gift,"
stage #12*, from the series *Studio Still Lifes*, 1977
Gelatin silver print, 11 x 14 (27.9 x 35.6)
Castelli Graphics, New York

*Gap between set and painted backdrop; feature film, "It's a
Wonderful Life," stage #12*, from the series *Studio
Still Lifes*, 1977
Gelatin silver print, 11 x 14 (27.9 x 35.6)
Castelli Graphics, New York

*Marble Staircase; serialized Movie for TV, "Rich Man,
Poor Man," stage #37*, from the series *Studio
Still Lifes*, 1977
Gelatin silver print, 11 x 14 (27.9 x 35.6)
Castelli Graphics, New York

*Sacramento Arms motel court looking out on sternwheeler
and Western sets*, from the series *Studio Still Lifes*, 1977
Gelatin silver print, 11 x 14 (27.9 x 35.6)
Castelli Graphics, New York

*Shark fin atop pneumatic underwater sled; feature film,
"Jaws 2"*, from the series *Studio Still Lifes*, 1977
Gelatin silver print, 11 x 14 (27.9 x 35.6)
Castelli Graphics, New York (p. 83)

Fluxus Collective

Fluxus cc V TRE Fluxus (Fluxus Newspaper No. 1),
January 1964
Edited by George Brecht and the
Fluxus Editorial Council
Offset print on newsprint, 23 x 18 (58.5 x 45.7)
The Gilbert and Lila Silverman Fluxus Collection

Fluxus cc V TRE Fluxus (Fluxus Newspaper No. 2),
February 1964
Edited by George Brecht and the
Fluxus Editorial Council
Offset print on newsprint, 22½ x 17½ (57.2 x 44.5)
The Gilbert and Lila Silverman Fluxus Collection
(p. 63)

Fluxus cc fiVe ThReE (Fluxus Newspaper No. 4),
June 1964
Edited by the Fluxus Editorial Council
Offset print on newsprint, 23 x 18 (58.5 x 45.7)
The Gilbert and Lila Silverman Fluxus Collection

George Brecht (b. 1926), **Alison Knowles** (b. 1933),
and **Robert Watts** (1923–1988)

Blink Stamps, 1963
Offset print on gummed and perforated paper,
6 x 6½ (15.6 x 16.6)
The Gilbert and Lila Silverman Fluxus Collection

George Maciunas (1931–1978)

Fluxpost (Smiles), 1978
Offset print on gummed and perforated paper,
11 x 8½ (27.9 x 21.6)
The Gilbert and Lila Silverman Fluxus Collection

Robert Watts (1923–1988)

Yamflug/5 Post 5 Collage, 1963
Collage, with photostat and ink,
21 x 35 (54.5 x 88)
The Gilbert and Lila Silverman Fluxus Collection
(p. 53)

Stamp Machine, c. 1965 and 1982
Metal, paint, and glass, with offset print on
gummed paper, cardboard, and coins,
17½ x 8 x 6⅝ (44.5 x 20.8 x 17)
The Gilbert and Lila Silverman Fluxus Collection
(p. 53)

McLuhan Sweatshirt, c. 1967
Silkscreen on cloth
The Gilbert and Lila Silverman Fluxus Collection
(p. 184)

Jack Goldstein (b. 1945)

Untitled, 1984
Acrylic on canvas, 72 x 72 (182.9 x 182.9)
Collection of W.J. Hergenrader (p. 129)

Dan Graham (b. 1942)

Figurative, in *Harper's Bazaar*, March 1965, p. 90
Harper's Bazaar, New York (p. 66)

Gran Fury

Kissing Doesn't Kill: Greed and Indifference Do, 1989
Silkscreen on 3 panels, 30 x 144 (76.2 x 365.8)
Art Against Aids/On The Road (a project of
AmFAR) and Creative Time, Inc., New York
(pp. 166–167)

Hans Haacke (b. 1936)

The Right to Life, 1979
Silkscreen on chromogenic color print (C-print),
50¼ x 40¼ (127.6 x 102.2)
The Gilbert and Lila Silverman Collection
(p. 87)

Robert Heinecken (b. 1931)

Periodical #5, February 1971, #1 of 6, 1971
Altered magazine and offset lithograph,
11 x 16 (27.9 x 40.6)
Collection of the artist; courtesy
Pace/MacGill Gallery, New York (p. 78)

Periodical #5, February 1971, #5 of 6, 1971
Altered magazine and offset lithograph,
11 x 8 (27.9 x 20.3)
Collection of the artist; courtesy
Pace/MacGill Gallery, New York

Jenny Holzer (b. 1950)

Selection from *The Living Series*, 1980–82
Cast bronze, 8 x 10 (20.3 x 25.4)
Barbara Gladstone Gallery, New York

Five selections from *The Survival Series*, 1983–85
Cast aluminum, 6 x 10 (15.2 x 25.4) each
Barbara Gladstone Gallery, New York

Larry Johnson (b. 1959)

Untitled (All), 1987
Chromogenic color print (C-print),
40 x 40 (101.6 x 101.6)
Collection of Richard Prince; courtesy
303 Gallery, New York (p. 165)

Untitled (Black Box), 1987
Chromogenic color print (C-print),
40 x 40 (101.6 x 101.6)
Private Collection; courtesy
303 Gallery, New York

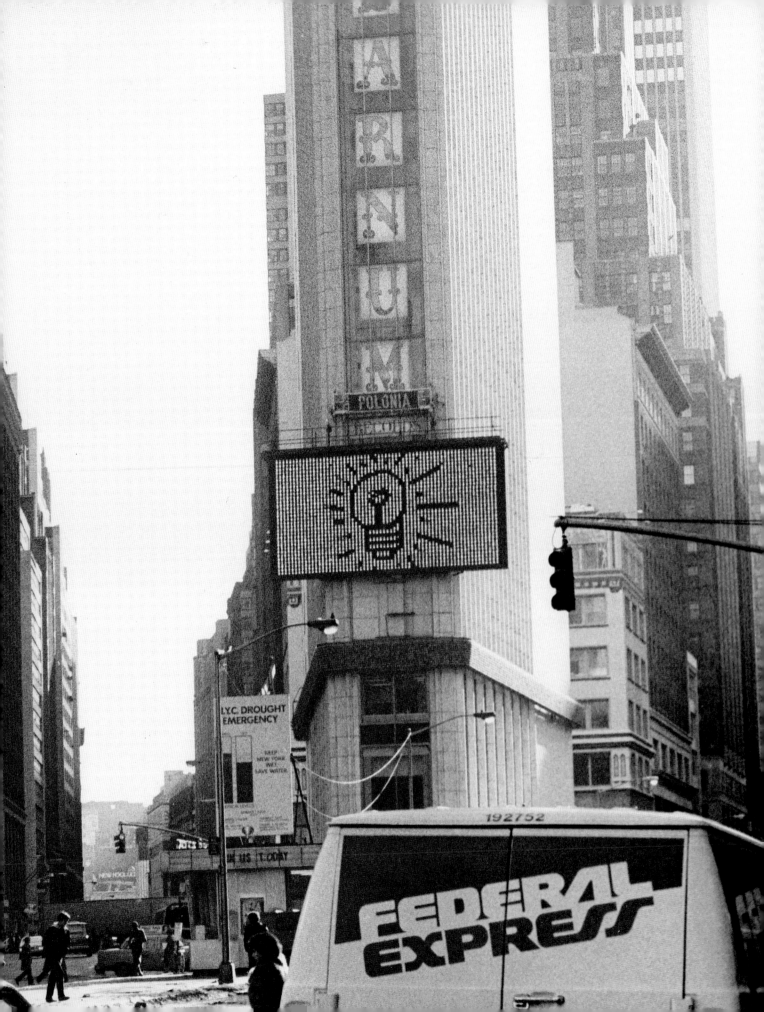

Untitled (Hard To Believe), 1987
Chromogenic color print (C-print),
40 x 40 (101.6 x 101.6)
Collection of Steve Salzman; courtesy
303 Gallery, New York

Untitled (I Hated That About You), 1987
Chromogenic color print (C-print),
40 x 40 (101.6 x 101.6)
Collection of Richard Flood; courtesy
303 Gallery, New York

Edward Kienholz (b. 1927)

TV 8301 W, 1967
Mixed media, 8 x 9½ x 11 (20.3 x 24.1 x 27.9)
Collection of Virginia Dwan (p. 54)

Carole Ann Klonarides (b. 1951)

Famous for 30 Seconds, Artists in the Media (excerpt),
1987
Single-channel video with sound
Lent by the artist (p. 146)

Silvia Kolbowski (b. 1953)

Here and There (excerpt), 1986–89
Mixed-media installation, 27 x 120 (68.6 x 304.8)
Collections of José Oubrerie, Cicely Wylde-
Oubrerie, and Julie Ault; courtesy Postmasters
Gallery, New York (p. 157)

Jeff Koons (b. 1955)

Bob Hope, 1986
Stainless steel, 17 x 5½ x 5 (43.2 x 14 x 12.7)
Sonnabend Collection (p. 69)

Louis XIV, 1986
Stainless steel, 46 x 27 x 15 (116.8 x 68.6 x 38.1)
Collection of Gerald S. Elliott (p. 153)

Michael Jackson and Bubbles, 1988–89
Porcelain, 42 x 70½ x 32½ (106.7 x 179.1 x 82.6)
Sonnabend Gallery, New York (p. 152)

Joseph Kosuth (b. 1945)

One and Three Photographs, 1965
3 gelatin silver prints, 22½ x 90⅛
(57.2 x 230.3) overall
Collection of the artist; courtesy
Leo Castelli Gallery, New York (p. 64)

Barbara Kruger (b. 1945)

*Untitled (Your moments of joy have the precision of
military strategy)*, 1980
Gelatin silver print, 40¼ x 50¼ (103.5 x 128.9)
Rhona Hoffman Gallery, Chicago

Untitled (Your manias become science), 1981
Gelatin silver print, 37 x 50 (94 x 127)
Collection of Dr. and Mrs. Peter Broido (p. 116)

Untitled (You are not yourself), 1983
Gelatin silver print, 72 x 48 (182.9 x 121.9)
Collection of Edward R. Downe, Jr. (p. 117)

Annette Lemieux (b. 1957)

The Ascension, 1986
Typewriter and gelatin silver prints,
192 x 13 x 12 (487.7 x 33 x 30.5)
Collection of Dakis Joannou (p. 137)

The Power of Flight, 1989
Latex paint on canvas, 122 x 79 (309.9 x 200.7)
The Israel Museum, Jerusalem; Collection of the
American Friends of The Israel Museum, gift of
Phyllis Goldman

Les Levine (b. 1935)

We are Not Afraid, 1979
3 photo offsets, 21 x 21 (53.3 x 53.3) each
Museum of Mott Art, New York (pp. 92, 93)

Sherrie Levine (b. 1947)

Untitled (President: 1), 1979
Collage on paper, 24 x 18 (61 x 45.7)
Collection of the artist; courtesy
Mary Boone Gallery, New York (p. 67)

Untitled (President: 2), 1979
Collage on paper, 24 x 18 (61 x 45.7)
Collection of the artist; courtesy
Mary Boone Gallery, New York (p. 90)

Untitled (President: 3), 1979
Collage on paper, 24 x 18 (61 x 45.7)
Collection of the artist; courtesy
Mary Boone Gallery, New York (p. 91)

Untitled (President: 4), 1979
Collage on paper, 24 x 18 (61 x 45.7)
Collection of the artist; courtesy
Mary Boone Gallery, New York

Untitled (President: 5), 1979
Collage on paper, 24 x 18 (61 x 45.7)
Collection of the artist; courtesy
Mary Boone Gallery, New York

Roy Lichtenstein (b. 1923)

Image Duplicator, 1963
Magna on canvas, 24 x 20 (61 x 50.8)
Collection of David Lichtenstein (p. 44)

Keith Haring, Spectacolor Board,
Times Square, New York, 1982

Robert Longo (b. 1953)

Untitled (Men in the Cities), 1980
Charcoal and graphite on paper,
108 x 60 (274.3 x 152.4)
Collection of Brooke and Carolyn Alexander
(p. 115)

Untitled (Men in the Cities), 1980
Charcoal and graphite on paper,
108 x 60 (274.3 x 152.4)
Collection of Jerry and Emily Spiegel (p. 114)

Frank Majore (b. 1948)

Blue Martinis, 1983
Silver dye bleach print (Cibachrome),
20 x 16 (50.8 x 40.6)
Collection of the artist (p. 142)

Hornet's Nest, 1985
Silver dye bleach print (Cibachrome),
24 x 20 (61 x 50.8)
Collection of the artist

Crimson Splendor, 1987
Silver dye bleach print (Cibachrome),
60 x 48 (152.4 x 121.9)
Holly Solomon Gallery, New York (p. 143)

Allan McCollum (b. 1944)

Perpetual Photo (No. 126B), 1982–86
Toned gelatin silver print, 43 x 53 (109.2 x 134.6)
Collection of Alain Clairet; courtesy
John Weber Gallery, New York (p. 124)

Perpetual Photo (No. 119), 1984–1986
Toned gelatin silver print, 62½ x 39 (158.8 x 99.1)
Collection of Alain Clairet; courtesy
John Weber Gallery, New York (p. 125)

Matt Mullican (b. 1951)

Untitled (Bulletin Board), 1979–89
Mixed media on board, 96 x 48 (243.8 x 124.5)
Collection of the artist; courtesy
Michael Klein, Inc., New York (p. 119)

Peter Nagy (b. 1959)

Entertainment Erases History, 1983
Photostat, dimensions variable
Jay Gorney Modern Art, New York
(p. 122–123)

Bruce Nauman (b. 1941)

Clown Torture, 1987
Video installation: 4 monitors, 4 video players,
2 video projectors, and 4 speakers,
dimensions variable
Collection of Coca Moroder; courtesy
Donald Young Gallery, Chicago (p. 164)

Nam June Paik (b. 1932)

Magnet TV, 1965
Black-and-white 17″ television set with magnet,
28⅛ x 19½ x 24½ (72.1 x 48.9 x 62.2) overall
Whitney Museum of American Art, New York;
Purchase, with funds from Dieter Rosenkranz
86.60a-b (p. 52)

Fin de Siècle II, 1989
Video installation: approximately 300 television
sets, 3-channel color video with sound,
dimensions variable
Analogue computer collaborators: Paul Garrin and
Betsy Connors
Digital computer collaborators: Rebecca Allen and
Hans Donner
Joseph Beuys videotape courtesy of
Seibu Museum of Art, I & S, Inc., Tokyo
David Bowie videotape courtesy of Isolar
TV wall courtesy of Samsung Electronics and
Sinsung Electronics, Seoul, Korea
Carl Solway Gallery, New York, and
Holly Solomon Gallery, New York

Richard Prince (b. 1949)

Untitled (label), 1977
Chromogenic color print (C-print),
20 x 24 (50.8 x 61)
Barbara Gladstone Gallery, New York (p. 88)

Untitled (watches), 1977–78
Chromogenic color print (C-print),
20 x 24 (50.8 x 61)
Barbara Gladstone Gallery, New York (p. 70)

Untitled (entertainers), 1984
8 chromogenic color prints (C-prints),
87 x 18 (221 x 45.7) each
Collection of the artist (p. 134)

Untitled (cowboy), 1989
Chromogenic color print (C-print),
50 x 86 (127 x 218)
Barbara Gladstone Gallery, New York (p. 135)

**An Elisabeth de Senneville design,
1989**

Robert Rauschenberg (b. 1925)

Overcast I, 1962
Silkscreen on canvas, 97½ x 72 (247.7 x 182.9)
Collection of Barbara and Richard S. Lane
(p. 38)

Die Hard, 1963
Silkscreen on canvas, 72 x 144 (182.9 x 365.8)
Collection of Irma and Norman Braman
(p. 40–41)

Surface Series from Currents, 1970
12 silkscreens on paper, 40 x 40
(101.6 x 101.6) each
Collection of Sarajean and David C. Ruttenberg;
courtesy Ruttenberg Arts Foundation, Chicago,
and Lorence Monk Gallery, New York (p. 80)

David Robbins (b. 1957)

Talent, 1986
18 gelatin silver prints, 10 x 8 (25.4 x 20.3) each
Private collection (pp. 148–149)

James Rosenquist (b. 1933)

Playmate, 1966
Oil on canvas, 96 x 209 (243.8 x 530.9)
Collection of Playboy Enterprises, Chicago

Edward Ruscha (b. 1937)

Large Trademark with Eight Spotlights, 1962
Oil on canvas, 66¼ x 133¼ (169.5 x 338.5)
Whitney Museum of American Art, New York;
Purchase, with funds from the Mrs. Percy Uris
Purchase Fund 85.4 (p. 212)

David Salle (b. 1952)

Pewter Light, 1986
Acrylic and oil on photosensitive linen and canvas,
69½ x 104 (176.5 x 264.1)
Collection of Elisabeth and Ealan Wingate
(p. 147)

Richard Serra (b. 1939)

Television Delivers People, 1973
Co-produced with Carlota Schoolman
Single-channel color video
Video Data Bank, Chicago (p. 99)

211

Cindy Sherman (b. 1954)

Untitled Film Still, 1978
Gelatin silver print, 10 x 8 (25.4 x 20.3)
Collection of Ronnie and Samuel Heyman
(p. 89)

Edward Ruscha, *Large Trademark with Eight Spotlights*, 1962

Untitled Film Still, 1978
Gelatin silver print, 8 x 10 (20.3 x 25.4)
Collection of Ronnie and Samuel Heyman

Untitled Film Still, 1979
Gelatin silver print, 10 x 8 (25.4 x 20.3)
Collection of Ronnie and Samuel Heyman
(p. 69)

Untitled, 1989
Chromogenic color print (C-print),
21 x 14 (53.3 x 35.6)
Metro Pictures, New York (p. 151)

Untitled, 1989
Chromogenic color print (C-print),
31 x 21 (78.7 x 53.3)
Metro Pictures, New York (p. 150)

Laurie Simmons (b. 1949)

Walking Camera (Jimmy The Camera), 1987
Gelatin silver print, 83¼ x 47¼ (211.5 x 120)
Collection of Edward R. Downe, Jr. (p. 171)

Tourism: Apollo 11 Mission (Moonwalk), 1984–89
Silver dye bleach print (Cibachrome),
40 x 60 (101.6 x 152.4)
Collection of the artist; courtesy
Metro Pictures, New York

Lorna Simpson (b. 1960)

Five Day Forecast, 1988
5 instant prints (Polaroid Land film), with text,
20 x 24 (50.8 x 61) each
Collection of Randolfo Rocha; courtesy
Josh Baer Gallery, New York (p. 156)

Alexis Smith (b. 1949)

The Twentieth Century #19, 1983
Silkscreen on found poster,
42 x 27½ (106.7 x 69.9)
Collection of Linda Kent (p. 169)

Mark Tansey (b. 1949)

Action Painting II, 1984
Oil on canvas, 76 x 110 (193 x 279.4)
The Montreal Museum of Fine Arts; Gift of
Mr. Nahum Gelber (p. 133)

Bill Viola (b. 1951)

The Sleep of Reason, 1988
Video installation: 2-channel video with sound,
3 video projectors, and monitor, 169 x 230 x 264
(429.3 x 584.2 x 670.6) overall
The Carnegie Museum of Art, Pittsburgh;
Gift of Milton Fine and Gift Fund for Special
Acquisitions (pp. 130, 131)

Andy Warhol (1930–1987)

Double Elvis, 1963–64
Aluminum polymer and silkscreen on canvas,
81½ x 71½ (207 x 181.6)
Estate of the artist (p. 39)

Red Disaster, 1963 and 1985
Oil and silkscreen on canvas, 2 panels, 93 x 80¼
(236.2 x 203.8) each
Museum of Fine Arts, Boston; Charles H. Bayley
Picture and Painting Fund (pp. 42–43)

New York Post Headliner, Oct. 24, 1983, 1983
Silkscreened aluminum foil,
20½ x 12 x 10 (52.1 x 30.5 x 25.4)
Collection of Christopher Makos (p. 118)

Oliver Wasow (b. 1960)

Untitled, 1989
Silver dye bleach print (Cibachrome),
50 x 33 (127 x 83.8)
Josh Baer Gallery, New York (p. 138)

Untitled, 1989
Silver dye bleach print (Cibachrome),
50 x 35 (127 x 88.9)
Josh Baer Gallery, New York (p. 139)

William Wegman (b. 1943)

Horned Cheer, 1978
Altered gelatin silver print, 14 x 11 (35.6 x 28)
Collection of the artist; courtesy
Holly Solomon Gallery, New York

Roduct, 1978
Altered gelatin silver print, 10½ x 12 (26.7 x 30.5)
Collection of the artist; courtesy
Holly Solomon Gallery, New York (p. 82)

Brooke, 1981
Color instant print (Polacolor ER),
24 x 20 (61 x 50.8)
Holly Solomon Gallery, New York

With Dogs and Babies — Actor's Nightmare, 1981
Color instant print (Polacolor ER),
24 x 20 (61 x 50.8)
Newport Harbor Art Museum, Newport Beach,
California; Purchased with funds provided
by Jim and Jane Lodge and Leon and
Molly Lyon (p. 121)

Ray and Mrs. Lubner in Bed Watching T.V., 1981
Color instant print (Polacolor ER),
24 x 20 (61 x 50.8)
University of Arizona Center for Creative
Photography, Tucson (p. 120)

Tom Wesselmann (b. 1931)

Still Life #28, 1963
Acrylic, collage, and working TV on board,
48 x 60 (122 x 152.4)
Robert E. Abrams Collection (p. 50)

Public Projects:

213

Krzysztof Wodiczko, *Projection on the Facade of the Whitney Museum of American Art, New York*, 1989.
Hal Bromm Gallery, New York

Billboards by Gran Fury, Lorna Simpson, Chuck
Close, Barbara Kruger and Jeff Koons on display
at ten locations around New York, from
November 22–December 31, 1989

The New York Times/Jose R. Lopez

The White House Shuffle, or How to Set Up a Photo Op

1 As President Bush pointed out what he thought were the markers for their photo opportunity positions, **2** Prime Minister Noboru Takeshita of Japan showed how he saw it. **3** As the Prime Minister scrunched his feet, **4** the President found his spot **5** and the moment was duly recorded. Page A5.

Acknowledgments

A project of this scope required the cooperation, advice, and support of many individuals and institutions. We are particularly grateful to the lenders, without whose generosity the exhibition would not have been possible.

We would like to thank the following people for their suggestions and assistance in sharing resources and locating works of art through the course of this project: Anne Ayres, Irving Blum, Irene Borger, Cee Brown, Leo Castelli, David Corey, Elaine Dannheiser, Jeffrey Deitch, Trevor Fairbrother and Kathy Halbreich (Museum of Fine Arts, Boston), Ronald Feldman, Richard Flood (Barbara Gladstone Gallery), Larry Gogosian, Elyse Goldberg (John Weber Gallery), Julie Graham (Paula Cooper Gallery), Dorothy Gutterman, Jon Hendricks, William Hergenrader, Barbara Hoffman, Walter Johnson (World Sign Company), Bill Judson (The Carnegie Museum of Art), Margery King (The Andy Warhol Foundation for the Visual Arts), Carole Kismaric, Frank and Patti Kolodny, John Latona (Seaboard Outdoor Advertising), Curt Marcus, Lanny Newman (*TV Guide*), Nam June Paik, Leslie Phillips, Richard Prince, Paula Royd; Barbara Schaefer, Becky Simmons, and Robert Sobieszek (International Museum of Photography at George Eastman House), Paul Schimmel (Newport Harbor Art Museum), Tony Schwartz, Ileen Sheppard, Tom Solomon, Morgan Spangle (Leo Castelli Gallery), Sandra Starr (James Corcoran Gallery), Meyer Vaisman, Doug Walla, David White, Virginia Zabriskie.

The compilation of photographs and source material for the catalogue and exhibition was an undertaking that involved the cooperation of several individuals: Christine Argyrakis (FPG International), Dr. Stanley Burns, Catherine Chermayess (Magnum Photo), Gene Ferraro (*New York Daily News*), Niel Frankel, New York Society Library, Emily Nixon (Leo Burnett Company), Scott Thode, Vanderbilt News Archives.

We are grateful to our advisory committee, leaders in various media industries: Jay Chiat (Chiat/Day), Arnold Glimcher (Pace Gallery/independent film producer), Don Hewitt (60 *Minutes*), Joan Konner (Columbia School of Journalism), Barbara Lippert (*Adweek*), Gilbert Maurer (Hearst Publications).

For the film and video components of the exhibition; Sony Corporation of America generously loaned the equipment which made the video installations possible. The television programs for "Metamedia" were selected from the permanent collection of The Museum of Broadcasting, Robert M. Batscha, President, and presented under its auspices. A generous gift from George S. Kaufman and the Kaufman Astoria Studios, Inc. provided additional funding for "Metamedia". Special thanks are owed to the contributing consultants of the "Metamedia" program, Paul Arthur, Ronald C. Simon, and Lucinda Furlong; and Art Simon for his assistance with the "Image World Film Chronology."

The development of this extraordinarily complex project has truly been a team effort. At the Museum, Tom Armstrong, Director, gave us great encouragement from the start. Many staff members have made valuable contributions. In particular, Beth Venn, Assistant, has attended to the many day-to-day details and organizational tasks such a project demands with intelligence, patience, and humor. Lucinda Furlong, Assistant Curator, Film and Video, coordinated the catalogue and installation for the Film and Video department. Matthew Yokobosky, Assistant, Film and Video, provided extensive program and catalogue research; Leanne Mella assisted in coordinating installations for the Film and Video department. Janine St. Germain, Daniel Canogar, Elizabeth Finch, and Stacy Epstein, energetic and capable interns, devoted time to catalogue research. Katie Gass helped in the early stages of development. Richard Bloes and James Coleman, projectionists, devised many ingenious solutions to technical problems in the video installations. Finally, we thank Grai St. Clair Rice, Exhibition Coordinator, for her remarkable accomplishment in ensuring that the manifold requirements — from initial research through final installation planning — were fulfilled.

The enthusiasm and personal involvement of Sam Yanes, Director of Corporate Communications of Polaroid Corporation, made "Image World" a reality.

Lisa Phillips
Marvin Heiferman
John G. Hanhardt

Photograph Credits

In the majority of cases, photographs of works have been provided by the owners or galleries, as cited in the checklist or captions, and stills from films and videotapes have been provided by the artists or distributors. The following list applies to photographs for which an additional acknowledgment is due.

Eddie Adams: 29 (left); Anthology Film Archives, New York: 94–95, 194 (far right); Mary Ashley/Courtesy The Kitchen, New York: 199 (far left); Associated Press Wide World: 76–77; Bruden Basch/FPG International: 33; Richard Bloes: 106 (right), 126–127; ©René Burri/Magnum Photos: 16 (center); Geoffrey Clements: 55, 106 (left); CBS: 194 (left), 195 (far right), 196 (far left); Bevan Davies: 65, 79, 81; ©D. James Dee: 118; *Details* magazine: 211; Dow Jones, Inc.: 188; eeva-inkeri: 148–149; Electronic Arts Intermix, New York: 100–101, 103 (left), 110, 192–193, 197 (far left); Fox Broadcasting Company: 200 (bottom left); Allen Frank: 102; Gamma One Conversions: 156; General Electric Medical Systems: 4; Vicki Gholson: 111 (left); ©Burt Glinn/Magnum Photos: 27; ©Arthur Gordon: 74; Greg Gorman: 75; ©Ernst Haas/Magnum Photos: 2–3; Diane Hall/Courtesy Electronic Arts Intermix, New York: 100–101; John Harding: 161; ©

Paul Hosefros/NYT Pictures: 10; Brad Iverson: 53 (center); ©1963 Bob Jackson: 28 (left); Garrett Kalleberg: 199 (left); Maysles Films, Inc., New York: 194 (right), 195 (bottom left); Jerry McMillan: 72 (top left); Todd Morris: 32; Ugo Mulas: 62; ©Gerard Murrell/Courtesy of WNET/THIRTEEN: 111 (right); Museum Ludwig, Köln, Courtesy Rheinisches Bildarchiv, Köln: 45; The Museum of Modern Art/Film Stills Archive: 104–105 (background), 180–181, 195 (far left), 196 (far right), 198 (left, far right), 200 (right), 201; National Aeronautics and Space Administration: 1, 56, 112–113; National Broadcasting Company: 19 (top center), 178–179, 194 (bottom left), 197 (bottom left), 199 (right); National Radio Astronomy Observatory/Associated Universities, Inc.: 16–17 (background); New York Daily News: 24–25 (background), cover; Yoichi Okamoto/LBJ Library: 29 (bottom); ©1989 Douglas M. Parker: 40–41, 169; Pelka/Noble: 69 (right), 114, 115, 160; ©Photoworld/FPG International: 8, 19 (top right), 174, 176 (left); Public Art Fund: 208; Adam Reich: 39; John Reuter: 163; ©Marc Riboud/Magnum Photos: 16 (top); Grai Rice: 12, 18 (center), 28–29 (top), 187, 189; ©Eugene Richards/Magnum Photos: 16 (bottom); Paul Ruscha: 46–47; Gary Schneider: 137; Lothar Schnepf: 144–145; Fred Scruton: 168; Signal Corps: 26; Buzz Silverman: 184; Sony Corporation: 202–203; Lee Stalsworth: 172–173; Glenn Steigelman: 30; Marita Sturken/Courtesy Electronic Arts Intermix, New York: 196 (right), 198 (far left); Scott Thode: 190–191; Gwenn Thomas: 99; Rirkrit Tiravanija: 162; UPI/Bettmann Newsphotos: 204; Video Data Bank, Chicago: 196 (left); Volkswagen United States, Inc.: 186; The Estate and Foundation of Andy Warhol, New York: 104 (center); Brian Weil: 71; Zindman/Fremont: 67, 147, 216.

This publication was organized at the Whitney Museum of American Art by Doris Palca, Head, Publications and Sales; Sheila Schwartz, Editor; Andrew Perchuk, Associate Editor; Ellen Rafferty Sorge, Production Coordinator and Aprile Gallant, Assistant.

Design: Bethany Johns
Typesetting: Trufont Typographers, Inc.
Printing: Eastern Press, Inc.